PRAISE FOR

'When art meets finance, "The Big Bang" takes on a whole new meaning. This is brilliant performative protest.'

—**Kate Raworth**, author of *Doughnut Economics*

'Banks rob us blind every day, and so Powell and Edelstyn started one that did exactly the opposite. It became a truly great work of art, and this book is a remarkable record of what we should learn from their achievement about the urgent need for debt abolition and peoples' financing.'

—**Andrew Ross**, author of
Creditocracy: And the Case for Debt Refusal

'Hilary and Dan are the Bonnie and Clyde of renegade economics, bringing a deeply imaginative, beautiful, rebel swagger to staid debate about debt. I love absolutely everything about *Bank Job*: its persistence, its guts, its compassion, its attention to detail and beauty. My visit to the Bank will stay with me always, and the ripples from this brave and brilliant project have only just begun.'

—**Rob Hopkins**, founder, Transition movement;
author of *From What Is to What If*

'In the adventure Dan and Hilary take us on, we see the antiquated architecture of the financial system for what it is and are motivated to join in with them to pull it down so that a new system can be built to meet the great challenges of the 21st century – earth-systems breakdown and obscene levels of inequality. This is a timely book, written with passion and verve, that shows how political will, creativity and the arts were deployed to transform the lives of debtors. Dan and Hilary's lived experience will inspire and strengthen the global movement for economic and ecological justice.'

—**Ann Pettifor**, author of *The Case for The Green New Deal*

'I can't think of any more exciting exposé of the role of debt in blighting people's lives than this book. As the spectre of debt looms over us in all its forms, from personal to sovereign debt, this book couldn't be more timely. As establishment politicians seek to load the economic burden of the pandemic onto people's shoulders across the globe, this exhilarating tale inspires the resistance we desperately need.'

—**John McDonnell**, MP and
former Shadow Chancellor

'We're all going around feeling something is wrong but it often ends up veering off in reactionary directions. I think this is wonderful because it marshals that sense of unease and builds it into a community and I love the way you are using it to create ties with each other and cancel debt and expose the sheer hypocrisy of the morality of debt.'

—**David Graeber**, anthropologist and author
of *Bullshit Jobs* and *Debt: The First 5,000 Years*

'Art pirates, debt destroyers and dreamers for a new economy unite! Hilary and Dan show us how the power of creativity can be a catalyst for grassroots activism when we need it the most. This book will be treasured by all those who are convinced that the radical imagination can triumph against capitalism.'

—**Max Haiven**, Canada Research Chair in Culture,
Media and Social Justice; author of *Revenge Capitalism*
and *Art After Money, Money After Art*

'The UK economy is weighed down by billions of pounds worth of unpayable debt – much of it owed by low-income households struggling to get by. With the COVID-19 pandemic slashing people's incomes – after a decade of wage stagnation – many households are now on the brink of default, even as the government pumps unprecedented sums of money into our financial system. *Bank Job* is a vivid portrait of the UK's debt crisis, which also answers the question as to what we should do with all this debt: blow it up!'

—**Grace Blakeley**, author of *Stolen: How to
Save the World from Financialisation*

'One of the greatest obstacles to change is our inability to believe in or visualise the world being different. That's where the creative activists and film makers Hilary Powell and Daniel Edelstyn succeed. Their work rips the veil from a banking and financial system which has normalised economic deception and destructive and irresponsible gambling on a vast scale. More than a simple exposé of the ludicrous rewards going to handful of speculators for risking other people's money, *Bank Job* shows how a community can come together to reimagine the economy to meets their own needs.'

—**Andrew Simms**, author, co-director of New Weather Institute, coordinator of Rapid Transition Alliance

'They didn't just blow the bl★★dy doors off: the whole van went up, and with it, the full sorry story of debt and its stranglehold on ordinary lives across the world. While countries and corporations wallow in the red, it's a black day indeed for millions when the balance of payments tips against them. Now, Powell and Edelstyn, the Thelma and Louise of finance hacking, deliver a rock n' roll history of where it all went wrong, and how it can start to go right. We all owe them a debt of gratitude for the cunning collaborative creativity of their project, but it's not over yet. Much more action is needed, and *Bank Job* gives you all the tools to finish what they started. Right here's where we start paying . . . in sweat! Keep the engine running, we're going in. . . .'

—**Gareth Evans**, producer, *Patience after Sebald*

BANK JOB

HILARY POWELL
& DANIEL EDELSTYN

Chelsea Green Publishing
White River Junction, Vermont
London, UK

Chapter opening images by Phil Seddon, Hilary Powell and Daniel Edelstyn.

Project Manager: Patricia Stone
Developmental Editor: Muna Reyal
Copy Editor: Susan Pegg
Proofreader: Deborah Heimann
Indexer: Nancy Crompton
Designer: Melissa Jacobson

Printed in Canada.
First printing September 2020.
10 9 8 7 6 5 4 3 2 1 20 21 22 23 24

Our Commitment to Green Publishing
Chelsea Green sees publishing as a tool for cultural change and ecological stewardship. We strive to
align our book manufacturing practices with our editorial mission and to reduce the impact of our
business enterprise in the environment. We print our books and catalogs on chlorine-free recycled
paper, using vegetable-based inks whenever possible. This book may cost slightly more because it was
printed on paper that contains recycled fiber, and we hope you'll agree that it's worth it. *Bank Job* was
printed on paper supplied by Marquis that is made of recycled materials and other controlled sources.

Library of Congress Cataloging-in-Publication Data
Names: Powell, Hilary, author. | Edelstyn, Daniel, 1976- author.
Title: Bank job / Hilary Powell & Daniel Edelstyn.
Description: White River Junction, Vermont : Chelsea Green Publishing, [2020]
 | Includes bibliographical references and index.
Identifiers: LCCN 2020029942 (print) | LCCN 2020029943 (ebook) | ISBN 9781603589697
 (paperback) | ISBN 9781603589703 (ebook) | ISBN 9781603589710 (audio)
Subjects: LCSH: Debt—Social aspects—Great Britain. | Debt cancellation—Great Britain. | Art
 and society—Great Britain. | Art and social action—Great Britain. | Bank notes—Great Britain.
Classification: LCC HG3754.5.G7 .P69 2020 (print) | LCC HG3754.5.G7 (ebook) | DDC
 332.70941--dc23
LC record available at https://lccn.loc.gov/2020029942
LC ebook record available at https://lccn.loc.gov/2020029943

Chelsea Green Publishing
85 North Main Street, Suite 120
White River Junction, Vermont USA

Somerset House
London, UK

www.chelseagreen.com

To Esmé and George. Long live the creative anarchy and imagination of childhood.

To our parents and to everyone from Walthamstow and across the land and seas who has joined the Bank Job and made it happen.

CONTENTS

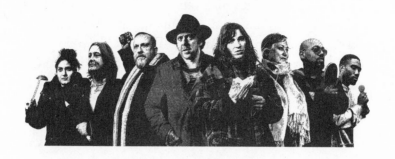

Introduction

May 2019. A golden Ford Transit van explodes on London Docklands wasteland with a backdrop of the Canary Wharf financial towers. Papers flutter through the morning air and with this act £1.2 million of UK high-interest debt is cancelled. What led to this early morning debtonation, a culmination of our journey down the rabbit hole of debt and money, a quest and a questioning of the moral arguments around debt and the injustice at the heart of the current economic system?

Five years ago, mid-creative crisis and post first feature documentary film, searching for stories and meaning, Dan travelled off to the US with a camera in pursuit of the social movement Strike Debt and their 'Rolling Jubilee' project that buys student and medical debt for pennies on the dollar, then abolishes instead of collecting it in 'a bailout of the people by the people'.[1] Out of Dan's initial curiosity as

to why they would do that, came further research and his realisation that, in the words of founding member and New York University professor Andrew Ross in *Creditocracy*, 'Our future is mortgaged, calculated, and owned far in advance, and our democratic right to change it for the better is effectively minimized.'[2]

From that moment on we were on a mission, with Strike Debt's words reverberating in our heads: 'Join us as we imagine and create a new world based on the common good, not Wall Street profits.' How could we write off debt in the UK? As filmmaker (Dan) and artist (Hilary) we grappled with the question of how we could make a film about this that could move people to think, to question, to act and... to change. To break through the purposefully opaque language of finance, questioning and countering the overbearing narratives around debt – narratives that keep us trapped. After many dead ends and turning points, we found the answer in our home and the people who surround us. Amid the terraced streets of the London suburb of Walthamstow, our Bank Job was born as a community heist on the financial system.

> *It feels as if our generation has lost the right to dream*
> *And to stand for what is right*
> *But climbing onto the roof of my house*
> *In the suburbs of east London*
> *Weighed down with mortgages and other debts*
> *Looking over a suburban landscape*
> *Where people nursed their visions to sleep*
> *I wanted to sumon the courage to dream again*
> *of changing the world*
> *And to seize my own destiny*
> *Before the hour grows too late*

The Bank Job

Our plan (as they always are) was simple. We would open a bank, print our own money, sell it, raise enough money to buy up £1 million worth of debt on the secondary debt markets and then destroy it.

Step one: get a bank

In March 2018, in a former cooperative bank on a high street in our London suburb, we opened Hoe Street Central Bank (HSCB) to the public. Here we gave ourselves the power of a central bank and printed our own money. This was our very own 'magic money tree' whose existence has been denied by successive governments, that could print banknotes/art daily and exchange it for sterling.

Employing a crack team of local residents trained up in traditional print techniques, we made banknotes featuring local people we felt were picking up the pieces of a broken economic system, people who had value that the government didn't recognise. Replacing the Queen and famous figures from British history, from Adam Smith to Charles Darwin, were anti-creditocracy heroes Saira Mir and family who run the homeless kitchen PL84U Al-Suffa, Gary Nash of Eat or Heat food bank, Steve Barnabis and Josh Jardine of The Soul Project youth service, and headteacher Tracey Griffiths of Barn Croft Primary School.

The bank became a hub of economic education with the 'performance of making' offering a tactile way into the concepts and preconceptions we aimed to tackle. The project went viral and, alongside queues down the street, the banknotes travelled across the world to locations as far flung as Singapore, Texas and lighthouse stations off the coast of Scotland.

We raised £40,000 through selling the banknotes/art at their face value (initially £5, £10, £20 and £50 notes, then £100 and £1,000 notes), with half going to the organisations featured on the banknotes and the other half into a fund to buy up and cancel (instead of collecting) £1.2 million of local predatory high-interest debt (payday, credit card and catalogue). This cancellation was a quiet process of spreadsheets refined by postcode, grappling with acronyms from GDPR (General Data Protection Regulation) to the FCA (Financial Conduct Authority).

Step two: pull off a heist

Most heists aim to fly discretely under the radar. Ours was always hell-bent on making the biggest splash. If our project was to do what we intended, and challenge and be an intervention in the prevailing public narratives around debt, we needed to make a noise about it. Buying the debt was really quiet and invisible. We wanted to do something visual and dramatic. This became the 'Big Bang 2' – the controlled explosion of our 'debt in transit' van in front of London's financial district.

Again this was a collective act – funded by a global community who purchased bond certificates printed by our bank using the same team and techniques, and promising a return on investment in the form of a piece of this literal, visceral explosion: coins made from the exploded remains.

An article in the *Guardian* dubbed us the 'Rebel Bank' and we owned it, rewriting the rules of engagement in economics, debt, art and finance. HSCB was again open to the public, exhibiting the exploded fragments of debt and money in suspended animation, and establishing itself as a place that could fill a growing void in the increasingly financialised spaces of the city – a space open to public

imagination and debate, inviting people inside to share in a contagious vision of change.

Step three: film it

In *Bank Job* the movie – our film that all of this action becomes part of – we attempt to play with classic heist story structures and try to make sense of the unruly reality of life living the Bank Job, where the development, conflicts, crises and consequences are constant. Alongside the rupture of the EU Referendum, the UK has had three general elections in four years, and around the world far-right leaders have taken and consolidated power. At the core of the system we live within is a deep hypocrisy upheld by those it hurts most. Our children are growing, we have new friends, new focus and new fights. The world is in flames and flood, and the call and refrain of 'people power' ringing out across the streets of the globe brings some hope in the dark. And it has got darker since we began writing this. We are now in lockdown as the COVID-19 pandemic sweeps the world.

Step four: explode the view

Our act of debt write-off was inspired by Occupy Wall Street affiliate group Strike Debt and the multiple student debt buy-ups and public debt burnings they undertook in the US, recognising their power in educating people about how the debt system works and the power relations at play.

But at its core, the Bank Job is a project about debt and democracy or, most fully, debt and freedom – the impact at all levels of state-imposed austerity (imposed to supposedly 'pay back' national debt) and the crippling servitude of household debt are not only social and physical, they affect our collective imagination, our ability to dream and create a future.

In *The Crisis of Democracy: Report on the Governability of Democracies to the Trilateral Commission,* published in 1975, the

authors identified an 'excess of democracy' in the educational establishments of the US, with then Republican governor of California Ronald Reagan calling the University of California, Berkeley campus a 'haven for communist sympathisers, protesters and sexual deviants'. Evidencing this in the large-scale participation in anti-war demonstrations, the solution was found in imposing tuition fees. For, as Andrew Ross states, 'short of armed repression, the loading of debt on to all and sundry has proved to be the most reliable restraint on a free citizenry in modern times.'

This shared awareness of how debt is a natural companion to money and that money creation by banks is fundamentally biased towards the lenders, or creditocracy, exposes the illegitimacy of certain debts and the skewed morality foregrounded by a 'creditor class'. The realisation that debt is a social construct and shared fiction, not a non-negotiable fact, is in itself emancipating.

Step five: spread the word

Actually, ideas of debt write-offs are not that radical. We wanted our campaign to spark a bigger movement across the UK demanding economic justice. As Laura Hanna of Strike Debt said when we met on the streets of New York, 'Things are not going to change unless people start to actually act themselves and build power at the grassroots scale and in the financial markets. We're not going to have a system change from above.'

The BBC's *One Show* described us as a 'nice couple', helping poor people and local causes. 'How lovely; you gave the money to the local causes – that's so nice' – we knew that would be what many people thought. But for us the idea of 'thinking through making' is central – making visible, tactile and malleable forces that we are told to believe are immutable. We believe in an empowered knowledge through participation and action.

Introduction

We are all, or we all should be, citizen poets, citizen artists, citizen economists. There is an urgent need for some far-reaching economic education, not only to help us understand the system as it is, but to take the next step in reimagining it. A step that encourages critical thinking, asks challenging questions, and grows from participation and collaboration.

What if the 2008 crash had been used as an opportunity to reshape the financial system with fresh purpose and create space to reimagine an economy that works for all of us based on economic justice? This leap of imagination lies at the heart of our Bank Job. The debt crisis cannot be corrected through local action alone, but grassroots experiments can provide both inspiration and concrete assistance to those caught at the sharp end of the problem and forced into traditional, crushing structures of stigma and blame. We wanted to challenge the highly moralising, psychologically powerful narratives of debt and money. Of Victorian notions of balancing household budgets, and religious and social sanctimonies about the sins of borrowing and the shame of debt. The project has given us hope that communities can be resilient and will stand together – that if we owe anything, it is to one another to shape the sort of world that our children can inherit with confidence. The feeling that we are not alone – or as the Strike Debt campaign puts it, 'not a loan' – that together we can create value that transcends the embedded debtor-creditor relationships that are ripping our communities apart.

The story behind the Bank Job

There has been a trajectory of banking deregulation and an increasing financialisation of society over the past 30 years that owes its origins to something that began happening

in our childhoods. Ex-prime minister Margaret Thatcher's 1986 Big Bang forged a path to the bailout of the 'too big to fail' banks in 2008 and the personal debt crisis that happened in its wake.

Neoliberalism took over from the post-war Keynesian economic thinking, which united economic growth with robust welfare regimes. Instead, neoliberalism claimed that we are best served by maximum market freedom and minimum state intervention. Free markets, free trade, free enterprise – the key word being free. But this freedom seems only to apply to one tier of society. Free education, a free-at-the-point-of-access healthcare system – all of these freedoms are being eroded, while those forced to turn to welfare or debt in order to survive are labelled freeloaders in an ongoing rhetoric against the poor and vulnerable. This is freedom for the few who hold the cards, debt peonage for the rest. Freedom to take profits offshore, to indebt the public services through private finance initiatives. Freedom to privatise our public goods. Freedom if you happen to be part of the creditocracy; the financiers and politicians, who along with their enablers and enforcers in popular media and corporate law, have architected a system in which public goods such as healthcare, education and housing have become commodities to be paid for through credit and loans, rather than through taxation.

At the peak of the 2008 banking crisis, the UK government had liabilities worth trillions of pounds.[3] In the emergency bailouts that were agreed by then prime minister Gordon Brown, the UK taxpayer bought £45 billion of shares in the Royal Bank of Scotland and just over £20 billion in Lloyds Banking Group.[4] However, while the public effectively now owned the majority of these banks, the ensuing stimulus packages, quantitative easing and share sell-offs have not been carried out with the well-being of the public nor the

responsible transformation of the banking system in mind. This was a debt write-off on a massive scale happening in the shadows, with limited moral outrage or indeed public explanation, shielded by the endemic lack of engagement or understanding of economics.

This bailout of the banks and not the people heralded over a decade of austerity. Although allegedly to balance the national books, this has been widely disproved and denounced. On a 2018 visit to the UK, witnessing rocketing food bank usage and homelessness, Philip Alston, the UN's rapporteur on extreme poverty and human rights comes to a damning conclusion, 'The experience of the United Kingdom, especially since 2010, underscores the conclusion that poverty is a political choice. Austerity could easily have spared the poor, if the political will had existed to do so. The political choice was made to fund tax cuts for the wealthy instead.'[5]

It's now time for the bailout of the people.

The problem of debt

Declining government spending in Britain and quantitative easing (the Bank of England creating money to keep the financial system flowing) has seen private debts balloon to over £1.6 trillion in 2017, most of which are mortgages (banks choosing to invest in 'assets' rather than public goods or green infrastructure that will help society as a whole).[6] Between 2012 and 2017 unsecured credit increased by 19 percent, student debt doubled to £100 billion and council tax arrears increased by 12 percent.[7] Debt has become a product of a consumerist society, needed to pay for the essentials of life – housing, cars, holidays, and now food and bills. Historic low interest rates are available to lenders, who

are getting rich on debt, but not to the poorest, who are charged massively inflated rates. This data is symptomatic of a creditor class gone wild.

How could we buy £1.2 million worth of debt for £20,000? Like commodities, people's debts are traded by the companies that own them, their price reducing as the debts get older and less likely to be repaid until they become around 1–2 percent of their face value. The debtor, though, still owes and is chased for the original amount, with consequent damage to their credit report.

A new way of seeing

Above all, our Bank Job is a leap of imagination and faith and an ongoing act of education. A 2017 Positive Money survey states that 85 percent of members of our UK parliament do not understand our banking system or how money is created in the modern economy.[8] This not-so-shocking 'shocking ignorance' of our politicians extrapolates across a society built on continuously regurgitating the assertion that 'there is no magic money tree' amid outmoded Victorian platitudes and judgements. The reality of money creation is mind-bending – that commercial banks literally create money when they make loans. There are basic facts that are neither widely taught nor publicised: that money is no longer pegged to gold. That when you take out a loan the money does not come from a collective pile of other people's savings. That everything you vaguely think you know is probably wrong and that perhaps it all goes 'over your head' for a reason. We are a society in the dark and where critical thinking and imagination falter, fear and prejudice take over. There is a profound responsibility to understand and engage.

Introduction

Ignorance is far from bliss: it is a cage; but then, so is knowledge without action. Through coming together in a Bank Job we have sought out and shared an empowered knowledge to expose and challenge debt as an instrument of control.

Debt, democracy and freedom are intricately entangled, and if debt is the key tool of a neoliberal order then what do we have in our toolkit? Creativity, community, collective action and critical vision – taking our place amid a growing chorus of voices demanding that economics be done differently, and doing it ourselves and with others. Making space – in the mind, on the screen, page and in the city – to open up a process of questioning received wisdom, and creating and working with a new currency of ideas where art and action are mediums of exchange and change.

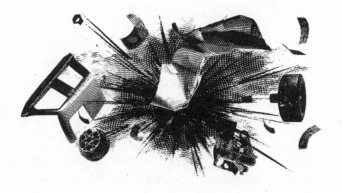

The First Big Bang

*I*n *the beginning there was a story. Here we interweave the stories that shape us with the bigger story surrounding our childhoods in 1980s Britain. Big Bang 1: we were too young to understand the impact of Thatcher's 1986 deregulation of the financial markets. From Dan growing up in the Troubles of Northern Ireland dreaming of New Wave Paris to Hilary's itinerant vicarage childhood, catalogue of manual labour and exposure to Oxbridge elitism, the backdrop of the rise of neoliberalism pervades every area of life.*

We turn to the bigger role of stories that both create and stand in the way of freedom, and the role of the artist in 'turning the world upside down', poking holes in the prevailing narratives and rewriting what we are capable of. From Thatcher's Big Bang to the big bang happening within ourselves that led to our exploded view of the systems we live under, personal and collective narratives fuse and overlap. It

Bank Job

is a demolition journey, setting charges amid the fault lines
of our lives, jettisoning outmoded baggage and salvaging the
values that drove us to this.

Perhaps who we are doesn't matter. But context does
and as we tell the story of a Bank Job our own narratives
intertwine. We were faced with the need to make sense of,
and indeed overcome, the stories we were told growing up:
received wisdoms, religious ideas and Victorian attitudes –
the master story of economics – as household rules. These
stories and the gaps in them, the blanks in the history books
and consciousness, defined the parameters of our life and
possibilities. This project has been a journey of demolition,
planting a series of charges to expand the barriers and fault
lines. Smithereens for all of us. Gathering the fragments in a
redemptive salvage operation.

There are those 'where were you?' moments. When
Princess Diana died. The dawn of the new millennium.
September 11, 2001. But in everyday circles no one asked,
'Where were you in the 2008 crash?' We weren't there to
watch the digits fall. Didn't have anything to lose. Didn't
understand the implications. Didn't bother to look as we
went on with the daily business of making ends meet. It
was a world of high finance far away from the every day. Or
so we thought.

So where were we? Children of the 80s, 'Xennials' on the
cusp of Generation X – a giant X marking the spot where
neoliberalism took hold of our land- and mind-scapes. And,
if we are 'on the cusp' perhaps we may find our power there,
at a point of transition between two states – scepticism and
optimism, analogue and digital – unashamedly embracing
the enterprise culture that was a backdrop to our youth,
rejecting nostalgia for active hope, spurning denial for

holding power to account. And this is not something we were conditioned for.

Both our mothers' memories were indelibly marked by the flames of Liverpool burning. Born into war, they lived through the formation of the welfare state that is now being corroded with the acquiescence, if not approval, from those who benefited most. These everyday erosions are coming thick and fast, and it is now the job of everyone to take notice. To find new ways of seeing and acting. In our case our particular histories on this planet, on these islands for much of these last 40 years, under consecutive Conservative and New Labour governments, have been shaped by the shifting relationship of people to finance that led to the financial crash and is threatening life on Earth.

Dan

In 1976 the Apple Computer Company was launched, *Rocky* was released and Concorde made its first commercial transatlantic flight. But more significant than all of that put together, at least for me, I was born in Newtownards, near Belfast, Northern Ireland. My father was a flamboyant cancer doctor at the forefront of chemotherapy research, my mother a psychologist. Her thick red hair and green-brown eyes declared her warmth and intelligence. He looked like a young Einstein – receding hair poking out at jaunty angles as if conducting electricity. When I was born, they were living on a small island in Strangford Lough. They had moved to the dilapidated three-century-old house as an escape from Belfast and reality, but the idyll they created soon became a place of broken memories and heartbreak as we rattled around it on our own.

Bank Job

In 1979 Thatcher became Prime Minister and my father died. I was three and my brother Max was four. Along with a rusting Aston Martin in the garage, he left a large shadow across my childhood – his death commemorated in inches of newspaper print and across local TV news bulletins: 'Cancer pioneer died at 47 from the disease he dedicated his life trying to cure.' He put his work above all else but adored his family. After work, sometimes he'd pick up a shotgun and prowl the island, my mother following him with a large glass of his favorite scotch as he took potshots at birds. He never hit them, apart from once. He was so full of remorse that he buried and held a funeral for it, reciting the Kaddish. That was the end of his career as a hunter, though I remember finding a revolver in a cupboard along with some yellowing photographic ID. When my mum told me he had died, I asked, 'Who shot him?' Shootings and bombings were the norm. I wanted revenge.

As I grew up, I was lulled to sleep by the sea lapping on the rocky shoreline and the stories about my father. His death was so large it drowned out all other context from my childhood. He became a legend. The salient points were always the same. A man of great charm and magnetism dedicated to his patients. A great doctor in charge of running Dublin's Hume Street hospital's cancer department and Belfast's Belvoir Park simultaneously. A man who had started up the Ulster Cancer Foundation but, when they refused to fund his experiments, had started another charity, Action Cancer, which has become one of Northern Ireland's biggest. He worked with radioactive isotopes without wearing the proper safety equipment. A reckless, brilliant self-sabotaging man with expensive tastes. A man who *was terrible with money and left debts.*

His character was so strong, his absence so great, that even thinking about it almost 40 years later I feel its pull like

morose gravity. His parents had escaped from the Russian Revolution, his mother was from a wealthy Jewish family who had lost it all in 1917. Many of them had disappeared, some murdered by the Nazis when they invaded Kiev and others dispatched by the Italian fascists in Odessa. The pull to revisit the homeland that these stories conjured proved too much to resist and my first feature documentary, made with Hilary, was a process of mending the broken twines as I saw them and understanding how far I needed to burrow down into my roots, *my foundations*.

Hilary

Born 1977. Isle of Man. Middle of the Irish Sea. A one-year-old Dan would have been toddling along the shores of Strangford Lough looking west across choppy waters. This was the year of the Queen's Silver Jubilee, the Sex Pistols released 'God Save the Queen' and when the power of the financial sector over our economy and therefore our lives was beginning. Not many people noticed. There's no future/ and England's dreaming. The spirit of the 60s, let alone punk, did not reach the doorstep or hearts of my parents. Both God and Monarchy were sacred, and the Sex Pistol's rebel lyrics 'Don't be told what you want / Don't be told what you need' were not yet ringing in my ears. We happened to be living in an offshore tax haven, yet the secret travels of money were a world away from the booze and vomit stains of Irish Sea crossings in winter and the fairy shores of the folk songs they loved.

A year later Derek Jarman released his own punk poetry in the form of the film *Jubilee*. Queen Elizabeth I is transported through time to a shattered Britain to interpret the signs of

anarchic modernity. Off the screen my family made its own, less nihilistic journey from the Isle of Man to Gloucestershire in south-west England. This was apparently the Winter of Discontent yet the photo albums show only the nostalgic vision of a young couple with a toddler and another baby on the way. Family albums and cine reels don't have much space for political realities, framing out overflowing dustbins and awkward conversations. Living in the Stroud valleys my childhood was full of snow – a deep, forgetful snow I now mourn in the grey slush of London and a warming Earth. We were shielded from harm and politics and, through extremely careful household management and inbred frugality, debt. In a family 'made good' and making a very self-conscious step away from the previous generation of servants and labourers – to become 'educated', to become teachers – there was a lack of solidarity with the unions. The rubbish strikes were an inconvenience. Talking politics, sex or religion was not polite and yet, they find a way in: in the Mayday processions so alive and well in those rural parishes where my father began his training as a clergyman, in the very architecture of the housing estates we occupied, from wild cheese rolling to giggles on the green. In the calendar of my childhood, May 1st was not Labour Day but something more primal. Our red-letter days marked saint's days, not the red of Labour, and my childhood is tinted by the first taste of the blood of Christ and the circular wafer of his body. Throughout it all there was a Christian siding with the underdog pronouncing 'blessed are the meek, for they shalt inherit the Earth',[1] though in real life, they shalt get totally done over. Meekness is not a virtue or blessing if it means bowing to and not questioning power. These were the philosophical conundrums confusing and forming me from an early age. What have they got to do with debt and money, freedom and democracy? A great deal.

Dan

My mother's hard work and laissez-faire attitude to our upbringing led to an amazing freedom to run wild: a freedom that led to threats of borstal or naval college. She was always busy and frequently worried about my moral development. I asked for her guidance on everything. I couldn't understand why there were children dying in Africa when I watched Band Aid – or indeed why there was poverty at all, when we had it so good. My mother told me that 'life just wasn't fair'. It was very sad, but you just couldn't change the world.

I saw the world through the eyes and stories of my mother. She was born near Liverpool into an English Catholic family with pretensions of grandeur but living in conditions somewhat below what my grandmother felt she deserved. My grandfather became a captain in the merchant navy during World War II and my granny had been a nurse. Born in 1937, air raids and austerity were marked somewhere in my mother's soul. Her cupboards were full of tins and jars of aging peanut butter and jams of every hue. She lived frugally. Indeed self-denial became a central tenet of her world view and, mixed in with her more meritocratic ideas and in conjunction with her protective frugality, came her ideas on debt. I should 'neither a lender nor a borrower be' and 'cut my cloth according to my kind'.

However, alongside these very common-sense approaches to money were other layers. From an early age my mum revelled in telling me how lavishly my father was able to spend. She viewed entrepreneurs as creative risk takers who lived or died by the boldness with which they made their choices. I was to fulfil some tragic, half-imagined legacy of my father as recounted through my mum's stories of lost riches, huge public service, experimentation and a form of risk taking in

which social contribution trumped personal financial gain. If I was to be *half the man my father was*, I'd need to formulate a way of serving the public on his scale and finding a way to burn my fingers on some other metaphorical radioisotopes.

Although I would never end up saving lives through cancer treatment and disease research, I felt my fate might be to change the world through story. But was that really possible? Almost all noble deeds are stories against adversity, and all atrocities are justified and encouraged through stories. Stories are the most potent weapons ever invented. They give us meaning and fuel, they tell us who to take aim at and why; they show us who we are, whose side we're on and who and what we're against; they orientate us in right and wrong and give us meaning; they tell us what we should be doing with our lives.

Hilary

Seven years old. The year my father decided to go in for the church. A blessing and a curse. 'Peace be among you.' 'And also with you.' That was something I could believe in. Hands meeting and touching. My small fist clasping a woodlouse while shaking hands with an elderly, smiling man. The hands I imagined carving their mason's marks in the cloistered, gothic arches my sister and I came to frequent, watched over by gargoyles as we were left to our own devices. The wonder of cathedral thinking permeated my imagination with a soundtrack provided by the constant crossings of the harp string infrastructure of the Severn Bridge. *Croeso i Cymru* – welcome to Wales – prompting spirited renditions of the Welsh national anthem every time. These family visits passed through a landscape marked by industry, but the miners'

strikes were invisible from our route. Privatisation happened while I was being reprimanded for picking pebbledash off the walls of bleak bungalows and force-fed stew and bara brith by my grandmother. While I remember this *mamgu* as someone regularly saying it would be the last time we'd see her but who remained firmly alive, to my mother she was a battleaxe in brown whom I was in mortal danger of becoming. A threat and insult that I chose to see as a positive – a woman who managed a smallholding and took on household demolition jobs with aplomb.

Dan

In 1984 I was eight years old. I remember hearing about the miners' strike on the news. My mum told me in no uncertain terms that the unions were doing their best to hold back the country. The miners, just like the Irish nationalists, were totally unreasonable. My mum had managed not just to survive after my dad died, but to pay off his debts. Working long hours as a single mother she used the money she earnt to send us to weekly board at a local prep school. I remember the immense feeling of betrayal when 'sent away', disconnected from the blissful days of early childhood when we had our mum all to ourselves. On long summer nights we explored the furthest extremities of the school grounds, playing in the woods and learning English, Latin, Irish folktales and maths from teachers who became legendary characters haunting our memories to this day. I loved the school, despite the carvings in the desks: 'UVF', 'Taigs Out' (the loyalist paramilitary group Ulster Volunteer Force, and 'taigs' a derogatory name for Catholic nationalists). The version of contemporary Northern Irish history that circulated

in the subtext of the school was that of the Protestant elites there to fight for Conservative Unionism. Sometimes at night, tucked up snug in one of the dorms of the school, you would hear the muffled sound of a bomb or shots travelling across the loch. They were so far off that they made you feel safe and out of harm's way. The Troubles were on TV, almost never directly seen, always mediated, and only rarely did they enter directly into my cushioned existence. Every morning in the school there was an assembly. It was a high Protestant school and between news and sermons we would recite the Lord's Prayer. 'Give us today our daily bread and forgive us our sins.' Some versions of the prayer ask for forgiveness of our *debts*, depending on their interpretation of the original language – and of the translator's economic beliefs...

Hilary

My mother shuddered when she told the tale of meeting her future father-in-law for the first time. Driving faster and faster down a narrow country lane he turned to her with missionary zeal to ask: 'If I was to crash now would you be saved?' Debt, salvation, redemption and guilt intertwined in a childhood watched over by God. Or was it Big Brother? Or Santa? A holy trinity of oppression, joy and mystery fused with the Sunday-school stories I absorbed. Of sacrifices, burning bushes and parted waters. There was a force stronger than us and for me it was not God the Father or Father Time, nor the Land of my Fathers, but Mother Earth.

First on the buzzer in the Stroud valleys' primary school nature quiz my childhood was a litany of flower and bird names. Beyond identification and classification, ideas of stewardship and theology underpinned my understanding of

nature. I'd later recognise this in the complex systems thinking I'd already internalised, but then it was a nurseryman grandfather who'd managed to prove his financial worth to his love by successfully getting a job as gardener in a big house, a father who knew the song of every bird and a passionate botanist mother. It was paper bags on dahlias, pilgrimages to snowdrop woods, a vision of a world of sap rising and roots stretching, spoors on the wind and feathers stroking skin. It was a place where science, superstition and religion could all agree on one thing. The wonder of life on Earth.

Alongside the lore of nature, frugality was a kind of religion. 'Waste not, want not' was our motto and chocolate was quite literally given in the same recycled prescription bags used on the dahlias. An aficionado of picnics and leftovers, my childhood diaries foreground food – and what it cost. Intricate budgeting continued on into my adult life in a profound Protestant work ethic. Making ends meet and proud to be doing it. A litany of multiple jobs. A litany that built great solidarity but impinged on the potential of my creative ambition. Early on this was the making and the undoing of me – this need to balance my books.

But before I had a chance to do that I had the tricky business of growing up to do. Reading, not balancing, a multitude of books as I questioned the gospel truths of my childhood. Combining the cheerful fatalism of country superstition with the traces of Baptist fundamentalism, these potent commandments caused conflict and confusion: 'Thou shalt not come in the front door and go out of the back door, thou shalt not covet. Thou shalt not cross two knives, drop salt, see one magpie, hold a horseshoe the wrong way, cross a black cat, but thou shalt respect the word of the Bible, bishops, politicians and, most particularly, the BBC. Thou shalt respect authority whether right or wrong'. *Que sera, sera.*

Dan

By 1989 my mother's threats of borstal became a journey across the sea following my brother to Gordonstoun School in Scotland. The tough Outward Bound school was born from educator Kurt Hahn's ideas. Hahn, who had escaped Nazi Germany, was a Jew with a strong bent for German Protestant thought. A little like my mother, the school was modelled around well-heeled frugality. His central idea was to put people through hell and show them that they were capable of more than they thought: *'plus est en vous'* ('there is more in you than you think')! Once again every morning the Lord's Prayer ingrained itself in our deeper-most core.

My early beliefs in social justice were relentlessly targeted and I ended up stapled to the wall in my boxer shorts. At least the annual 'sprog run' had been stopped the year before I arrived. This consisted of a race round and round the house for the third years, with senior boys lining the route and hitting the 'sprogs' as they came through. The last sprog standing was declared winner, while the others were punished for their weakness. The Darwinian message was clear: play the game or face the consequences. If we obeyed the years above, we would thrive. If we questioned them our lives would be a misery. As they pointed out, it wouldn't be for too long, and soon we would be in the fourth and fifth year, out of danger and able instead to bully those beneath us. I will never forget the terrible logic of this.

I taught myself guitar and wrote, sensing that within these creative acts lay a form of freedom and perhaps an alternative to the prevailing culture of the place. As a child I had been an obsessive diarist; now I turned to photography in direct response to the loss of my father and the belief that everything was changing so fast the only way to hang onto anything was

to document it. I spent hours in the school darkroom. In this way, I could keep control and become a god of the things that mattered most in my world. To preserve order, to make sense of things and to curate a world I wanted.

Hilary

1989. The fall of communism. As walls fell in the east there were only smashed doors, hearts and garden furniture as I struggled to contain a rising frustration – now living in a rented bungalow in a cul-de-sac on the island of Guernsey, cornered by dense fir hedges and a moral universe I questioned. My Prague Spring was yet to come but lay dormant and expectant. At 13, stuck on an island, my brave future self was a waving apparition as she cycled onto the Harwich to Hook of Holland ferry with an oversized backpack, overtaken by convoys of military vehicles, travelling into an exciting unknown. For now, it was self-consciously lonely walks on beaches where salty sea and tears mingled and a resilience and rebellion grew. It was there in the WWII bunkers that flanked the coast and the stories of the resistance as 75 years later the Channel Islands celebrate their liberation. Liberation. On the network of island roads often completely occupied by cows I became forever inseparable from my bicycle: my escape method, metaphorically and quite literally, from stones thrown because of my grammar school uniform in 'enemy territory'. It was my glimpse of the nature of freedom. While not yet familiar with Havel's 'The Power of the Powerless', the images of the wall falling, of the story of a Mr Pye who grew wings and flew from the nearby island of Sark, and an introduction to *Jonathan Livingston Seagull* formed a road to liberation.

It ended up being a ferry journey. A relocation north to the 'homeland'. Seaside towns, bleak mountains and a grey Irish sea. I'd left behind the incomprehensible suicide of the only teacher who made sense – a Buddhist teaching religious studies who'd introduced me to Schumacher and encouraged the questioning that so provoked and destabilised me. History had been made dull by the spitting recitation of 'The Charge of the Light Brigade' while classmates graded the females of the class by looks. A history relayed through rote dates and dominated by war.

Blossoming and thriving were not words to associate with time at these multiple schools. Extremely quiet rebellion and acquiescing to obedience. An unbearable lightness of being. At school. At church. Elsewhere. Both books and work became a freedom. T.S. Eliot and toy shops, *King Lear* and pulling pints, Camus and wedding catering, baking scones for retired holiday makers to the strains of Classic FM. *Thus Spake Zarathustra*. A journey home from a marquee with a drunk driver on a mountain pass and the awful feeling that this could be the end before it had even begun.

Dan

While being forced to jump into a freezing North Sea off the yacht *Sea Spirit*, my own spirit yearned for Paris. I became a francophile at the age of five. In the books we read everyone seemed so polite and nice. 'Hello, my name is Pierre, would you like to come and listen to some records?' I wanted to go there. Later it was for the Gauloises and girls. The Channel Tunnel opened. Newspaper headlines declared 'No Longer an Island'. French and English tunnellers shook hands through broken rock. I was irredeemably romantic. Irredeemably

European. In Paris I worked as a photographer's assistant and spent long hours drinking red wine with new friends with dodgy pasts. I got into portraiture and lighting. I worked a stint in McDonald's alongside a communist organiser narrating all that I felt about the injustice of the working system. I remember being frightened by his radicalism. Frightened that I agreed with him. My own political voice was very repressed after public school indoctrination.

When I was asked why I wanted to study history, I remember saying, 'So that we don't repeat the mistakes of the past.' The tutors told me that history isn't about taking sides or avoiding old mistakes, but rather about creating a scientific methodology to accurately reflect what actually happened. This disconnection between the storytelling of history and the drawing of moral conclusions seeped into my heart and it seemed as if all meaning had been removed. The interview itself was part of a moment in history that denied political agency to historians. The damage it caused reverberated around me for years to come. *Stories without value cannot exist.*

If my dad's legacy loomed large it was in my mother's footsteps I followed as I headed to University College London to study history and French. My mum escaped a repressive Catholic upbringing full of nuns and guilt through hard work and determination, heading to UCL at 16 as one of the first female psychology students. She edited the student newspaper and at just 19 got a job on Fleet Street working for the *Daily Sketch* and *Daily Express*. On my mother's twentieth birthday she had a double-page spread right in the middle of the newspaper but, married and pregnant, she followed her husband to Belfast. When this first marriage broke down she returned to university and gained a PhD in psychology. Her background and values

echoed Margaret Thatcher's ascension, and growing up I was introduced to the world of politics through the eyes of a high-achieving, Conservative-voting public servant. Dutifully I became editor of *Pi*, the very same newspaper she had edited. I had huge ambition and a massive desire to impress her. My own route to Fleet Street ended up with a job in Pret a Manger on The Mall where my sandwich-making skills came on in leaps and bounds while my journalistic ambition died. I threw myself into the history of political thought and the philosophy of history. I read Orwell, Wells, Hobbes, Plato, seeking my own philosophy of the present and discovering dystopia.

Hilary

1995. An escape from scarred mountains to the seemingly mythical dreaming spires of Oxford. My dad drove me and my mother's old green trunk south through the border towns of the marches. In a bookshop in Ludlow, I reached for an azure blue illustrated book jacket: J.M.G. Le Clézio. *The Book of Flights: An Adventure Story.* The perfect accompaniment to my unfurling 'choose your own adventure'. Under the lanterned dome of Oxford's Radcliffe Camera library I devoured more of his words plotting out the 'Route to Utopia' that became my dissertation, weaving a path from Bloch's *Principle of Hope* to Ilya Kabakov's *The Man Who Flew into Space from His Apartment.* The sheer thrill of even entering that space didn't dissipate. I was living the dream. But completely ill equipped for it. I had been enamoured by the golden light of arcadia, consumed by the romance of Oscar Wilde, *Brideshead Revisited*, driven by the noble quest for knowledge.

The First Big Bang

As I came to see, it wasn't all about being, in the words of Grandpa Potts in *Chitty Chitty Bang Bang*, P-O-S-H posh. I was met with a new acronym: PLU. Something I was quickly told in no uncertain terms I was not. 'People Like Us.' On a recent tentative return to the City, sitting in the Kings Arms on Easter Sunday, Dan pointed out the ridiculous private members club group portraits on the walls. Piers Gaveston Society. The now infamous image of the Bullingdon Club. This was an elite, parallel world I never collided with, only glimpsed, or rather felt, in the pinch of a bum as I waited on the tables of Magdalen College, in the slights, in the simmering polite violence of it all. I was already doing what Dan has come to label 'method arting', operating in multiple worlds with an anthropological turn. Othered by being artist, Oxford student, but working multiple jobs because, like everyone else doing it, I had to. Revelling in these constant disguises and reinventions. But there were other currencies I couldn't get by the hour – a convention of debate, culture, connections, an inherited confidence in my place in the world. I was ripe for crushing. Only I wouldn't be. This was the era of Pulp's 'Common People' – an anthem sung out at every disco by hereditary Lords with their own yearnings and baggage to overcome or not. Standing sentry as gallery attendant in the Museum of Modern Art, Oxford, I watched with strange, perhaps misplaced, sympathy as the yearly 'milk round' handpicked the 'finest minds' for City corporations, feeling powerful, even superior on my minimum wage duty shielded by a force field of naive, potent curiosity. Inside the cover of the children's book *Curious George* is the inscription 'Stay Curious' – the best advice in the world and something that I cherish from those days – a spirit of inquiry and imagination encouraged and nurtured across disciplinary boundaries, from anatomy school to studio, laboratory to library.

Dan

The beginning of the onset of moral confusion took place. I dyed my hair and started a band. Erasmus opened up our educations. I spent a year in the Paris-Sorbonne University, Paris IV. Here, I dutifully wrote a postmodern novel with plenty of existentialism while composing film and theatre reviews for *Time Out: Paris*. The way history was taught in scientific detail repelled me. There was no talk of revolution; no 68. I got the education I needed in the repertory cinemas and cafes of the Left Bank. Truffaut and Godard. Anna Karina. I was living a film. On the walls of a Parisian cafe I came across a raft of paintings based on a photograph I'd been at the taking of, just six months earlier. The image is of a young boy throwing a ball at a wall in Catholic west Belfast – a mural stating 'Time for Peace'. It proved to me there and then the power of photography. This was the year of the Good Friday Agreement. Both my accent and links with Northern Ireland had receded but I remember the hope this engendered, epitomising the optimism in British politics at the time. Things felt good. I wasn't yet ready to hear the words of Chomsky in the deep debates I had with my mother's surprising new boyfriend.

Back in London I became the film editor for the *London Student*. Overwhelmed by the scale of terrible things happening in the world, but overcome by a desire to pursue my dreams, I held at bay my political feelings and tried instead to focus on getting a career off the ground. The world could wait – or so I thought, at least until I was established. So with that in mind I launched myself in totally the wrong direction – like almost everyone else. Emerging from university I made a short film on a Hi8 camera expecting it to catapult me to Cannes, not into depression. The world was spectacularly indifferent to my arrival.

Hilary

1998. Spat out of Oxford the year before tuition fees were imposed by New Labour. Another book with a jacket of sacred blue and gold came with me as I left those tainted, now off-bounds spires. *Visions and Blueprints: Avant-garde Culture and Radical Politics in Early Twentieth-century Europe.* Ex Libris. Contraband visions I have brought with me through life. Though at first those visions were clouded. The 'how to be an artist' seminars and instructions of our final year just led to escape into matinee screenings with kindred, depressed spirits. The 'art world' described was not a world I wanted to go anywhere near. Joseph Beuys was dead (though I had spent the first term thinking he was teaching me). The White Cube. God. Queen. Country. Dead to me. This was the era of the YBA's (Young British Artists) entrepreneurialism and shock tactics, where political and art establishment partied together and then prime minister Tony Blair's PR machine sought to hijack Brit Pop. When young art graduates thought that the only route to 'making it' was to replicate the success of Damien Hirst and company's breakthrough exhibition *Freeze* that brought with it the patronage of the high priests of the art world I seemed to be allergic to. Making it and making meaning didn't seem to necessarily go hand in hand.

Meanwhile I was wearing an oversized blazer, taking people up and down in the Royal Academy lift, telling unappreciated stories of the great glass elevator, mesmerised by the hours standing invigilating exhibitions: *Chagall: Love and the Stage*; Charlotte Salomon's *Life? or Theatre?* Hiding behind bins as an agency gardener from a gaggle of familiar lunching lawyers on Embankment to avoid the moment of awkward recognition and justification: that in some ways

job after manual job was an addiction, a research method, a necessity, a toughening, a crisis and a project in itself.

Dan

Leaving university in 1999, credit was in easy supply. I had no idea what I was doing while making my early films, but it didn't stop me from getting loans to make them and maxing out credit cards. These debts I took on in the same spirit of reckless heroism that I imagined my father chalked up. And in many ways, short-term pain didn't matter because the fame and success that were surely on their way to me would easily pay them all off. And the riches, I felt, would far outstrip the temporary cash-flow issues that accompanied the bottom of my overdrafts, the squealing of the credit card statements. I was investing in my film education. Doing it myself. 'Using Visa to pay Mastercard.'[2] The early films I made revealed the inadequacies I had in storytelling for screen but, in order to improve, I made more and more, veering between the surrealism, dark comedy and politics I connected with my lived experiences. Number one was set in the London Underground about a private detective who loses his mind searching for a woman he fancied – it was terrible but I was hooked. I enrolled on a three-month course in New York, learning to tell my story through onscreen imagery rather than words. Cutting 16mm black and white film on a Steenbeck editing table, I made 'Jesus of New York' – a rock 'n' roll messiah with a message of peace. I felt the pull of realism and my roots, returning to Northern Ireland in an attempt to look at both sides of the conflict as told through music. This first attempt at documentary was slightly ill conceived, going nowhere

but teaching me a lot. Driving down the Falls Road in a conspicuous Land Rover with English plates, we ended up with an IRA escort to our fortified West Belfast music club destination. The most exquisite music I'd ever heard protected by heavy metal grills. It wasn't till a few years later that I got my first films onto Channel 4. By then they were focused and clearly structured. I was learning my craft and sensing that filmmaking was really a passport to adventure. Bit by bit I inched my way towards competence.

Hilary

What I was seeking didn't seem to be in this Cool Britannia. Excruciating class structures and prejudices sit extra uneasily when you fall between the categories and cracks. As a cycle courier, I was interviewed for a TV series to fake it as a show jumper but was I 'faking it' as a courier? Was the daily exertion of mind and body and the life they screamed for a traitor to my education? You went to Oxford?! What are you doing here then? Alienated on all sides by such narrow conventions and stereotypes. Choose the City, choose a fast-track career path, choose a job in arts admin. Choose fixed-interest mortgage repayments. Choose life. Choose knowledge. I choose this. For now.

And so I left. Strategically, via cat sitting, campsite *montage* in France, obscure Welsh funding and the blessed Erasmus. When I moved to the Czech Republic to study for an MA in Scenography, a velvet revolution enveloped me – meeting those who had stood with dissident/former president Václav Havel; it was a poetic and political awakening. I was immersed in and informed by the idea of 'total artwork' or *Gesamtkunstwerk*. I wandered Prague with a tape recorder,

organising concerts for cars and people in Czech museum grounds and later Amsterdam docklands. There I moved from a cockroach-infested, spy-ridden apartment to the flat of a young descendant of Pushkin. In Amsterdam, via the kindness of new friends, I squatted an empty flat that backed onto a towering garden of balsam, later moving into a storage cage in the shared attic where I slept fitfully in boots with a baseball bat. From shifts slicing cheese for youth-hostel breakfasts followed by days in Amsterdam's Vondelpark film library, life was beautiful. A reclusive Brazilian friend welcomed me in to her constantly darkened room as cinema – New Wave, Agnès Varda, Luc Besson. My life played out like the screens she inhabited. Night shifts in industrial parks packing envelopes, sorting biscuits, squirting mayonnaise into catering-size bottles, handling the brioche chute in a commercial bakery. Cycling glistening streets in the cold dawn, swimming in greenhouse water tanks in my own magic realism movie.

Back to Blighty. The millennium had arrived. The Tate Modern had opened. Gilbert and George had declared 'art is power'. No one appeared to take this too seriously. The international coalition Jubilee 2000 (from the biblical Jubilee where slaves are freed and debt forgiven) pulled off the cancellation of billions of dollars of third-world debt, convincing Tony Blair and Gordon Brown and the US government to act, but as with the solar flare of Bastille Day, I had no idea of its occurrence. I was now nocturnal. Enforced caffeine breaks, forty winks in the travel section on the night shift in an Oxford Street bookshop. The dark existence of cocktail bartender. Life was back to front and upside down. DJs offering me heaters for a grotty bedsit powered by defunct 50p pieces. Making friends for life fuelled by vodka and Red Bull. My meandering with intent needed some new intention.

Together

And so we teetered on the brink of some kind of adulthood. And this is where we end our reminiscence – this whistle-stop ride through the contours of our geography. Our childhoods, our educations form us and then we form ourselves. The hard work, the searching, the real education had only just begun.

And much of this was done together, overlapping ideals in collaboration and conflict. Together we shared, lost and found purpose, living in breeze-block industrial studios laying the foundations of what would become Optimistic Productions, like amnesiac bricklayers at times, forgetting what house we were meant to be working on in the first place.

We were enveloped in a vibrant congregation of ambitious young Europeans travelling to London for fashion, photography and music. Dan sang his songs alongside them in the all-night bars of Soho. I camouflaged the 'vicar's daughter' sign I thought was on my forehead. We were all libertarians without apparent politics, adrift in an intoxicating, toxic concoction of ambition, competition and romanticism.

We roamed, a lot, 'drifting into the arena of the unwell'[3] and out again seeking out value beyond payroll and wage packet, though needing them all the same. The life we lived was at odds with expectations, though the occasional accolades kept the critiques at bay – PhD, television commissions, feature film, supported by job after invisible job. Post person. Gardener. Cycle courier. The constant making and creating. Slowly owning the label 'artist'. The march against the Iraq War and its lack of power led us, like many, to feel disenfranchised and apolitical. The closest I got to protest outside Westminster was when, covered in mud from an agency gardening job, I was stopped by police on Parliament Square for cycling on the

pavement just trying to get home. The fine was a day's wages. This realisation spurned anger and tears: at time wasted, at a ridiculous day-to-day survival in a system stacked against us. Meanwhile, global temperatures rise, Concorde takes its last flight and we emerge from the (now banned) smoky corners and basement bars of our 20s with heightened awareness.

The Paris 1968 rallying cry 'Beneath the paving stones, the beach' was naively scrawled onto the graffiti-laden walls of our first studio together. The poetry and the politics of it slowly came together via the people we worked with and the books we carried on devouring – the Space Hijackers, Walter Benjamin – and then through Hilary's work around the London Olympic site and the mechanisms of power and finance it revealed.

Standing up in front of people eager to hear a linear narrative of progress, I am shocked that there is indeed sense, focus and magic in this chaos. Doing an edit job on life and finding direction. Our worlds and influences came together. Hilary's of making, cutting and splicing film, urban space, materials – Thomas Kilpper, Gordon Matta-Clark, Derek Jarman. Agnès Varda – an investigation of value, a love affair and rescue of the discarded in an archaeological vision of the world. Dan's fluid journey through word and image, music and laughter, from Cartier-Bresson to punk rock. Darkness and light overlapped in utopian thought tinted by the dystopian imagination of Ballard, Orwell, H.G. Wells, disaster survivalism and disaster capitalism, with a touch of the surreal and comedic from Monty Python to silent cinema.

Marey, Muybridge, Méliès, the Lumière brothers – we shared a love of early cinema from *The Arrival of a Train at Ciotat Station* to *Man with a Movie Camera*[4], where documentary, magic and modernity combined. We didn't yet know it

but we would come together in attempting our own home-grown, DIY-documentary version of *Modern Times*[5]. Chaplin was acutely aware of and disturbed by the rise of nationalism and the social effects of the depression in Europe. A supporter of Roosevelt and the New Deal, he read books on economic theory, even devising his own economic solution. In the film his Little Tramp character becomes a factory worker breaking free from the tyranny of the industrial assembly line, poverty and unemployment of the Great Depression. What was the machinery that subsumed and threatened imagination 60 years on? I was deeply aware of my own role as a cog in the mechanisms of the City, the parallel, divided worlds of glass entrance foyers and dark service yards and post rooms – living the illusion of freedom while couriering documents to sign. I lingered on the edges of the Occupy encampments in the City of London absorbing their messages: 'Foreclose on Banks. Not People', 'Capitalism is Crisis', 'People not Profits', 'We are the 99%', though not yet acting on them.

We had moved through our early lives 'hands free'. The arrival of Google, Wikipedia, Facebook, Twitter and mobile technology were beginning to change the way the world was understood and organised. A news that we now only occasionally tuned into moved more rapidly than time zones, surrounding us, unnamed murmurings beginning to sound out and take focus. To seek out the first Big Bang means to look through this dancing static, reaching back in time through our own minds and matter. From those tumultuous, mysterious atoms came children. Esmé and George expanded and contracted our world at the same time – narrowing our focus and increasing our determination.

This was our genesis story, our selective creation myth, with all our moral baggage and values inherited directly or by

stealth from ancestry and society. We were not born into anarchist intellectual traditions, we cannot weave a perfect story of social mobility, cannot be defined or silenced by inconvenient or fortunate accidents of birth and class – like everyone's story it is more complex than that. We can recognise and use the privilege of our education and move to act based on a sense of the responsibility of freedom, to use our talents and resources, to refuse to be defined or made inert by the powerful stories used to contain us. Like Derek Jarman, brought up amid the barbed wire of army barracks, these stories are the things that we can embrace and rally against, destroy or salvage, in order to 'recreate ourselves, emerging from the chrysalis all scarlet and turquoise',[6] reinventing ourselves and our social imagination out of the debris of the past.

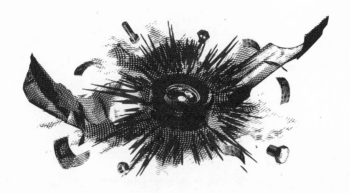

CHAPTER 2

Revelations:
Debt and Money

O ur Bank Job emerged from a crisis point but had its
*origins in a thoughtful, persistent vision, and growth
of a socially and politically engaged artistic practice. In the
anticlimactic void beyond the epic adventure of our first feature
film,[1] the books by Dan's bedside were building up fast: Wil-
liam Morris's* Useful Work Versus Useless Toil, *George
Orwell's 'Why I Write', Viktor Frankl's* Man's Search for
Meaning. *Impatient groans met this tormented, urgent search
for meaning in the wake of the new, riotous, life that joined us.*

Our revelations began with a journey through Debt: The
First 5,000 Years *by David Graeber to the powerful case for
debt refusal laid out by Andrew Ross in* Creditocracy.

*So behind the curtain – what have we discovered? That
the sacred morality (thou shalt repay thy debt) is flawed and
hypocritical in a world in which the 2008 financial crisis saw*

the biggest debt write-off in history (for those at the top). How the secondary debt market operates and how it can be hacked. How money is created in our society and how this could be changed. The power of financial elites over the government and people, and ways to tackle this. So now we have that knowledge, the revelation: what do we do with it...?

For Dan, his emergence was long (and torturous), forced to question deeply held beliefs and misconceptions, embarking on his journey down the rabbit hole of economics – a voyage of awakening kick-started by his existential crisis and heading to an urgent call to action against the injustice and hypocrisy this revealed. This horror at the hypocrisy of it all is the galvanising driver of Bank Job – to become a very public counter to the perverse moralising directed at those at the bottom and not at the system that creates such inequality. There is something very wrong in the dominant public narrative around debt when in 2008 the banks get bailed out to the tune of billions, but the very idea of a 'bailout of the people by the people' put forward by the Rolling Jubilee project of Strike Debt is derided. This Bank Job has been a journey of economic education and awareness – paying attention to the 'man behind the curtain' and sticking it to him.

Dan

When a friend first told me about Strike Debt buying up student and medical debt in the US and cancelling it, I was still struggling with a huge personal debt burden taken out against a vision of future success. Hearing about this act of debt abolition, I was intrigued and challenged. My overriding reaction to Strike Debt was, 'Why would anyone do that?'

Revelations: Debt and Money

I knew enough about anti-capitalist groups to understand that this debt abolition was a form of protest against student tuition fees and medical bills, but I hadn't yet been exposed to their analysis. As far as I was concerned debt was something you had to repay. Debt was debt. No one forced you into it. Needing something to break the inertia I went to the website and I saw that they had raised close to $1 million and used that to abolish just under $32 million worth of student and medical debt. I was excited to read about all the people who had put this thing together and wanted to learn more. To me they were outlaws, rebels with a cause who lived outside of the system. One of the things I most admired about them was their certainty – they must be so sure of their belief to go that far to make the point. It was hard not to idolise them as they stood up for a cause bigger than themselves.

I emailed them but had no reply. By this time, the group were pretty exhausted by all their activities and moving on to push for debt refusal in the form of the Debt Collective. This kind of exhaustion I now understand. There was no need for them to respond to a then enthusiastic but apparently clueless filmmaker. But I persisted. One of the founding members, Andrew Ross, had written a book called *Creditocracy: And the Case for Debt Refusal* and was coming to London to take part in an event organised by Jubilee Debt Campaign and giving a lecture at Queen Mary University of London. Although, at that point, he hadn't returned any of my emails, I ordered a copy of the book and was blown away by his arguments. My understanding of the financial system was totally transformed.

Ross agreed to meet on the university campus in east London and we discussed the work of Strike Debt in New York and

all over the US as a decentralised network of debt resisters including activists, artists and organisers. They had started in New York City in 2012, growing out of the Occupy Wall Street movement, creating anti-debt organisations around the US, publishing *The Debt Resisters' Operations Manual* and were the organisational base for Rolling Jubilee. Ross was warm and open and the book was a passionate argument, exploring contemporary western history from the 1970s onwards as a fundamental assault on US and European welfare states. It was early days but I got him to tell me some of my favourite bits from the book on camera and then I brought out a homemade detonator/bicycle pump that I persuaded him to plunge down to edit in an explosion over the top.

I learned things through Ross that shocked me, and I felt I would never be able to look at the world the same way again. I was galvanised to action. The first thing that *Creditocracy* did was to define itself in stark and dystopian terms:

> *It is not enough for every social good to be turned into a transactional commodity, as is the case in a rampant market civilisation. A creditocracy emerges when the cost of each of these goods, no matter how staple, has to be debt financed, and when indebtedness becomes the precondition not just for material improvements in the quality of life, but for the basic requirements of life. Financiers seek to wrap debt around every possible asset and income stream, ensuring a flow of interest from each.* [2]

What Ross is talking about is later unpacked as 'the public goods' as defined by welfare states – healthcare, education and housing, access to legal protections where necessary – all now being stripped away from state support and accessible only through credit arrangements.

Revelations: Debt and Money

With this glimmer of a story and a new mission to make a film to share this illuminating knowledge I gained a small commission[3] to enable me to fly to the US. I met again with Ross and members of Strike Debt, witnessed students standing up and giving testimony at Department of Education hearings about the crisis in student debt, sat down with the debt-buying team who had worked with Strike Debt and who would subsequently help comedian John Oliver in his own dalliance with debt. I was at once welcomed and openly resisted. In Los Angeles I posed next to the Hollywood sign – defiantly, whimsically, as the dreams of the big time did not appear to align with the social mission that now fired me and the ad-hoc budgets and uncertainty involved. It was hard to imagine a Hollywood movie about debt. The concepts might be interesting but the film wasn't yet and I returned to the UK with only the fragments of a narrative.

Back in London mulling over Ross's book and thinking incessantly about the structure of the film I now wanted to make about debt became all consuming. I had been warned off trying to replicate their work in the UK. It involves so much work and, after all, it had been done. They had gained a lot of press, bought up and written off millions of dollars of debt, and achieved a lot in their aims of public education.

However, as we have learned, you can think you have stormed the castle and set the media alight, but realise that even when occupying a prominent position on a high street only a fraction of people, locally and nationally, have a clue about what you've been up to. Projects like this, by their very nature, are still operating in the margins. It takes a culmination of actions, a chain of action and reaction, adaptation and distribution to make a dent in public discourse. Moments start a movement and, although Strike Debt had moved on to equipping communities with the tools for debt resistance,

could we take up the baton and get these arguments into the UK mainstream and beyond?

We were always very aware that buying and destroying debt in this manner was not a solution to the debt crisis but, as Ross articulated clearly, Strike Debt was like striking a match for the sparking of a movement that could prefigure a massive abolition of debts, and within the existing state of affairs it would need as many sparks as it could get.

I threw myself into research and was directly led to anthropologist David Graeber's monumental book *Debt: The First 5,000 Years*, which became the leafed-through bible of this project – a study of the history of debt in human societies where morality and debt, power and politics, entwine. Like Ross, Graeber challenges the fundamental assumption that we should always pay our debts. These two writers are associates in my mind and have both given huge service to the Occupy movement; Graeber is credited with coining the phrase 'the 1 percent' – our puppet masters: the wealthiest of us, who pull the strings of power. Graeber's book is a historical epic, taking in the history of political thought, a rich tapestry of characters from Hitler in WWII to European colonialists as far back as Nehemiah and on to King William III, whose reign saw the establishment of the Bank of England in order to borrow the money he needed to fund a war with France.

Grappling with this literary treasure I felt I was falling into a view of the world that was so at odds with my previous one, I wondered if I'd ever find my way back home. Graeber's central question is: what is this hold that the idea of debt has over people's imaginations?

With scenes captured from his writing of history, I tried to bring this story to life. Hilary was busy on a project in Purfleet, Essex – a critique of industrialised capitalism via

Revelations: Debt and Money

Wagner's Ring Cycle set in a landscape where London spits out its waste. She was always making and bringing people together, immersed in the process of gathering or gleaning she thrived on. She was too busy to have a crisis.

I hijacked her scrapyard location and we staged scenes inspired by this dizzying book. Where we had previously filmed with a Raven called Loki wandering the car yard with a local sailor as Wotan, king of the gods, we now cast Orwell, Thatcher, Jesus and a cow. God sits having a haircut, Orwell makes a fine speech amid the overenthusiastic use of a smog machine and the shots of replica weapons from Purfleet Heritage and Military Centre. Comte and Durkheim stand in deep philosophical debate and our stoic Jesus ends up puking from a cross held up by Nazis purely for safety reasons. In retrospect the reasoning has receded but it was a process of trying to make sense of and find ways of communicating this vivid, yet buried, history of debt – and the overlapping violence, religion and philosophy that forms it. To find a way of translating concepts and texts into vision and action.

We owe a debt to those who believed in the project from early on – turning up on darkened industrial marshland to take their historic roles, and to those thinkers and writers across the ages who sent their books out like ships on the sea. Ross. Graeber. Our Homer and Aristotle to the contemporary narrative of debt and financialisation.

Those days and texts introduced us to the Trilateral Commission, who introduced student debt as a means to remove their feared surfeit of democracy. One of their next observations also rang true: that intellectuals come in two varieties. The 'technocratic and policy-oriented intellectuals' admired for their unquestioning obedience to power and their services in social management, and the 'value-oriented

intellectuals' despised and feared for the serious challenge they pose to democratic government, by the 'unmasking and delegitimatisation of established institutions'.[4] We admire the latter, who through unflinching analysis of the skewed power relations of state and finance, justify economic disobedience as a protective deed on *behalf* of democracy. The activists, artists and thinkers who have most deeply challenged our previous certainties have shown again and again that the question of debt itself, and particularly of repaying one's debts, is more complex than it first appears. Debt might be a sum of money owed or it may be a claim made against an individual or a nation that was not taken on voluntarily or fairly at all, or it may be as deep as our relationship with the universe and all that has gone before.

Meanwhile the story was still adrift and showed no signs of coming together. I took to frequenting our rooftop, struggling out onto the chimney pots and surveying this kingdom. Looking at this through the prism of *Creditocracy* revealed a dystopia of surveillance where credit agencies score our eligibility for essential financial requirements, answering not to democratically answerable agencies but to Ross's creditor class.

I began to see myself as the 'Debtonator' – a superhero figure whose job it was to rid the world of debt. How I was going to do that was not clear. Through going into more debt myself seemed to be the uneasy answer – a destructive experiment with my own credit score. Hilary had already taken out a personal loan for the scrapyard drama via the 'home improvements' tick-box validation. I filmed a short trailer intercutting the Debtonator with Ross's anarchic analysis of economic history and footage from early *Dracula*. We filmed scenes with a fictional vampiric bank manager in the kitchen, set fire to the same kitchen filming a comedy about

a dog/psychologist who had lost purpose. The theatre of the absurd had entered our home though Viktor Frankl beckoned me on with *Man's Search for Meaning*.[5] The voiceover of this early trailer reiterated my feelings, still searching for my 'why', calling out to other souls adrift – a brigade of workers nursing their dreams in a suburban sleepscape. Unable to ever keep up, struggling to enact the change and to live up to the vision I had set myself. I wrote a poem/spoof trailer voiceover: 'It feels as if our generation has lost the power to dream of changing the world. Standing on the roof of our suburban home I wanted to summon the power to dream again of changing the world, before the hour grew too late.'

I climbed the roof again. I evaluated. I animated myself flying over the rows and rows of terraced houses seeing them afresh via my new economic knowledge of debt and the 2008 financial crash that at the time had been a distant thunderclap. Now I hovered through cloudy skies, past all these households struggling to make ends meet, keeping up with mortgage repayments and rising rents, all the while watched over by the rising towers of London's financial districts, always visible, from the football games on the playing fields, dog walks on the marshes, poetic moments on the roof. Even if the household debts that occupy these streets and minds were not intentionally imposed as political constraints, they unavoidably stifle our ability to think freely, create, act and fulfil our democratic responsibilities.

By the time of the 2008 crash, reckless lending had got so out of hand that there was no longer a need to prove earnings. It was rooted in the 2007 subprime mortgage crisis in the US when banks could bundle together packages of mortgages, get them five-star rated by allegedly impartial ratings agencies and sell them on quickly. By supplying fraudulent

ratings of the quality of debt bundles, they aided and abetted the banks in selling junk debt to investors, making profits out of mortgages that were financial time bombs. The scale of the banking fraud was epic and unprecedented. Although the subprime mortgage market in the US was a tiny percentage of global lending, all the banks were so closely networked that the crisis began causing problems to the whole sector. When Lehman Brothers collapsed, the US and UK went into overdrive, bailing their banks out. The scale of the US bail-out immediately after the crash has been estimated at $498 billion and, according to fullfact.org, £137 billion of bailouts went to UK banks.[6] The true costs were much greater due to ongoing quantitative easing as more bank debt was bought by the Bank of England and more money created to keep the banks solvent.[7]

The fear was that had the governments not bailed out the banks, global capitalism as we know it would have ground to a halt – millions would have lost their savings and their homes, and a breakdown of law and order accompanied by revolt, riots and revolution would likely ensue. And so, in plain view, an industry brought to its knees by fraud and criminality was rescued by the state, a public intervention effectively cancelling the bank's debts. On the surface it made sense – but it was also an illustration that the moral relations of creditors and debtors are not always clear cut. Rather than leading to a revision in the power relationships between the private banking sector and society at large, the crisis ended up further entrenching the power of the financial sector and diminishing that of the state and in turn the people.

'As with any unjust social arrangement, a creditocracy has to be stripped of its legitimacy in the public mind before its actual hold on power is dissolved.'[8] And this psychological and political hold on power is strong. Ross understands

and highlights that while we might be very 'aware of the irresponsibility and fraud of the big creditors who won't pay their own debts' and 'offload all their risky loans to others, we still accept that it is immoral to fail to repay our debts to them.' Lawyers, courts, police, the threat of a ruined credit score are the 'instruments of coercion' that enforce what Ross terms a 'payback morality': 'backups if the mechanism of consent falters.' He puts forward a fundamental challenge to the thesis that an oppressed citizenry should have to pay its debts. They have already paid, multiple times. He argues that clearing loans that only benefit the creditor or 'inflict social and environmental damage' should be renegotiated. Selling 'loans to borrowers who cannot repay is unscrupulous and so the collection of such debts should not be honored.' The right of banks and their beneficiaries to claim unearned income from debts so easily created should not be recognised as binding. 'The credit was not theirs to begin with' as 'most of it was obtained through the dubious power of money creation' – 'fractional reserve banking and the "magic" of derivatives' – described by Warren Buffet as 'financial weapons of mass destruction'.

This was mind-blowing, explosive stuff. So how to counter the legitimacy of this creditocracy? How to shift discourse from the psychology of the consenting debtor to resistance and reveal the extortion behind the creditor's guise of moral authority? These were now the questions which came to haunt me. I wanted to popularise the work and analyses of this deeply moral group – however the truth was that the Debtonator still struck a lonely figure. Asking questions about debt, let alone challenging the legitimacy of certain debts, is, as I discovered, still very much a taboo. After all, if debts can be negotiated, the power structures built on unjust creditor–debtor relationships might crumble away

like castles in the sand. So the tide must be held back. It must be ignored and even fought, otherwise all that may be left is chaos and disorder – or so whispers the fear.

I felt that many of the people I spoke to didn't want to think about the moral grounds of our economy, for fear that they may have to confront relationships which they themselves have established within their personal working lives and business practices based on the cruelties discussed in the abstract. In the early days of learning about the problems of debt, I too felt anxious about the burdens this new-found information might place on me and my family, beleaguered as we already were, underpaid and undervalued, and fighting every month for the financial oxygen needed to live.

Talking to those I knew and loved, I began to see our attitudes around money and debt were underpinned by often vaguely understood philosophical systems that were circulating almost without our awareness. That the framework I was grappling to expose and understand was not just something interesting in the abstract but rather an unstoppable force in all of our lives. My mother, who usually had a morsel of admiration for my adventures – if secretly harbouring feelings of disappointment about the choices I had made in pursuing a career in filmmaking and song – could not disguise her distrust and even disgust at the theories of debt repudiation I shared with her on undertaking the project. Any question of whether debts could go unpaid would leave her horrified, and as my arguments were met with stony-faced silence, I felt deeply embarrassed. I still remember her telling me about the son of one of her friends who she said had turned out to be a Marxist. She said this with abhorrence, as if the word were shameful and the worst possible outcome for the friend's child – like some mental illness in a Victorian household, a secret to lock in the basement. The

moral of her short story was aimed squarely at me, but this was too fascinating for me to let go of merely to save face. As the Lord's Prayer tells us, 'Our Father in heaven, hallowed be your name. Thy kingdom come, thy will be done, on Earth as it is in heaven. Give us this day our daily bread, and forgive us our debts, as we also have forgiven our debtors. And lead us not into temptation, but deliver us from evil.'

From a young age, we're told we have to pay our debts, and this moral precept seems undeniable. To repudiate this is automatically seen to challenge the very basis of moral thinking. The power and moral credibility of creditors is upheld deep within us. Whether we consider ourselves religious or not, in countries awash with the leftovers of Christian morality, the notion of our guilt (or debt) is well articulated in our culture. Christ the 'great redeemer' came to pay the sins or debts of the world with his life; when I was a child we recited the prayer above with 'forgive us our sins', as opposed to 'forgive us our debts', but these lines are effectively interchangeable. The notion that our good deeds are weighed against our bad during the final judgement at the gates to heaven is like listening to the outcome of an Experian credit check. Are we deemed worthy to access the heaven of home ownership and consumerism? Will we be allowed through the pearly gates? This interweaving of debt and guilt reduces metaphysical thoughts to the language and logic of a marketplace transaction. The shame financial debtors feel is the same as that of sinners, and often debtors are forced to 'confess' much as a sinner would to a Catholic priest. The German word for debt, *schuld*, is interchangeable with guilt. To get into debt is to have done something sinful. Is it any wonder that the movement to refuse debts is a challenge?

Strike Debt's Rolling Jubilee very purposefully avoided the idea of debt 'forgiveness' with its implication of a guilty

debtor/sinner. The idea of a debt jubilee originated in the ancient near east and is mentioned in the Bible as the periodic cancellation of debts, the liberation of slaves and the restoration of common lands. Some iterations accentuate a ruler's magnanimous forgiveness, but most emphasis is placed on the power of the indebted and enslaved in calling for their own jubilee from below. And this is called for the world over as nations are enslaved by debt. In the Global South more is extracted through debt now than through natural resources at the height of imperialism. Debt has simply been replaced by the powerful as a form of control to consolidate that power.

Graeber weaves the stories of nations, who, having overthrown their colonial masters were loaded with forced reparations and debt. In 1895 France invaded Madagascar, declaring that country to be its colony. Post 'pacification' it levied heavy taxes on the local population to enable their 'civilizing' infrastructural programme and plantations. Despite this violent takeover of their land, the Malagasy were told in no uncertain terms that they were in debt to the French, a debt still being repaid to this day. Haiti was a nation founded in 1804 by former plantation slaves who rose up against their French colonisers, declaring themselves free and equal. However, their former masters insisted that the new republic owed 150 million francs in damages for the expropriated plantations and costs of their failed military campaigns. This sum was intentionally impossible, leaving Haiti to be labelled a 'debtor' nation and synonymous with poverty ever since. Where direct military power or state violence fails, the implementation and moral language of debt places the blame and burden on those at the bottom who 'owe' those in power. The list goes on, spanning colonialism, petrodollar states, dictators and the IMF, but puncturing

these depressing, repeating narratives are moments of debt resistance and relief.

In 2008 Ecuador became the first country to examine and contest the legitimacy of its foreign debt. A committee overseen by then president Rafael Correa with a rallying cry of 'life before debt' concluded that a large part of the debt was a result of corruption, lack of transparency and shady deals that did not benefit the people of Ecuador. That the debt was indeed 'illegitimate' and that they were justified in defaulting. And not simply defaulting. A default was announced, Wall Street panicked, the price of Ecuadorian bonds fell and Correa subsequently bought back this debt at a fraction of its previous value and cancelled it, effectively shorting the value of Ecuador's national debt.

In responses to extractive debt the legacy and power of the jubilee was put into practice when, through multiple strategies and the power of a wide-ranging coalition of organisations and individuals from the Church of England to Thom Yorke, economist Ann Pettifor led Jubilee 2000, a global campaign that led to the cancellation of more than $100 billion of debt owed by 35 of the poorest countries. We were honoured when later in the project she visited our bank and, sitting in the governor's office, talked of how the entire history of the world can be seen as a struggle between creditor and debtor. In the post-war period the creditors were subjugated to society, but from the 1970s, basically throughout our lifetimes, the balance of power has moved more and more to creditor.

All of this was a revelation. In John Carpenter's now-cult classic film *They Live*,[9] a drifter arrives in a town that looks much like many other late 1980s US towns. But there's a difference – the place has been invaded by aliens. They are trying to control the world and only he and a small group

of people can see them. It happens by accident when he finds a box with strange glasses. When he puts them on, he can truly see. This is how I felt in the early days after reading *Creditocracy* and then later David Graeber's book *Debt: The First 5,000 Years*. A new way of seeing had opened up and life would never again be the same. The question of how to intervene in deep systemic issues as an artist and filmmaker is complex. The best answer may well have been that we should put the kettle on and try not to worry. That's a good British technique, and it has worked very well for me in the past, but once you've glimpsed behind the curtains and revealed the mechanisms of Oz there is no real return home.

Home. Perhaps that was where we should start, for as T.S. Eliot said, 'And the end of all our exploring / Will be to arrive where we started / And know the place for the first time.'[10] Did we really know Walthamstow, our home in London? The community is not quite living within the call and response cries of debt of the Bow Bells but it is under seven miles from the City. Perhaps we should look again and ask, 'Is Walthamstow a creditocracy?' To answer this the Debtonator had to get down from the rooftops and out of the books and connect with the many other debt-burdened Debtonators around him.

Home. Economics.

Down on the ground the Debtonator began an investigation, and slowly a plan and a team was built around the rapidly growing evidence that Walthamstow was indeed a creditocracy. In this period we met the founder of the local Eat or

Heat food bank. He had lost his job as head of the children's centre for giving out free tins of food to families in need – his heart had got in the way of his head and he had been piling more and more tins up underneath his desk. It became an absurd disciplinary matter as he ended up losing his job in a twist that Kafka might have been proud of. Since he started the food bank, the referrals had not stopped increasing. He spoke of people in full-time jobs who were having to choose between feeding and clothing their children or paying their rents. We met more and more local people who were angry and worried by what they saw around them as government cuts crippled vital services. Legal aid solicitors were struggling on, working for less than minimum wage. The Christian Kitchen were endeavouring to feed the increasing numbers of local homeless people. Our small children were starting primary school – a school that was suffering massive, apparently unavoidable budget cuts leading to staff shortfalls and a contracted curriculum. Our local Whipps Cross Hospital is a sprawling nexus of imposing but faded Victorian buildings surrounded by trees. We learned that the hospital belonged to Barts Health NHS Trust, the most indebted of all hospital trusts in the country through the PFI (Private Finance Initiative) schemes initially set up by the Conservatives and expanded dramatically under Blair's Labour government. PFI was an ingenious way of building much-needed infrastructure without using tax-payers' money up front or borrowing more, thereby keeping the national debt down. There was only one snag – the finance came from private sources and the interest rates have been massive. It's estimated that PFI companies have extracted multiples of the initial loans with many based in off-shore tax havens. All around us were cuts and debt, and yet all around us, in news broadcasts and headlines, we were met with justifications for

this. Once again, it took us back to the home and the idea of the household.

Home. Economics. These two words are uttered in the same breath by politicians who either share in a widespread lack of economic understanding or use this void as a weapon. We are constantly told that the economies of our states should be run in the same manner as our households. The English word 'economy' can be traced back to the Greek for household management, but in contemporary economics this government/household analogy is a fallacy – as Ann Pettifor states: 'Using microeconomic reasoning (the household budget) to draw macroeconomic conclusions about the nation's budget was, and is, plain wrong.'[11] The Government's harsh spending cuts of post-crash austerity have been enacted in the name of 'balancing the budget' and 'living within our means', capitalising on the moral language that surrounds our understandings of money and ironically forcing many UK families to live well beyond their means in this failed, detrimental experiment underpinned by free-market ideology rather than sound economic theory.

Violently contracting public spending, cutting services and jobs in the name of 'tightening belts' doesn't benefit the citizens of a country. Instead it leads to a negative vortex of lost livelihoods, lost employment and lost taxation, which in turn leads to less 'productivity', consumer demand and spending power. This, in turn, leads to increasing levels of personal debt taken on to service the shortfalls in earnings and fill the gaps in lack of social provision. As government spending falls, personal household debt has risen to paralysing levels. This then subdues, stalls and ultimately crashes the economy.

The household analogy is simple and widely accepted: the government needs to live within its means. Like a typical

household, if the government consistently spends more than it receives in income, the nation's debt will ultimately become unsustainable and the country will go broke. The familiar logic of the household analogy has become so embedded into the narratives of public life that spending proposals that would help tackle some of our most pressing challenges – the housing crisis, unsustainable household debt, climate change – barely make it out of the door, stopped in their tracks by rival politicians and the media asking where the money is going to come from. Progressives in the UK are frequently laughed out of the room for being fiscally irresponsible and not understanding how the economy really works with cries of 'they'll bankrupt the country'.

The powerful dogma of austerity is embedded in public consciousness. It blames the financial crisis on a mountain of debt caused by individuals irresponsibly borrowing and living beyond their means and sustains the narrative that the difficult task facing the government is to cut spending in order to pay off our debts and eliminate the deficit.

This deficit or national debt is something everyone seems to know all about, a dangerous burden that we must eliminate through more sacrifice, and yet when he visited our Bank Job, the late economist John Weeks[12] quickly unpacked erroneous beliefs about the national debt, which were being used to justify further cuts in public spending in the spring budget of 2018. Weeks asked us to consider whether the UK national debt was really the problem it was so often depicted as. He demolished the figure of national debt as 85 percent of gross national product as a figure to put the fear of God into us. He pointed out that 27 percent of the national debt is owed to the Bank of England – a bank that is owned by us all and that can't legally charge any interest to the government. So a 'meaningless' debt. He then

pointed out that a further 20 percent of national debt is in the form of pension funds – the pensions of teachers, doctors, nurses – owed by the government. He argued that this again is totally safe debt as the government can never run out of funds. Now he'd got us down to around 38 percent of national debt. The next 20 percent is government debt owned by banks – these bonds allow banks a safe haven for their cash. Government bonds, backed by the UK taxpayers, are the safest form of debt. In times of crisis, these bonds often yield negative interest rates. Around 5 percent of the national debt is UK households putting their savings into government bonds. Another safe haven – low interest rates in exchange for some security. So, when pulled apart like this, when examined in this light, this idea that the government must 'repay' billions of pounds from the 2008 crisis is exposed as a lie. The national debt is actually a series of safe havens, backed by the UK taxpayer – the ultimate vault of British wealth. It's not something we should truly aim to reduce but rather something to celebrate as a miracle in economic ingenuity.

Austerity is a compelling story and it is critical to expose the fallacies of it as continuation of the mantra that, as Margaret Thatcher proclaimed, 'there is no alternative' (TINA). Her words 'the problem with socialism is that you eventually run out of other people's money' are echoed in arguments against public spending when, in reality, the problem with our current debt-fuelled economy is that so much wealth is being extracted from borrowers by creditors that the system is on the point of breaking.

There is another way. Tax people fairly; ensure corporations pay tax, put in place a social safety net and welfare system, create public projects that supply jobs and solve the

urgent needs of our time in a prosperous, shared economy. In 1933, economist John Maynard Keynes published *The Means to Prosperity*.[13] Advocating fiscal and monetary stimulus to counter the Great Depression, he deeply condemned the UK government's use of austerity as an attempt to solve this. His ideas were taken on by then US president Franklin D. Roosevelt, who unleashed the power of a massive programme of public investment and public works in the New Deal. Employment numbers soared, new businesses prospered, tax revenues flowed in. Critically he targeted money lenders by imposing regulations on the bankers who had caused the 1929 crash, putting people before the finance industry, even declaring that balancing his budget in 1936 would have been, 'a crime against the American people.'[14]

In summer 2018 Professor Philip Alston, United Nations special rapporteur on extreme poverty and human rights, visited the fifth largest economy in the world and penned a damning report on the UK. It revealed a systematic and devastating economic assault against the poorest and most vulnerable section of British society. He stated: 'Successive governments have brought revolutionary change in both the system for delivering minimum levels of fairness and social justice to the British people, and especially in the values underpinning it. Key elements of the post-war Beveridge social contract are being overturned.'[15] The creation of the welfare state, the rebuilding of Britain and the establishing of the National Health Service after WWII could not have been done without using government stimulus packages to build a fairer economic system in which wealth was distributed between the many, rather than being extracted from the poor and stockpiled offshore by the few. Austerity and, in turn, the poverty and hardship it causes are a political choice and ideological weapon.

There is a such a thing as Magic Money

Faced with multiple epiphanies, the Debtonator hadn't been having a good time. Many would-be superheroes are troubled, alienated from the societies they inhabit, but nonetheless they remain dogged in their pursuit of justice. The Debtonator was no different, except that he felt that if he was unable to ever get anyone interested in his attempts to journey into the world of debt, how could that be of use to anyone? If he was unable to unleash his super-power, what kind of superhero was he at all? In order for the Debtonator to achieve his goal, he had to step aside, hang up his cape and die. Because, the truth is no one really wants to talk about debt – but money is a different story.

The powerful have hijacked two things in potent combination. First, the moral language and assumptions around debt are used as weapons against the economically weak, stifling resistance. Second, they control the money supply. In *Creditocracy: And the Case for Debt Refusal* Ross meticulously documents the profits of the biggest US, UK and European banks. After 2008, the graph soars skyward and the correlation between bank profits and personal indebtedness is eyewatering. Ninety-seven percent of all money is created as interest-bearing debt. Money is quite literally created or conjured into existence when banks make loans. This was a shock to our system: that banks create money as interest-bearing debt. In other words, money is created out of thin air but accompanied by debt. I had thought loans were made from other peoples' savings. This meant money didn't really mean anything – it was in fact an accounting trick. As banking regulations became looser, more and more money was created. Around 65 percent of loans are created as mortgages. We are living in massive property and debt bubbles.

Revelations: Debt and Money

The real trick western democracies pulled in the wake of the financial crisis was that they persuaded us, the public, that in order to pay for massive bank bailouts and to 'balance the books', government spending would need to be cut. On closer examination, the truth is that the cost of quantitative easing and bailouts – where central banks just created numbers on a screen to help private banks who were running out of liquidity – were not actually made of real money at all. Rather, the Bank of England just created and pumped money into the UK private banks as required. In his BBC Radio 4 documentary *Shaking the Magic Money Trees*[16] Michael Robinson investigates the reality that lurks behind the scenes of mainstream economic storytelling. The documentary opens with the lines: 'We tell children that money doesn't grow on trees. Politicians tell us that there's no such thing as a magic money tree. But is that really true? Since the financial crisis a decade ago it's produced well over £500 billion.' Sarah John is introduced as Head of Sterling Markets Division at the Bank of England – Robinson tells us conspiratorially he and his team are the first journalists ever allowed into the room inhabited by Sarah, the room in which part of our money supply is magically created.

[Michael Robinson] 'You are the people who make the money come into being?'

[Sarah John] 'That's correct, yes.'

The Bank of England buys bank bonds and John shows Robinson how to produce cash from nowhere:

[SJ] 'Very simply, there's a button on my screen that you can see that says 'allocate' … Once I push the allocate button, hey presto, I've bought £1 billion of gilts.'

[MR] 'Where did the money come from?'

[SJ] 'That money is created by the central bank.'

[MR] 'It comes out of thin air? Essentially, it's out of nowhere. You did it by hitting the button.'

[SJ] 'That's right! We can create that money just by the push of a button.'

Following the Brexit referendum in 2016, £70 billion was created in this way.

[MR] 'Is it exciting?'

[SJ] 'The first time you do it, you don't forget it. But it becomes part of the routine and you do get used to it.'

The true 'cost' of the bailout is therefore the immediate cost of making the banks solvent through government intervention, plus the cost of the Bank of England buying back what are often toxic bank debts, not because they are worth anything but precisely the opposite – they are buying junk to keep the banks alive. It's like a car dealership buying wrecked cars at full price just to chuck them away. It keeps the car manufacturer going and the illusion that everything is OK. This purchasing of debt is the essence of quantitative easing. Quantitative easing never stopped since 2008, but some critics refer to this as a form of life support. Were the Bank of England to stop buying up junk debt, what would become of our private banking sector? Its lack of health is well disguised, but whether it's propped up in its bed with a grin or not, underneath the covers all is not good.

This machine creating new cash is not helping the masses whose personal debt burden has never been so acute. According to Dr Chris Harker from UCL's Institute for Global Prosperity, there are now almost 9 million people in the UK in immediate peril of going personally insolvent. Increasingly the volunteers and employees of money advice services such as Step Change and Citizens Advice are no longer able to provide adequate advice,[17] as there's literally nothing that can be done within their power. They talk of a storm surge[18] within the advice arena

of people coming in who had totally unsustainable personal balance sheets.

For lending to be considered moral, it must involve some risk to both parties, invoking a jointly binding contract called 'moral hazard'. The lender must not lend recklessly – for instance, if a filmmaker has a crazy idea to make a film where he buys up debt on a credit card and there is no evidence that this filmmaker will be able to sell his film, then a bank should not really lend him the money. This is because if a lender thinks that a loan is 'not a good bet' it could result in that lender losing their money and if that happens enough they would go broke. The bank would usually want to have some form of certainty that this will not be a bad debt. However, if a state effectively says through its actions: 'Don't worry about whom you loan money to, even if it's that dodgy filmmaker, because if it goes bad, we will press a button and make good on the bad debt incurred by him,' this removes risk from the lender who has become 'too big to fail', and means that there's only one party in the deal expected to pay their debts – the filmmaker. The banker has become invincible. The filmmaker will still be punished if he fails to make his payments, by bank penalties, negative credit scores, county court judgements and possibly even bankruptcy, but the bank itself knows that if the worst comes to the worst, there's a magic wand that can be relied upon. There is a shadowy but fundamental imbalance in the power between creditors and debtors.

Solidarity Street

This project began in our homes – the thrifty households we were born into, that nurtured and formed us, the home

we made for ourselves in Walthamstow and the community that surrounds us and reaches out from the local to the global. Now as COVID-19 puts us in lockdown we are all forced to remain at home and think again about what this means to us and our body politic connecting all of us on our home planet. The word economics might be connected to household management but, as Kate Raworth writes, 'Bring that into our contemporary context and it's the grandest of ambitions: to help manage our planetary home in the interests of all its inhabitants ... From "take, make, use, lose" to regenerate and restore.'[19]

Right now, in a state of shock about the state of our island home, there is a need to recognise that we are not our governments and to find power in the shared communities that become our intellectual and spiritual homes, places of solidarity from which to launch our explosive signals.

Our lives have been framed by the austerity story, by dangerous debt and cruel cuts. We have sought out ways to maximise our democratic right to change it for the better. As people around the world stand on their balconies in song, the time has come to fling open the Overton windows of possibilities[20] in our terraces, high-rises, maisonettes and semis, calling out for solidarity, reclaiming and subverting the chants of 'take back control' to take back control of how we educate and act.

Then, we decided we would give ourselves and our community the power of central banks, the power of the government – the power of bailouts and money creation. Rather than talking, we'd think through action. We were going to abolish local debt and print our own money. Who's in?

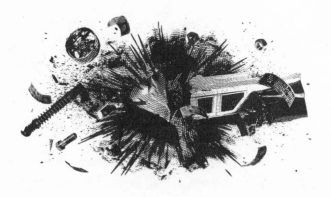

CHAPTER 3

The Heist Begins

*H*ow do we tell a compelling story of debt and money creation, that isn't boring and worthy and that can reach out to a diverse audience, stimulate a rebellious imagination and inspire action? It again returns to story structure – how to frame a narrative. This chapter charts the struggle through Story: Substance, Structure, Style, and the Principles of Screenwriting *(Robert McKee)*.

Returning from filming with debt resistance movements in the land of fiction (LA) we began a journey through classic tropes, from lone superhero (the Debtonator) to the moment we assemble the team and become 'a community heist taking on the financial system'.

How did we get to our Ocean's Eleven moment, recruiting the team for our Bank Job in a messy reality that involves time and effort, building trust, financial risk and wrong turns, and starting on the ground and in our community?

Bank Job

This is where plans were put into action and where the abstract concepts of debt and money were tackled through paper, print and the public opening of our Rebel Bank. We explore what we did, what we learnt, what we would do differently and how others might do the same.

The Debtonator's travels through debt had been profound and revealing but he was still an isolated figure. It appeared to be a quest no one was much interested in. Driving down a country road in Devon on a family half-term break it suddenly came to us. We would pull a heist on the financial system – a collective Bank Job.

In fact, these kind of 'eureka' moments never come out of nowhere. We had been labouring under the wrong story structure for years. The journey had taken us through comedy (inadvertent) and cult horror (from *Dracula* to *They Live*) and emerged through in-depth research and revelations about money creation from Positive Money to the Robin Hood tax. We had taken a voyage through an ingrained narrative of injustice and come out the other side ready to expose and take it on. We might have limited experience of activism, but we had watched enough heist films to know that there were some key rules to follow: if your heist goes off exactly as planned, without any hitch, it's not much of a story. Accordingly it should have plenty of hiccups and complications. Not a problem. And there should be an element of the ridiculous. Tick. We began to get traction. The irreverent fun of it all became contagious. Our call to join the Bank Job was met with more and more replies.

Within the heist genre, there should be an underlying plausibility to the story coupled with a willingness to break the rules. Above all, there should be something that makes you root for the team as they come together to pit their wits against an apparently unassailable adversary – a cause

to believe in. 'The house always wins' was the statement of fact the *Ocean's Eleven* team planned to overturn. Could we do the same with a financial system rigged against the many for the few? Although the 1969 comedy caper *The Italian Job* remains a classic heist inspiration, our own anthem would counter its catchy, 'We are the self-preservation society.' Our Bank Job would be based on mutual aid, mutual preservation and care. Rather than pulling off a heist for personal gain, this Job had community liberation at its heart.

Obviously this 'caper' was our real life, and archetypal plot structures would not play out smoothly. One positive of overlapping life and film was that any problems (and there were many) could be seen at a distance as 'jeopardy', so despair was diluted. It remains slightly disappointing that this caper didn't involve more drinking in basement bars, looking moody and attractive, and doing some kick-ass moves – it was mainly relentless work and it was just beginning. But we had a genre to play with. Now for the modus operandi.

Finding the faces

The first thing every heist needs is a team and the first team members would be those whose faces would go on the banknotes we planned to print. A visit to the Brixton Pound HQ had driven home the loaded symbolism of the paper/plastic notes we all carry with us – of monarchy and state and an establishment that we are not part of. Encoded in the money we use is a national pride and nostalgia showing us figureheads out of time and out of our league. Instead of the Queen and famous people of British history, we would feature local people who were picking up the pieces of an unjust economic system.

This proved to be harder than we thought as we searched the borough for people we felt were fighting the financial fall out of austerity. At first we wanted to include someone from the NHS and fire service, but both these public servants were difficult to recruit due to something called 'purdah', which means that people working for the state are not allowed to connect their work with political ideas in public. Although there were plenty of firefighters who agreed with our critique and aims, and were up for meeting, it wasn't going to be easy to get them on a banknote. Becoming a face on a banknote means stepping up and becoming a sort of symbol of the resistance, celebrated for your work in the community but also part of a bigger critical move. At that moment this was a big step. No one had any idea if the project would become a success, a lightning rod for haters or a massive flop. We could only tell them our honest aims for it and ask for their trust and time.

Gary Nash

Gary Nash, founder of Eat or Heat food bank, was the first to believe in, or at least entertain, our vision. We returned to the food bank, housed in a basement beneath the local Quaker Meeting House, to take his portrait amid the tins and tins of beans and chickpeas. He was totally committed to his work at the food bank, to the detriment of his own precarious position, losing his job because of his obsessive commitment to helping families in need while also caring for elderly parents and dealing with his own health issues. He was rightly angry at a system that has seen food bank usage rise so persistently in the UK but stoic in his care, helped by a team of committed volunteers, some of whom had once had to turn to the food bank themselves. The whole activity is built on empathy and solidarity, not pity or judgement. He told us of his life growing up in east London's Stratford East

theatre, his early acting days and passion for photography. His sense of humour and theatricality made him the perfect fit and we filmed slow-motion team sequences outside the town hall and threw banknotes all over him at the bottom of our road. He even donned a balaclava in the spirit of debonair rebellion.

Saira Mir and family

The others were harder to persuade. Via Steven Saxby, a local socialist priest, we heard of an inspirational woman running a homeless kitchen called Saira, who provides free hot meals and a friendly environment to the elderly, people in need, the homeless and those who are living in conditions of social, economic and cultural deprivation and isolation.

We emailed her about the project, explaining that we would love to put her face on a banknote and that we would then sell these and the proceeds would be divided up between her organisation and those of the other note characters and a debt write-off.

She now fondly recounts the story of first hearing from us and how she was convinced it was an elaborate hoax and that she had been hacked. After the vicar's assurances that we were, in fact, legit she agreed to meet and invited us to her house, where we sat and drank tea with her and her husband Farooq as they explained the work they do with PL84U Al-Suffa. We hit it off. Saira spoke with conviction about what she saw as a duty to provide hot meals and fellowship to those less fortunate, and she was clearly angry about a system that was yielding such high demand for the services. Her husband Farooq was charming with a twinkle in his eye, and the whole family are part of the work they do – Sanah, Aadam and Zuber, all working alongside their parents, playing table tennis and card games with their 'guests' – not 'clients' or 'service users' – serving the hot food, running

multiple errands picking up heaters, food and donations for families in need. As we came to learn from later invitations where we found ourselves hanging out with the local mayor and being interviewed on Islamic TV, Saira was extremely well connected and respected in multiple faith communities in the borough. Signing off her messages with a red rose and the words 'stay blessed' she believes in the good in people and that there is more that unites us than divides us. They showed us photographs of themselves with the King of Jordan holding an award they'd recently won for their work on interfaith relationships.

We laid out the case for them joining the Bank Job and tried to explain the connection between the banking crisis and the soaring poverty underpinned and exacerbated by the 10 years of austerity we'd been living through at that point. Our plans for a Bank Job appealed to their sense of social responsibility but also to their obvious sense of mischief. Aside from the money we intended to raise for the organisation, the project also promised new experiences in film and photography and increased community connections, being part of something bigger that could possibly become an adventure rather than a burden. We were delighted when Saira and her family agreed. The plan was taking shape.

But we still hadn't heard back from Steve…

Stephen Barnabis

Steve was really hard to get hold of. Stephen Barnabis was running the Soul (Support Our Unique Londoners) Project, providing activities, role models and hope for young people, particularly those from deprived backgrounds and living in turbulent and often frightening physical environments where gangs operated and turf wars were endemic. Steve had set up

the Soul Project in 2006 after his cousin had tried to break up a fight and been fatally stabbed in the process. His goal was to provide a context for young people to escape the violence of the estates, and to have a safe space to think bigger and to be able to see the horizon and life beyond their current situation. We persisted with emails and calls and Steve agreed to meet. We drove up to Wood Street with the video camera and entered the building which then housed the Soul'Project. On the ground floor Steve ran a hugely popular soft-play centre Tumble in the Jungle as the income-generating activity. We had spent many hours in these very ball pits with our children with no idea at all about what was happening above our heads or the social mission underpinning the organisation.

Steve's building was enormous and in terrible disrepair. There were buckets catching rainwater in many of the rooms he showed us on our tour. The building had once been a movie studio. Walthamstow had a rich history of producing films in the early years of the twentieth century, though many of the companies were extremely short lived. The Precision Film Company built a studio at Whipps Cross in 1910 but stopped production in 1915. Steve's building was built by the Cunard Film Company Ltd in 1913–14. The company didn't last long, folding in 1915. The building was then taken over in 1916 by the Broadwest Film Company, which specialised in filming novels and stage plays. This early legacy of the building was reflected in Steve's vision for the place – equipped with lights and cameras and audio suites, he, Josh and the team taught his group of young talents film and music production.

We wanted to persuade Steve and Josh that their story intertwined with the story of finance we were trying to tell. That their struggles to make the world better for the kids who were coming into their orbit was linked to a financial system into which inequality was inbuilt and increasing. It was clear

that Josh and Steve were acting on little more than faith. They told us that despite the fact that 3,000 young people were benefiting from their youth engagement programmes and 400 families visited the centre each week, their building was being sold from under them, but that they still wanted to keep their mission going. They were up for being on the banknotes and asked if we could come back to film and document their awards ceremony, in which they would be bringing in many of the young people who had found a temporary respite from the worlds they were inhabiting. Returning to the building with Naomi, a young ambitious filmmaker working closely with us at the time, we met a range of people from tiny children to teenagers and their families. All the children received awards, but in the air there was a feeling of something ending – the eviction of the Soul Project hung there in gloomy subtext, while Steve stood filling the air with hope. There were speeches from Steve and parents who had recently lost their loved ones to gang violence. It felt a tremendous privilege to have been invited into the Soul Project and to have witnessed what turned out to be its last months.

Now when we find ourselves on that street, we look at the boarded-up façade behind which Steve and team had nurtured and empowered countless young people. Since their removal, the doors have remained closed and development signs hang impotent – no real action seems to be taking place. Steve talks of a period of grief and inertia after the loss of the building, something we are now familiar with. All of the equipment was burning up cash supplies as it sat in seven storage units while he figured out how to keep the Soul Project alive. Now he's started up again, this time collaborating with two of the young people who have been through his programme themselves and want to give back to the world. For the moment they're operating Project Zero out of an old shipping container in

the new Box Park nearby, but they, like many other commu-
nity organisations, need a secure space to grow and flourish.

Tracey Griffiths

We needed one more note character and had set our sights
on the headteacher of our children's primary school in
Walthamstow, Tracey Griffiths. The government's education
cuts were having an obvious impact on the school's ability
to function. Since 2015 every prime minister has claimed to
put more money into schools than ever before. But the fact-
checked truth is that nearly all schools in England are worse
off now than five years ago. The Stop School Cuts campaign
website shows that after years of government cuts, 66 out of
67 schools in Waltham Forest are still in crisis with an £18.4
million shortfall across the borough in 2020. For Barn Croft
Primary, this means a shortfall of £124,260 in 2020 (a loss of
£624 per pupil). Led by a parent at Barn Croft, Sian Simon,
the families and children of Waltham Forest took to the
streets in May 2017, congregating on the town square with
the chants of 'No Ifs, No Buts, No Education Cuts'. But these
cuts continue to take a big toll, evident in the way teaching
assistants have to be dismissed, art and music are abandoned,
and the school can't even afford the stationary it needs.

At first, Tracey was reluctant, but equally very angry and dis-
appointed with the deep cuts to her education budget, and we
explained that if we were successful we would also be helping
to fund a tiny piece of that budget shortfall. It took a couple of
months to wear Tracey down – it was clear that she was keen to
stand up, but she was worried that it would potentially backfire
and undermine her position. Tracey stood defiant for her por-
trait in the school playground and soon the whole school were
on board – children taking part in film scenes, visiting the bank
in action, proud of their headteacher and school.

———

Later this pride, fused with humility and slight embarrassment, could be seen in all the note characters as their faces were plastered over the bank exterior (thanks to Wood Street Walls and Subvertiser), housed in international collections and travelled the world over. We made sure it was not a competition between causes, that all would get an equally divided share of what we raised and that each note figure was produced in denominations of 5, 10, 20, 50, 100 and 1,000, so no one was allocated a higher value than the other. The protocol and logistics of it all were surprisingly complex. Obviously each organisation had their specific supporters with personal connections and the story of a primary school fighting increasingly severe financial cuts resonated around the country.

Assembling the print and production team

So, we had the faces of the project. Now we also needed a crack team of professionals recruited for their specific set of skills. Luckily we didn't have to look too far, finding a network of local people and creative resources mostly within the adjoining terraced streets that had been built in the late 1800s to house a burgeoning population of industrial workers. The streets the Debtonator had been looking at from the rooftops now came alive to us, housing a diverse array of people that we began to work with. A few doors up our street, in a gap in the uniform terrace that was once a garage, printmaker Spike Gascoigne operated Walden Press. As we began to unpack the purposefully traditional, tactile and analogue processes we would use to make our banknotes, we asked him to come on board with the letterpress, teaching us

and the team, trouble shooting and advising on the ambitious process we had planned. Letterpress as a relief printing process has the potential to make multiples and was first known in Europe through Johannes Gutenberg (dubbed the father of modern printing) and his invention of mechanical movable type printing. In 1439, this was a revolution in the history of the production and distribution of knowledge itself.

Walthamstow's connection to print resonated more deeply through the project as the birthplace in 1834 of British designer, poet, novelist and socialist activist William Morris. Alongside his famous textile and wallpaper designs, he founded the Kelmscott Press as a typographical adventure, printing exquisite editions of poetry inspired by medieval illuminated manuscripts. But his work in print also overlapped more closely with his social activism. In the late 1800s, alongside the emergence of a mass print industry, he financed, edited and wrote for *Commonweal* (the Socialist League's monthly publication) and proffered small-scale radical publishing, reproducing his speeches as affordable and accessible 'penny pamphlets'. It was in his name and the legacy of his ideas that Waltham Forest became London's first official Borough of Culture in 2019, with the bid document celebrating 'makers, radicals and fellowship', though just how radical was a recurring question. His portrait, patterns and famous quotes adorn the walls of Waltham Forest, but it was his ideas that had more agency for us. We invited William Morris himself (or an actor playing him) to take part in one of the numerous events we hosted alongside our money printing, returning to his works *Useful Work Versus Useless Toil* and *News from Nowhere*, and the continued relevance in this world of meaningless debt and demeaning work that supports the system and the wealthy but fails to provide enough

for the workers to live on. We see Morris as the spiritual relative to our project, as someone who believed in art and imagination as vestiges for hope and social change.

The legacy of the craft of print and poetry at least lives on in our local Paekakariki Press, and we were introduced by Spike to its founder Matt McKenzie in a crowded cafe on our hunt for Adana presses to print our banknotes. Matt lives in the next street with his partner, Helen Porter, who would later come on board as paper-maker extraordinaire teaching us how to transform shredded ex-Bank of England tender into our big money (100 and 1,000 large notes/artworks). Established in 2010 to preserve and continue the tradition of letterpress printing, the press itself operates out of an old industrial building off Hoe Street that also houses artist's studios with an encouraging website banner declaring 'art changes people, people change the world'. Surrounded on all sides by a dizzying array of press and type, walking into the space is to enter a repository of a pre-digital age, and yearning for the handmade has seen a big revival of interest in these early print technologies.

Following the river from the London 2012 Olympic Park to Waltham Forest, the Lea Valley has been at the centre of historic print innovation and industry. While downriver, chemical inks and dyes were invented and made, printing and newspaper publishing are two of Walthamstow's oldest industries with numerous now defunct printing operations. Later, as people wandered in off the street to see what the heck was going on in the former bank on Hoe Street, they breathed in deeply the bouquet of inks, saying that it took them straight back to their days working in local print shops, fiddling with the machines, relishing this space of production that housed the foil-blocking machine and screen-printing facilities. Taking pride of place in the windows of the bank were the two

The Heist Begins

Adana presses, borrowed from the crowded sanctuary of print where melted metal, words and text created their own poetry.

Meanwhile, we were in a bit of hurry; finding a place where (small-scale) mass production and beauty, art and activism were not exclusive. We were using and adapting the tools of our age, combining analogue and digital to create something of beauty and use that perhaps William Morris could approve of.

If this was a Hollywood heist, we'd all have edgy nick-names. Our reality was that people we'd previously nodded at in the street or known as 'so-and-so's dad' now actually had names. We had encountered Phil Seddon clearing up after school Halloween discos and knew he was a graphic designer but not too much else. We met and began working on the design ideas together, drawing on earlier prototypes and the portrait photography, sharing rich Pinterest collections combining heist film posters, currency design and a palette of obsolete office stationery. He continued working on the project throughout all its various manifestations, becoming 'Head of Worrying' on a production line that required an inordinate, unreasonable amount of guillotining and rolled up his sleeves greeting visitors, monitoring blenders full of paper pulp, stamping documents, patiently adjusting unruly foil-blocking machines while remaining all-round design guru.

A web of connections and collaborations was growing. We widened our search to the other side of the railway bridge at the bottom of the road and, on morning dog walks, enlisted established portrait photographer Peter Searle to work with us, trudging to the park with lighting umbrellas and instructions to look epic to our team of patient banknotes.

Arts producer Nicky Petto had been a long-term collaborator and now lived around the corner. The project she had previously worked on with Hilary was really a prototype

for what the money-printing operations would become. In 2014 'Pop Up Pop Up' opened as a public production line of a pop-up book *Legend: An A–Z of the Lea Valley*, a poetic miscellany of lost places erupting mutinously into the present. Conceived of and designed by Hilary, the project became a collaboration with a team of people from diverse backgrounds working over four days to assemble as many books as they could, learning and sharing new skills, thinking through, making and using this tactile medium of pop-up as a way to open up discussion about the Olympic regeneration project with visitors to the public manufacturing base.

In this new context, as colleague, friend and neighbour, Nicky operated with meticulous professionalism as we dealt with the council, filled out funding applications, strategised and recruited our team. She brought realism at times at odds with our unwarranted optimism. She always had our best interests at heart, even when we flagrantly ignored and overruled these ourselves and, though other work claimed her, she offered help where it was most needed, at events and with the dreaded but most useful 'evaluation'.

The money team

Together we put a call-out far and wide across the borough and, after hosting our interviews at the local William Morris Gallery to convey at least a veneer of respectability, we were joined by a new money-printing team.

This team all had different reasons for answering the call – to learn new skills in print, to do something 'different', to respond to the project's themes and action around debt, to earn some money. While ironically sabotaging ourselves, we were keen not to follow the typical path of the 'opportunities' promised by many art projects as 'good for your CV' and 'good experience'. We offered the London Living Wage for

something that was hopefully more interesting and fulfilling than the average job paid at this rate. Most of the team had their own stories of the way debt had disrupted their lives and were motivated to join the project because of this.

The slightly awkward interviews soon turned to training sessions. There was a performance to the making that was made clear at the beginning. Life would be on film, the making of the money would be public, the role of print-maker would also be a role of talking about the project so it was important we all knew the story and the issues we were tackling and could share this with curious visitors. Every step of the way was an act of education and exchange.

Sue Brown and Alison Kay became the virtuoso front-of-house team for the launch of our bank. As the hours ticked by in the first week of opening, this unfortunately didn't entail too much but they'd soon have to kick into action after a *Guardian* newspaper article about the project was released and we were swamped.

Sue was a fantastic ball of energy: a former senior cashier clerk and customer service manager who'd been very active in a local community library and with an efficient, welcoming face that could turn guard dog if necessary.

Alison had heard about the project through her work volunteering with Gary at Eat or Heat. She had been a primary school teacher in the borough for her whole career and had a very clear reason for joining the project, having just been made redundant because her primary school had been forced to make cuts to pay its PFI loan repayments. So much of the school budget was lost to these repayments to the private sector that, as a non-classroom based member of staff identifying and supporting children who were struggling with mathematics, she had to be let go. On one level, as an expert in maths intervention she was concerned about the low levels of numeracy

among adults in the UK and the effect on their ability to manage their money and stay out of debt. On another, she was angry at the hypocrisy of the system that caused her redundancy and the rising use of the food bank that she now volunteered with. She became an articulate and essential member of the team, meeting and greeting, managing the increasing sales and ticketing of events, and later became invaluable as we drowned under a backlog of orders travelling out around the world. She brought in family and friends, mucked in clearing glasses and plates at the many events we hosted, and shared in the triumphs and disappointments in equal measure.

The project also attracted artists with their own independent practice, keen to work as part of a team. The wonderfully named Alistair Gentry came with a generosity of spirit and get-stuck-in attitude that we cherished, always turning up exactly on time in the uniform/costume of grey shirt and trousers with burgundy braces, donning his olive-green apron and translucent green visor, ready to tackle the day. As a writer and artist, he had written and spoken on the economics of the creative industries and been an activist for fair livelihoods for creative people, including with the Paying Artists campaign by a-n (The Artists Information Company). He understood being part of the project as an extension of this, and a way of informing his own future work on these related subjects. He had a vast experience of working with public participants and audiences, previously running a satirical tourist information centre from a high-street shop and a community digital fabrication lab, and this was put to good use here as he seemed to relish inviting visitors in, doing 'the tour', explaining the issues. We admit to hiding at times, letting Alistair take over when the pace of visitors got too much. Alongside his professional, artistic interest, there was another, all too common to artists, reason for his involvement recounted in his first application:

The Heist Begins

On a personal level, I can't afford to live in London in general but I'm sort of trapped here because also I can't afford to leave. My apparently relatively successful career as an artist has left me massively in debt, essentially in working poverty (I need new shoes for example, and can't afford them, and I'm currently choosing to be cold and buy food rather than put the heating on), and apparently fairly unemployable in a conventional sense if my constant rejections from basic jobs are anything to go by. I relate very much to the stress, anxiety and depression that can come from low, precarious income and the ways that debt and poverty can close off a person's opportunities and rights to self-determination.

Alistair told us the tragic story of his parents losing their house due to illness. The heartbreak of this injustice was still raw. When the *Guardian* journalist visited, they quoted him: 'My parents lost their home during the recession,' says Alistair Gentry. 'Anyone can get into debt. It doesn't matter how rich you are to start with … It feels really good to roll up your sleeves and literally get inky, but also metaphorically, to do something about it. Not just sit around and having a moan.'[1]

Continuing themes from his earlier novel, *Career Suicide: Ten Years as a Free Range Artist*, he constantly takes on the 'art world' with acerbic wit and a clarity of vision and critique that is highly relevant to our own practice. The kind of issues and attitudes towards art he explores are evidenced in the making of this project – the idea, often perpetuated by artists themselves, that artists don't deserve to get paid, the romanticism and preservation of the 'struggling artist'; the idea that if you talk about the value art has beyond finance and its possibility to enact change, you're labelled or castigated as 'community art project', or 'local' art, somehow lesser than the rarefied sphere of artist deities, but also open to be instrumentalised and co-opted by the growing field of institutions

claiming and defining social engagement. It boils down to Alistair's key question, 'Why does everyone in the art world get paid, apart from the artists?'

This came to us in various forms through our work as we already played with and questioned ideas of value – of the value of money itself, of labour, of art. The reasons people bought the banknotes were diverse, from wanting to be part of a 'bailout of the people by the people' (the tagline of the Rolling Jubilee), contributing to the local causes, loving the banknotes for what they symbolised, as art – and a fusion of it all.

We were at times shocked and upset when people understood their contribution as solely a 'donation' or at best an exchange for our 'bit of paper'. We emphasised the labour and debated the value of art, but the need to vocalise justifications felt uncomfortable. We were delighted people were coming from far and wide to be part of the project. Exchanging sterling for HSCB currency was to join the Bank Job and that was what we had wanted.

In fact, it was our own fault for building self-sabotage into the very structure of the work, leaving us no option for covering our costs for the production of the banknotes as the proceeds went 50/50 directly to local causes and the debt write-off fund. This transparency made them attractive – nothing was siphoned off into the admin costs that are associated with charitable giving. But there were very real and severe costs that were not factored in. The accidental donation was our time, intellectual and artistic labour, energy and love, teetering at times on the brink of the oft-identified 'burnout'. An art teacher buying a note late in the process interrogated us to ask if the proceeds would go directly to buy debt. We answered honestly that at that point the debt write-off had just been confirmed and paid for, but we were dealing with all the costs around that, from excess postage to

wages and materials costs. She asked for a refund. There was zero recognition that if it wasn't for the hard work behind the scenes and investment of time and money in this work of the art she taught, there would be no debt write-off to contribute to and that both the production of art and the pulling off of a heist require multiple professional skill sets and resources. The notes had travelled across the world, were bought speculatively, entered the niche world of 'notaphily' and were collected by institutions from the V&A to the British Museum. This became a form of validation that aided our quest, which alongside a plethora of press and social media shares pushed us over the line to reach our target – raising £40,000 by the end of summer 2018.

Bank Job was a chance – often rare for artists – for Alistair to work on a project in the community he actually lived in, not transplanted via artist's residencies into new places to respond to with limited time. The positive side of this was also a challenge for us. This proximity was a strength but also an anxiety – if things go wrong in relationships there is no escape from the meetings at the school gate and on the street corner. Life and work were not separated. The pressure was on: we had won people's trust and belief through our determined commitment to the project, but could we actually pull it off and deliver each organisation with much-needed funding while buying up and cancelling the £1 million worth of payday debt we aimed for? In the early days of the project there was a constant sense of dread with restless nights and insomnia behind the scenes of the positive environment and attitude we made and projected. We were only a fraction of the way to our target amount and meanwhile lurching into debt ourselves. What on earth were we doing?!

Whatever our private crises, production in the bank was going well as members of the team found their niche. Farah

Bank Job

Ishaq quickly became an expert in screen printing, speeding through the sheets of banknotes accumulating on drying racks in the back room. She lived on the next street to ours and was well known locally through the street murals she undertook and cared for. After 18 years as a journalist, she had bravely embarked on a career as an artist doing a part-time MA at the University of East London. She had her own experience of debt and the ongoing financial challenge of being a single mother.

We had our own childcare issues as we attempted to keep the space open beyond restrictive school hours and often Farah's young daughter became part of the bank crew alongside our children, helping out, sorting and stamping, together claiming the bank as a space of play and exploration. They were joined by Suzanne's three young children parking up their wheels alongside other bicycles in the space as people made special journeys to visit the bank. Suzanne Lemon had a successful career as an art director at the *Guardian* but wanted to get her hands dirty with the stuff of print. By the end of the project she was an expert in letterpress, acquiring her own press from Paekakariki Press and getting ours up and running with each new plate and print we produced. Her partner worked for the food bank NGO the Trussell Trust and they were acutely aware of the structural issues in our economy and society that lock people in poverty.

These economic issues were something that came out in everyday conversation as we went about the business of making money. Lucy Gregory grew up in Waltham Forest in north-east London, and like many struggled with unemployment, debt and unaffordable housing. She had previously volunteered at the now closed local Credit Union and had a specific interest in ethical lending, and art and activism in the community.

Isobell Blackwell talked passionately about the detrimental impact student debt had on her and how hard it was coming

out of education into zero-hours job opportunities. In her application she states: 'As a person who is currently suffering under the burden of massive debts, the idea of raising awareness about this pernicious economic issue and discussing ideas to tackle it is extremely refreshing and empowering.' She had heard about the project when Hilary went to give a talk at the local Waltham Forest College, a talk that also attracted the soft-spoken, meticulously hardworking Meltem Tigli, a young art student keen to understand how the system worked. She was later joined by her twin sister and together they kept things organised and tidy while all around chaos ensued.

We might have discovered Walthamstow was indeed a creditocracy, but we also uncovered and connected a resourceful, creative and critical community. And so we gathered people, materials, expertise and support around us. There were many more who joined us and worked hard as a team to pull off the first intensive period of money production. Some came and went through changing circumstances and the priorities and precarities of existence in London.

Some, like Anthony Lane from the local Transition Towns network, and anthropologist and activist, Doug Saltmarsh, popped in and out providing the moral support needed – those 'keep up the good work' moments that sustain you through the low points. Others remained for the unexpected duration of the project, never quite believing us when we got in touch saying would they be up for joining us for one last 'job'. This was a long-haul project and the jobs continued.

When we finished printing the first batch of money, we moved onto the big denominations. When we'd reached the target £40,000, we began printing paper bonds and later we made coins. It was a marathon effort to sustain the action and keep awareness going around the project, moving through waves of behind the scenes and public production. Through

the course of the project, together we learned techniques of screen printing, letterpress, foil blocking, paper making, pulp printing, fly press operation, metal casting. Each one of these steps involved new collaborations, seeking out experts to share their knowledge with us all. Sometimes enlisting help was harder and more circuitous than others. Rob Fawcett from the local woodwork and metalworking space Blackhorse Workshop came to the rescue to customise our fly press after a long process of tortuous dealings with patronising toolmakers and aborted collaborations with blacksmith/artists as timings shifted. The ethos was to keep production and suppliers as local as possible, though sometimes we had to range further afield. Buying the foil-blocking machine involved a trip to Colchester, Essex, and a sermon on the dangers of generosity from an admittedly successful businessman with two Range Rovers lined up outside. It was a constant balancing act of financial limitations with ambition and imminent deadlines.

In the dog days of summer, when the bank became a cool sanctuary for ourselves and other animals, Helen Porter arrived to calmly oversee our new adventures in paper making. We had travelled out to Debden in Essex, home of the Bank of England Printing Works, to collect two allocated boxes of decommissioned tender – briquettes of recalled paper £10 notes diverted from the incinerator for our creative intentions. The team stocked and monitored hypnotic food processors blending the old banknote fragments to a pulp, occasionally jolted out of reverie by the smell of burning and a small explosion. We searched for someone who could teach us pulp printing – a process merging screen print and stencil so an image is created as a thin layer of paper bound to paper. We found Stephanie Turnbull, who had previously worked with Hilary as the stone lithography print technician at the Curwen Studio, and she arrived, heavily pregnant, coping with relentless

sun in a yard strewn with makeshift tanks of paper pulp to share this technique. After two days of guidance we were let loose.

Miranda Moore, a friend and neighbour who worked with us through these various learning curves shared that it was this 'can do' attitude that made the project special for her as she operated the foil blocker and made her first successful paper sheets. Our default position was a belief that everyone could do it – could learn new techniques and put them into practice – and so they could. It was a faith and a letting go that was rewarded. We put in place a framework for trust and production and expected care and responsibility as we all worked towards the same goal in an evolving community. Sometimes, inevitably, this trust was unwarranted and operations went slightly or spectacularly awry. This was a risk we knowingly took at times as we allowed visiting groups to 'contribute' and to expect the same level of deftness – of hands and minds – was not always realistic. Even with all the care and training in the world every step was new terrain and wastage was an unavoidable part of this. Efficiency was not the absolute priority of this manufacturing hub, as sharing skills and building relationships were also the core aims of this public making. A filing cabinet drawer labelled 'mistakes' was overflowing, but this was all part of the process, and later those 'mistakes' were ripped up by a team of enthusiastic children to make paper.

The learning process was amplified by the need to immediately share this knowledge with others, beginning a chain reaction of skill sharing and collaboration. The core team became demonstrators, teachers and specialist tour guides as groups flocked to the bank from universities and sixth-form colleges. Alistair was joined by George Sabapathy as a go-to reliable guide, whose background in customer service and patient teaching came together in the way he welcomed people into our world, confident in the knowledge that this

was something to get behind. He had previously endured working as editor on Hilary's films and his support extended through cups of tea and mechanics to picking up every last fragment of an exploded van.

With all that learning came envelope stuffing, counting, packing, posting, stamping, folding, trimming, cutting, chatting, tea making, and a lot of talking. Between ourselves and with the many people who visited the space, but also from the people we invited to contribute to our series of 'Money Talks', opening up the ideas that had driven the project to the public. We hosted university 'teach-ins' during strike action, workshops and debates where key thinkers from David Graeber to Dr Johnna Montgomerie and Brett Scott shared their heretical financial knowledge with surprisingly diverse local audiences from food co-operative members to bankers. This was pass-it-on education and an empowered 'thinking through making' in which the financial system, usually so abstract, was suddenly embodied and ideas contained in the pages of white papers or economics tomes came to life amid the washing lines of drying money.

We had always known that the aim and action at the centre of the project was to try to do what Strike Debt had done in the US: buy up UK debt and destroy it. Now, the process of raising the money to do that encompassed more than that – economic education, community resilience and other neat phrases that don't quite sum up the sparks that seemed to fly out. We had given ourselves the power of central banks. When we were dubbed the 'Rebel Bank' we owned it. This really was a community heist. We were shocked when, from its uncertain beginnings, it seemed to capture the imaginations of those who heard of it and messages came in from communities all around the country wanting to do the same thing. Many made a pilgrimage to the bank and the notes and bonds made in the bank travelled as far afield as Texas and Singapore.

Hoe Street Central Bank

So where did this magic money making all take place? In our very own bank.

When we came up with the idea of printing money we didn't have a space to host our operations. Making prototypes down the shed wasn't going to cut it if we wanted to scale up and engage more people. We had managed to persuade the local council to support the launch of the project with a small grant. It gave us the confidence to invest what we needed, contributing first to wages, initial materials and, more importantly, beginning to show that there were starting to be people out there willing to take a risk on this with us. They helped us gain what was going to be our HQ: a pop-up shop space in Hoe Street's Central Parade – a Grade II listed 1950s Festival of Britain-style housing and shopping block. The shop front was a pretty small, basic rectangle but at least it was street facing and available, and the limitations this imposed on us actually led to the fortuitous naming of our bank.

The space was called Hoe Street Central and we weren't allowed to change the signage so we just decided to add bank on the end. As the space was directly opposite the open HSBC (Hong Kong and Shanghai Banking Corporation) it had potential. A few weeks later an Arts Council funding bid rejection led to a timing lurch, which, in turn, led to the loss of this first space. Perhaps it is always amid chaos and failure that the best opportunities reveal themselves. We had employed a PR who'd spent her time labelling the project 'too lofty' while draining our extremely finite resources and resolve, and yet even out of this negativity there was a positive – she mentioned that the old Co-operative Bank just down the road on Hoe Street was being turned into some kind of coworking space. We were on the case.

Bank Job

The bank had previously been owned and run by the Co-op, but they had just vacated and a Welsh coworking co-operative called Indycube was taking on a temporary lease of their first building in London. Our local Labour and Co-operative MP was involved in this move and a bid to set up some kind of union of the self-employed. There had been a launch a month earlier that we had totally missed. We arranged to meet Dai Lloyd and Mike Scott from Indycube in the space, where they were busy painting it pink and blue and organising Ikea furniture into desk spaces. They welcomed us gingerly and with deadpan humour, trying to contain our enthusiasm as we overflowed with excitement at being able to operate out of a former bank. We negotiated costs and they agreed to us becoming 'anchor tenants' who would take on the responsibility of the day-to-day running of the site. We described our plans to set up the space for printing money and at first agreed to confine this to side rooms, though we were all too conscious that what we'd really love to do is turn the whole building into a form of *Gesamtkunstwerk* – a total work of art.

We owe a lot to Indycube for being so supportive of this project from this early stage, allowing the project to blossom, not clinging onto a rigid idea of what the space could be but enabling and believing in what it was becoming. Our relationship became a constant but not-too-tricky negotiation as, step by step, we persuaded them to approve a bit of a 'revamp' aka a total DIY refurbishment of the space. The failings of the deteriorating building became our friend – flooding from neglected roofing gave an excuse to joyfully rip up the faded blue carpet tiles and laminated floor. It would, after all, be easier to clean. All obvious evidence of the Co-op's occupation had been stripped out but poking around on the two vacant floors in a 1980s time warp we discovered old posters. These showed families smiling at cashiers' desks and

promises of living the dream, which at that time appeared to involve traveller's cheques, a caravan holiday and a boom box.

Hilary poured over pictures of old banks, excavating this particular one's history from the archives, examining the 'Fidelity Fiduciary Bank' of *Mary Poppins*, and Gringotts Wizarding Bank of Harry Potter. This bank had none of their accoutrements of grandeur (the elements that ease a smooth transition to wine bar) and any sense of its admittedly more modest heyday had been gutted and hidden by years of insensitivity and lack of care.

Choosing the classic two-tone green colour palette of 1940s institutions, we turned to the local Forest Recycling Project and its warehouse of reclaimed paint. We salvaged all the shades – apple, sage, lime, khaki, sap, magnolia – and dumped them into vats to create our own unique range. Later, when prizing off layers of plasterboard we were slightly unnerved to discover a two-tone green wall in exactly the same shade and ratio – the building was whispering to us. With the floor a dark green we brought in the furniture, itself a reclamation operation from local schools, the indispensable 'sell or swap' network, Ebay and charity shops. We put out a call for 1940s wooden desks and hid the Ikea furniture in a cupboard. This was more than a set – it had to be a functioning work and event space. Chairs arrived from a village hall in the Midlands to start a new urban life. Tradesmen fixing roofs or plumbing in the industrial sinks were treated to the Bank Job story and shared their own – one featuring the Hatton Garden heist. The finishing touches came in the form of classic green banker's lamps and a collection of chrome Argos floor lamps chosen for their shape to be sprayed green and old gold. (Fake) brass door signs declared 'Print Room', 'Bank Manager', 'Boardroom' and 'Vault'. Hilary was in her element, working with a tiny budget on a total transformation. After all that, many visitors exclaimed, 'Oh, it's great you kept it how it was.'

Bank Job

After hours of peeling back the opaque branded window covers, the simple white building exterior had an air of the Wild West about it. We went with that. We made our own HSCB window signs and employed a sign writer to paint a bold black B A N K. We were ready to open. Some were quick to warn us that painting this sacred word would incur the wrath of the Bank of England or the Financial Conduct Authority. We were always being told that we would be shut down because of this legislation or that agency. When we first started to print our own cash in the shed, our families seemed scared that we were breaching something undefined and that our profanity would meet with the full force of the law.

But this was not counterfeiting. We had no need or desire to forge legal tender. This was about creating something to counter and challenge what could be seen as a 'counterfeit culture' that was proliferating and lulling us into unquestioning acceptance of its rules and values.

Although even with those thoughtful aims, we could have done with some hard cash. We opened up the broad, reinforced doors of the imposing Chatwood-Milner vault. It was completely empty and emitting a strong scent of disinfectant with base notes of money (filthy lucre) that never quite dissipated, but we always hoped that in these crevices we might uncover some forgotten wads of cash or a stash of gold bullion in some special, lost hiding place. But that was not to be.

However, other treasures were found as Hilary continued apace, enlisting the help of Andrew Islam, multi-skilled handyman of distinction. We posed for photographs with sledgehammers, taking on a far bigger job than we thought and testing the tolerance of Ginette, the resident trainee reflexologist who was occupying the 'boardroom' with strained good humour and patience. We eliminated the

suspended ceilings and smashed up pointless boxed-in walls. Fragments of the past emerged – pencil marks on ceilings (Glen and Shaun, apprentice electricians was fitting trunking here at '6.00 o clock 3/11/81'), chequebook stubs, now retro chocolate bar wrappers, even whole cupboards inside stud walls labelled 'coin bags', 'notes', and a security desk behind plaster and steel mesh. The space opened up to its original height – a crucial elevation in preparation for bringing back and exhibiting our exploded van (the Tate Modern and Bank of England foyer had, on this occasion, declined the install).

The relentlessness of low budgets and determination led to an agonising trip to A&E for Hilary but something more painful was happening than a ruptured disc – she was falling in love with the building. When we first moved in, the ever-supportive Mark Hooper, founder of Indycube, was insistent in his advice of not getting too attached to a building – there are plenty around. Indeed, there are plenty of recently vacated banks around the country and that in itself is a story of potential. However, there is an empathy that extends to bricks and mortar, murmured histories and life stories. For while our own stories only reach as far back as the late 1970s, the bank has been on this world far longer. Made quite literally of this earth the building rose from the ground in a time of great growth in the city.

The Bank at 151–155 Hoe Street, Walthamstow: A story

As we've been gathering the team and glimpsing flashbacks of our own narratives it feels necessary to uncover a bit of the bank's story. Why tell a story of a building? Well, it is a key member of the Bank Job team. It has shaped our story.

Bank Job

Ideas need space. Not just in the head, but in the city, on the high street – space for people to meet and plan and take action. The bank, its history and legacy, are a key part of our community heist on the financial system.

The building has its origins in the accelerated developments of the Victorian era when Walthamstow was a village on the edge of a rapidly expanding London. On 23 March 1886 city merchant and local philanthropist Richard Foster sold the site to one Joseph Thomas Day, son of Caleb and part of a dynasty of Walthamstow Days, a family of publicans and brewers. Foster (1822–1910) most likely owned a speculative land parcel of dairy pasture. An advert in the *Eastern Post* in 1879 states: 'Sale by auction of about 60 lots of ELIGIBLE BUILDING LAND having frontages to Hoe Street, Walthamstow and the new roads leading there from and situated close to the Hoe Street Station on the Great Eastern Railway.' As head of his family's financial firm, Knowles and Foster, and director of the London and Riverplate Bank (later acquired by Lloyds and merging with the London and Brazilian Bank to form BOLSA with Lloyds as controlling shareholder) he was part of a growing financial sector with the resources for land acquisition and benevolent, charitable giving, much of which he put into a Christian mission enabling the building of four local Anglican churches, three of which stand tall today.

Oranges and lemons
Say the bells of Saint Clement's
You owe me five farthings
Say the bells of Saint Martin's

When will you pay me?
Say the bells of Old Bailey

The Heist Begins

When I grow rich
Say the bells of Shoreditch

When will that be?
Say the bells of Stepney
I do not know
Say the great bell of Bow

Dong Dong ...'

Standing amid rows of Victorian terraces built on the flood-plains of the River Lea, you can't see these church spires but the taller glass ones piercing the London skyline are omnipresent. Our local churches might not be part of this 16th-century nursery rhyme but its call-and-response song of debt would have resounded across the rooftops – when the bank was built, debtors' prisons had only been abolished 20 years before. Church, City, Colonialism, Corporation and Crown fuse in this wider narrative of money. The ancient City of London was, like its Roman founders, profiting from Britain's overseas empire and growing as a global finance centre. In turn, Walthamstow had become a popular rural retreat for these City merchants but urbanisation advanced rapidly on this idyll. Richard Foster may have made his way into his Moorgate offices on the new train lines, and many follow that same commute today travelling into Liverpool Street station, drinking in the same pubs the Days ran.

If the train tracks traverse power relations and private-public boundaries, these are mostly invisible to everyday lives and routine. When Hoe Street station opened in 1872, workers ran across fields to take the train. This is hard to picture now in the grime of a street where constant car traffic has replaced the streamlined trams in a retrogressive act seen across the capital.

This was a time of large-scale building projects across the district as the Lea Valley became home to industry and a massive accompanying house-building operation to accommodate the new population. Walthamstow doubled its population every 10 years from 1871 to 1901. Between 1894–1898 building works began on what would become the bank. Teams of labourers carted stock from nearby brickfields as horses brought chimney pots from nearby Higham Hill's potteries and beer for local drinking establishments serving the growing workforce. Hoe Street became a thriving shopping street with 151–153 occupied by Lloyd and Briggs Drapers. Their awnings stretched out above the bustling pavement while next door a stationers sold the latest range of writing implements to newly crinolined and corseted customers. Electric trams arrived in 1905 adding to the thrill of modernity amid the hustle and bustle.

And then came the Great War (1914–1918) and the records are more subdued. The archives are hushed about the changes that would have taken place in this time. Gaps in the narrative are gaps in people's lives and in the streets. Bombs dropped on Hoe Street when a German airship mistook Waltham Forest reservoirs for the Thames. In 1916 the skies lit up with the flames of a destroyed zeppelin. These bombs rained hard on the City of London. There was turmoil in the financial sector. The London Stock Exchange closed for six months. Panic and uncertainty led to the hoarding of gold and runs of the bank (as war was declared on a bank holiday, banks remained closed for a further three days to counter this). All leave was cancelled as the crisis required a full workforce and bank branches were on the frontline – some banks staying open 24 hours to cash cheques for officers returning from the front.

As the country emerged exhausted from war, it needed to rebuild its economy and incurred massive debts to its major creditor: the US. There, it was the beginning of the roaring 20s

and an era of apparently boundless prosperity. This was a time of invention and expansion – aeroplanes, Ford and Chrysler, radios, electrification... and the flowering of consumer culture. A major innovation of this period was buying in instalments and with consumer credit – 'buy now, pay later' – and they certainly did. UK banking flourished as the dominant group of clearing banks, or the 'big five', began multiple takeovers and mergers, but in 1921 this was reined in by the Treasury. One of these major players, the Midlands, responded to this by focusing on expanding UK bank branches (2,100 branches by 1939) particularly in fast-growing metropolitan and suburban areas and so, on 26 August 1921, Henry and Joseph Day sold the building on to what was then London Joint City and Midland Bank, and in 1923 the building's century of banking began.

There were tough times to come. The credit and exuberance of the victorious years were soon to lead to the Wall Street Crash of 1929. Victory came with a cost and Britain was struggling. It had already seen the General Strike of 1926 and now the Great Depression set in. How much of this was noticed on the streets of Walthamstow? Was it business as usual as systems were mechanised and new services introduced? While Wall Street crashed, there were parades and bunting along Hoe Street for Charter Day, celebrating Waltham Forest becoming a part of London and not Essex (full incorporation wouldn't be until 1965). There were cuts to public spending and mass unemployment, but the abolition of the gold standard in 1931 and the low interest rates that followed led to a boom in home building on these suburban edges. Meanwhile the threat of fascism on the streets of London was very real. By 1933 trams had replaced the trolley buses on Hoe Street, delivering members of the BUF (British Union of Fascists) to their headquarters at 111, preparing propaganda for Oswald Mosley's public appearances.

Bank Job

When WWII broke out in 1939, some of the Bank of England's operations were evacuated to Hampshire but the gold remained in the city. Records are scant about the fate of this high-street bank amid the air raid sirens of north-east London. Our bank narrowly missed a direct hit when a nearby block (now Central Parade) was erased. Was it open? Midland joined other British banks distributing war bonds, defence bonds and other government savings, but 478 of its employees enlisted and perished, and there were 1,350 reports of damage to branches from aerial bombing across the UK. These are the misplaced stories – of the stress, rationing and loss of war. And if the bank's doors remained open, how did the employees deal with the fact that the Nazis had introduced nine million forged £5 notes into the system to attempt to destabilise the British currency? Turning to the local history pages that proliferate on social media, nostalgia prevails with a dose of anti-immigration sentiment thrown in.

Emerging from the rubble, the bank remained standing, sturdy and trustworthy, committed to encouraging people that this was a safe place to store one's money. Governments and chancellors changed, the welfare state and the NHS were formed, reparations were arranged. In 1944 Britain was one of the 44 allied countries to be bound by the Bretton Woods system of global money management that tied currencies to the US dollar instead of to gold, so that the US was the only country able to print money. It also tightened international financial regulations and limited speculative financial investment to industry rather than currency manipulation and bonds.

In 1958 Midland was the first bank in the UK to offer unsecured personal loans when the government loosened limits on lending to boost the economy. The building became an extra in archived photographs from 1960 that document the installation of new sodium street lamps ushering in a

bright new world. Shiny cars replaced trams, Halfords bicycle and auto centre moved in next door, a furrier operated from what became the 'governor's' office. Did the bank manager ever live over the shop? Someone must have, dealing with accumulated paperwork and cleared cheques.

Around this time mainstream banks began pouring money into computerising their operations and launching mass-marketing campaigns. They presented a genteel face to their customer, though behind the scenes they competed to meet the needs of the 'great unbanked'. There were a lot of those. Many working people didn't use banks at all until the 1960s, with public houses operating as 'loan clubs' – their lives a world away from the City's deals, risks and securities. In 1967 Midland acquired a share in the merchant bank Samuel Montagu. This marked the first merger in Britain between a merchant bank and a deposit bank. The traditional lines between financial companies was beginning to blur – a signal of the merging of moral boundaries and darkening of ethics to come. Banking became another branded supplier to the marketplace, driven by special offers and mechanised services. In public, the bank launched some pretty avant-garde cinema adverts and the design object that was their guide on 'how to use a bank account'. We discovered this artefact in a dusty cupboard alongside leaflets explaining the 'Save and Borrow Accounts' (1982), 'High Interest Cheque Accounts' (1984) and 'Griffin Savers' (1984). These were met with cries of delight as visitors remembered opening their first accounts and the symbol of the Griffin – the traditional guardian of treasure.

 'Progress' continued apace. In the 1970s the first cashpoints were installed. Wednesday 10 February 1971 must have been a busy day in the bank as deliveries were taken of the new pence pieces, customer account balances were converted from £sd

to decimal, and time was given for outstanding cheques and credits in the clearing system to be processed in preparation for 'new money' day. The decimal age had arrived. Goodbye farthings and crowns. Hello pence and pounds, counted and sorted in coin bags, note labels and bands found inside the walls of our bank. The 70s were also a time to say hello to the relaxation of official controls on bank competition and goodbye to the gold standard. The Bretton Woods system collapsed – currencies were no longer in effect pegged to gold via the dollar. This was the age of the fiat monetary system with a country's legal tender backed by trust in the government that issues it, rather than any actual value.

Economic crises led to stagflation (high inflation, high unemployment and stagnant demand), strikes and riots. Enoch Powell's 1968 'Rivers of Blood' speech was reverberating. Did the waves of all this reach Walthamstow – the civil unrest, power cuts, rubbish bags piled high in the streets of what was increasingly a dormitory area for the clerical, finance sector alongside manufacturing and construction workers? What kind of tensions and chats happened at the cashier desks? We were born at the end of this decade as, out of the winter of discontent, Margaret Thatcher came to power and neoliberalism began to emerge from the shadows. The economic and political system was transforming and the promise was prosperity for all via trickle-down economics. How much of this trickled down to these streets?

The last entry for the Midland Bank in Kelly's Directory (an earlier version of the Yellow Pages) is the year 1982. Deep in the archives of HSBC in Canning Town, records show that a bank is not tied to its physical address – the branch never officially closed, it only moved to 192 Hoe Street, taking its sort code with it. Behind the scenes, Midland was teetering on the edge of bankruptcy having made the disastrous purchase and

sale of the US bank Crocker National Bank. After the 1986 Big Bang, Midland was bought by HSBC in one of the biggest banking mergers of all time, abandoning its City head office for HSBC's global headquarters in the shiny new Canary Wharf.

Amid the ascendency of banking monopolies, the Co-operative Bank took over this high-street site, built when the co-op movement was in its own ascent in response to the industrial revolution. What we now know as the Co-op can trace its origins to 1844 when a group called the Rochdale Society of Equitable Pioneers opened a shop and put in place a democratic structure of organisation and ownership focused around profit sharing, anti-discrimination, concern for community, member control and participation. It was part of the beginnings of a flourishing network of co-operatives formed to counter the 'deplorable warfare between capital and labour and to organise industrial peace, based on co-partnership of the worker ... [and to] promote the formation of central institutions for helping people to establish and maintain self-governing workshops.'[2] (International Co-operative Alliance.)

This co-operative spirit informs the guiding ethics of the Bank Job. Waltham Forest has a strong co-operative history, evident in the faded signs painted on the brick walls we pass everyday ('Owned and controlled by its members. Join your local Co Op') and the presence of a local Co-operative Party MP (the party, spawned from the co-operative movement, began in 1917).

In the aftermath of the Co-op Bank's waning fortunes of lost trust and turmoil, of an ethical bank with its ethics in question, it now hosted other co-operatives with belief in their defining values of self-help, self-responsibility, democracy, equality, equity and solidarity. Workers' co-operative Indycube took on the lease and then joined us as we organised 'Co-operatives in the Co-op' talking to local co-ops about the practicalities and

potential of co-operation from Organic Lea (growing food on London's edge in the Lea Valley) to Calverts printers. How can contemporary local co-ops help us to bond together at the grass roots and build an economy for the common good?[3] The debate focused on how worker co-ops can equip us to move forwards in an economy that is producing inequality and poverty as well as environmental destruction. As we write this, as London is closing down due to the coronavirus, this email comes through from Calverts: 'There's a saying that "necessity is the mother of cooperation". Never has that felt more true than today. Please stay strong, stay connected, and stay well.'

Changing times and streets

In 2017 the Co-op bank made a quick sale. One step in a large-scale dissolution of their assets. Throughout the country and across the big banks, high-street bank branches are being closed and buildings are made suddenly redundant. The UK has lost nearly two thirds of its bank and building society branches over the past 30 years, with over 3,000 closing in the last 3 years. The bank as part of the tapestry of community provision has been in total decline and what is left are the vacant shells of prominent high-street buildings – the embers of a declining (on the street at least) industry awaiting new use and value.

Two years after the closure of the Co-op Bank, there were still people arriving to attempt to cash a cheque, unperturbed by dust clouds and drying racks, not quite making the cognitive leap across timeframes. There was sometimes anger and confusion, and blame directed at us for the closure of the high-street bank and the rise of the cashless society. We directed them to a helpful sign listing all other open branches in London, but these were all tube and bus rides away. Many

were unable or unwilling to transition to digital, craving face-to-face contact and assistance, and unaware of how banking had mutated as an industry through their lifetimes. This sturdy Victorian architecture has lived through the Wall Street Crash, changing monarchs, governments, and cycles of boom and bust, two world wars, the rise and fall of the welfare state. Change was and is the one thing that could be counted on.

The major banks' taglines range from Barclays' 'fluent in finance' (so you don't have to be) to 'the world's local bank' (HSBC). Midland Bank's early coat of arms may have preempted their multiple mergers and acquisitions when it stated '*vis unita fortior*' (strength united is yet stronger) but the modern Midland Bank focused on the slogan 'the listening bank'. This former branch has had time to listen – to the labourers who built it, the gossip amid the dress racks, the cashiers' coffee breaks, the silence of the vault, the tears or congratulatory handshakes in the bank manager's office. The building contains stories of an expanding city, an industry and a high street's own boom and bust. As we exposed layers of the building's history we became entangled in a mass of multi-coloured data cables falling out of ceiling cavities, leading us on circuitous journeys to defunct servers. The complexities of the building's histories seemed to be embodied in the pulling out of these useless arteries – data cables telling of days before broadband, later piled high on the scales of the local scrap metal merchant in their own economy of material and meaning.

The diversity of shops listed in the authoritative Kelly's Directories for this stretch of high street has been replaced by a litany of estate agents windows in a ward made up of 5,000 households classed as 'not affluent'. For a short, incongruous time, one of these neighbouring estate agents moved into the bank while their office floor was being done – as we printed money up front, out back sales were completed

and deals done. In retrospect, we know now that our own occupancy was already subject to shifts in ownership and power. When we opened the money-printing production line in March 2018, the Co-op Bank disposed of their 'asset' without us being any the wiser, sold to the legal-aid solicitors based upstairs at 155 Hoe Street. At that point we would not have thought to make a bid to secure the space but as time moved on and the bank evolved as a hub of economic education, community and culture – an HQ of our heist as change-making operation – this became imperative.

———

A former high-street bank in Walthamstow has become a hub of cultural action leading social and economic change. Hoe Street Central Bank employs and trains local people, shares knowledge through public events and has bolstered the local economy through art sales supporting a food bank, homeless kitchen, youth project and primary school, and destroying £1.2 million of local debt.

Rejecting repetitive narratives of communities moved on by capital forces, the building is now an asset of community value (ACV) and we launch an ambitious community share offer to buy and develop the building. The 'Rebel Bank' will become 'Power Bank' – a space where culture leads debate and action on the economics of climate breakdown. A beacon of hope in a dense city in its sustainable, solar-powered design and hyper local and global community engagement. It will grow as a space that houses public print, darkroom and make space, flexible venue, bar and kitchen, artists' studios and social enterprise offices and top-floor live/work artist residencies.

So declared our application to the Mayor of London's regeneration programme the Good Growth Fund.

We drafted and redrafted business plans, architecture briefs and funding applications. We fell down another rabbit hole

investigating ownership models, enlisting the help of an expansive pool of expertise from Community Share Offer advisers, financial and business modellers, quantity surveyors and a team of student architects mentored by our friends down the street, architects Kristin Trommler and Tilo Guenther.

Our landlords, as the new owners of the building, were supportive of our tenancy and open in their intentions to sell. For one of them, it was divine intervention, a gift from God that we did not want to stand in the way of – well aware of the cuts that have decimated vital legal-aid provision. The building had been bought for just under £600,000 and was now on the market for £2.5 million. The gift of speculative financial forces would come to distort all relations. Money would be all that talked. A sales agent named Malachi proudly proclaimed himself a 'messenger from God' in a black sheepskin and fedora. For us, he was a messenger of the power and violence of capital, and the unfortunate social relations it creates. This all-consuming negotiation and fight for a building became a big part of our Bank Job – revealing most clearly the financialisation of everything and the speculative property bubbles at the heart of the personal debt crisis. Unable to secure the assurance of being able to be given time to raise the money required to bid, we moved to the Localism Act 2011 and quickly realised its inadequacies. This law allows communities to apply to local planning departments to get buildings listed as 'assets of community value' thus ensuring the 'community right to bid' within a six-month moratorium period where the owner cannot sell to anyone else, but it does not oblige the owner to accept the bid or deal with the 'community' in any way. What it did achieve was to rupture our good relationship with the owners. Our bid was seen as an unforgiveable aggressive act and not a protective measure in the unequal power balance of owner/tenant. When

we were given the deadline of Christmas Day 2019 to vacate the property, a public petition and pleas from local MP, local council, London Mayor's office 'Culture at Risk' team were considered unwanted and unfair 'political interference'.

Our ask was to negotiate a fair deal – one in which owners would secure a good profit, free of a building sucking their energies and in which the community would gain a vital asset that had already proven its need and value. We were in a catch-22; with no deal secured, we were unable to launch a fundraising community share offer or secure other organisational support. In essence we were doomed but we weren't quite ready to admit it. We launched an alternative and unfortunately abortive 'gold rush', likening the speculative financial market's colonisation of our high streets and lives with the invasion and exploitation of the midwest and beyond. We set out to make portraits of our supporters and community using early photographic techniques – making images quite literally created using silver and gold, placing and holding an alternative value on them: 'Portraits offered in silver and gold, our value outshines the stories we're told.' We started a petition as part of a growing campaign, and support came in, buoying our efforts but unable to change the seeming impossibility of our position:

'The bank has become something important / a place to cultivate and share radical ideas / and to generate hope in these troubled times!'

'At a time when we are losing public accessible spaces, this independent public hub driven by local need is invaluable. Energy and creativity to rebuild a broken community.'

'This is such an amazing space in a city that has been taken over by financial capital and property speculators. Ideas and alternatives need somewhere to develop.'[4]

All the while, our own agonising 'no deal' negotiations were taking place with a backdrop of Brexit and then yet another general election. As we awoke, distraught, on Friday 13 December 2019 to a Conservative government, we made one last, futile, plea to the owners: 'With the results this morning and the lack of reply from you it feels like hope is dead. We acknowledge that even without planning permission there is a value to this building and we are willing to pay. If we have a deal and a set target we can then gather the funds. We are resourceful and have a lot of backing. The uncertainty is the only factor disabling this.' Their reply, though not hopeful in terms of plans for the building, shared our concerns with the state of a nation. They were not the 'bad guys'. Property negotiations create toxic power relations and this was 'just business'. However, there are always choices and these were quadrupling rent and getting us out while an ACV was active to undermine its claim. It was heartbreaking. We deleted the 'bank' sign from outside, over painting B A N K in anger and tears.

As Christmas Day fast approached and we sifted through a chaos of boxes and organised rapid sales of equipment and furniture, Steve, of the Soul Project, arrived to pick up the coffee machine he had kindly loaned. He understood totally, still visibly affected by the loss of his space and the rupture and reverberations of this for his mission. The failure to come to a deal led to profound frustration at the waste of it all – of time, resources, all of our energies. We had wanted so much to show that we could do it, 'we' – being people and communities everywhere – could change the expected ending of a story involving developers, the high street, artists and communities. To win. And we hadn't won this one. On Christmas morn we brought the last of the bank's contents through the narrow corridor of our Victorian terrace and it was done.

'The Bank is dead. Long Live the Bank.'[5]

'The Rebel Bank is indeed much more than a building, it's an intervention in social imagining that is just the beginning of greater, positive things to come.'[6]

As we told everyone of our eviction the messages in reply overwhelmed and spurred us on:

> 'Your work having a home meant the community had a home and somehow this will evolve and grow.'

> 'Sad news, though your work and the community built is much bigger. Now more than ever this community needs to draw on its resilience for the battle ahead.'

The message was clear. The bank was not a building. It lived on in the spirit of resistance and resilience it had come to embody. We had learnt a lot from the six months of constant work that went on behind the scenes of our bid for the space.

We remain committed to the ideas we developed through the new collaborations formed. We are acutely aware of the urgent need for spaces to meet, create and organise in the city. This particular high-street bank now sits empty. We are no longer its guardians. But from its beginning this was an experiment in 'What If?'[7] What if, in the shells of every recently vacated bank across the country, on high streets no longer defined by spaces of consumption, there erupted flourishing centres of economic education and cultural action for a just future?

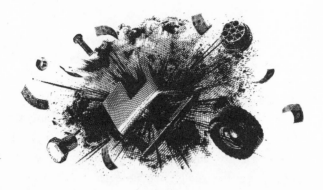

CHAPTER 4

Big Bang 2

A nother Big Bang. A not-so 'quiet catastrophe of *mind and matter'. Why? The outcome of our Rebel Bank was the purchase and cancellation of £1.2 million of local predatory debt. Why was the sending out of letters not enough? Why explode a 'debt in transit' van on a site with a vista of the financial district of Canary Wharf as backdrop? Chaos theory combines with economic theory as the abstract becomes concrete and visceral and the invisible becomes not only visible but spectacular. Can our small action have reverberating impacts? Exploding the public conversation around an unjust economic system through an act of creative destruction? We go behind the scenes of the organisation of this anarchic art action – a route that exposes censorship, the Kafkaesque red tape behind our democracy and a logic that sees more danger in a message than a literal explosion. Perhaps there is some truth in the meme 'Beware of Artists'.*

We had distributed half the dosh, turning up at a school and food bank with our alternative red budget briefcase/ box. Now to buy and cancel £1.2 million of local payday and catalogue debt. This was an arduous, imperfect process with many wrong turns and blind alleys. Working with a member of the debt industry with his own FCA (Financial Conduct Authority) license and a need for some kind of redemption, we eventually managed to isolate and legally purchase a bundle of debt by postcode. As Strike Debt had found out, the reason we were able to buy this much debt for a fraction of its original value was because we were making a hack into what is known as the secondary debt market. Debt, like sugar or soap, is traded as a commodity. Specialist companies operating in this industry may have bought your debt for a tiny amount of its original value if you have failed to make recent payments to the original lender, but the letters will still come through to you saying you owe the original amount plus interest.

Within the local postcodes of E17, E10, E11 and E4, we bought up a package containing the debt of 411 people averaging £2,960 each, with a total value of in excess of £1.2 million. This was all very quiet, involving spreadsheets, General Data Protection Regulation, phone calls and meetings. Due to the delinquency (old, lost, deemed 'unruly') of the debt we were not overrun with individual stories that could counter some of the shame and stigma surrounding debt, but we'd also been very wary of highlighting the 'debtor' in this way and consolidating the narratives of the debtor as 'other', as sinner to be redeemed or saved.

At the core of the project was a challenge to the hypocrisy that turns a blind eye to the mass bailouts of the banks, to a society in which those at the top get to negotiate their debts while others are faced with bankruptcy, bailiffs and bias. We

were writing off debt, raising awareness of the existence of the secondary debt market, but if the whole point of the project was to pierce the public conversation around unjust debt and question the legitimacy of a wider economic system that wraps debt around basic provision, we really needed to make more noise.

From its inception, when Dan, the 'Debtonator', handed over a makeshift debtonation device to Andrew Ross, the author of *Creditocracy*, the aim had always been to 'explode that debt' in more ways than one. Now we needed to get serious about our plans for doing this literally and to do that we needed money. Ironically, while printing money, we had been losing it. The project was all encompassing, with little time to gather funds from elsewhere and the small grants we were getting would not directly cover such a bold statement. We have already imagined what we could do if we were able to print our own money – but why stop there? The bank kicked into action again as HSCB began issuing its own bonds, playing around with and subverting the instruments of finance.

Bonds are traditionally a way for one entity to raise money by borrowing from another. They are debt based and deliver return for investors. In times of war, governments issued war bonds, calling on citizens and investors to loan them money in order to fund whatever endeavour they were involved with at the time. Government debt is seen as the safest place for investors to put their money, particularly in volatile times with a fragile financial system. At this time of global uncertainty, bonds are so popular that some countries are actually charging investors for lending them their money. We saw the bonds as our own form of 'war bond' – a cry to join us in exploding the conversation around debt and our current economic system. Our bonds were debt based

too, but do not yield financial return in the same way as traditional bonds. The return on investment was listed as:

- The bond itself. An artwork printed in the bank using traditional print techniques of letterpress, screen print, foil block and company seal with a finishing touch of gilt (another word for bonds is gilts or gilt-edged securities).
- An invitation to the explosion (to be confirmed).
- A fragment of the explosion. After the explosion we will collect the exploded parts, exhibit them in suspended animation and then melt them down to create commemorative coins – turning debt back into currency and providing a return more valuable than the initial investment.
- The chance to make history.

———

As people began to buy these in a move to support the endeavour, we worked frantically behind the scenes to make sure this action would actually take place. The production line kicked in, the team got together for this 'final' job and the bank opened up its doors to more action and debate.

Instead of the faces of Gary, Saira, Steve and Tracey, we 'borrowed' one of our children's toy trucks and, with more difficulty than expected, smashed it up, photographed it in various configurations and, together with Phil, created the versions of exploded image that were pressed onto the bonds with the trusty Adana, alongside the words: 'This bond is issued by Hoe Street Central Bank. The holder of this bond is entitled to a fragment of the remains of the collectively owned and distributed explosion of £1 million of payday debt – Big Bang 2.'

So why did we explode a golden 'debt in transit' van full of papers symbolising the £1.2 million of cancelled debt (we ended up buying more than we anticipated) and call it Big Bang 2? We wanted to make this symbolic destruction of debt visceral and real in an exploded, expanded sculpture to shake the foundations of both capital and art, and provoke deep questioning of our current debt-fuelled economic system.

This was financial education and it was time to drop the niceties. Out came the balaclavas and pitch alternators that led to comedy rather than menace.

The ascendancy of neoliberalism

October 1986: the Margaret Thatcher-led Conservative government deregulation of the financial markets – Big Bang. The impacts were far reaching, from the bank on the high street to the slowly eroded structure of society. Big Bang was a defining moment where the latent power of finance, which had been regulated to serve the needs of the people, was now set free – this was the moment when those in charge of the City rapidly became 'Masters of the Universe'. Outside of the new economic spheres we have come to occupy, so little is publicly understood about this paradigm shift in consciousness away from the social contract and yet it has shaped our moral universe and personal narratives.

Where were we during this apparently big bang? No earth-shattering reverberations for either of us. Dan. Aged 10. Probably just watching *Top Gun*, running wild on the edge of a Northern Irish lough, riding BMX and into heavy metal. Hilary. Aged 9. Watching thunderstorms rattle around the Stroud valleys, roaming housing estates, parks and underpasses on rollerboots and being rejected from BMX gangs

but attempting the jumps anyway. There are no memories of meal times with parents deep in political discussion. The world beyond was just that. Unlike its cosmic namesake, it had no apparent impact on life on Earth as we knew it. No one mentioned it. So it hadn't happened.

But on the trading floors of the City of London it had, and what was to happen there would have a profound influence over the lives of ordinary people everywhere. Like the cosmological Big Bang the language around it is difficult to comprehend but it is imperative to try to get to grips with this dark matter.

With the pronunciation that 'economics ain't particle physics mate'[1] comes the real issue of economics for too long being treated and revered as a science subject to irrefutable laws rather than a system created and able to be changed by people. That the system we live under is open to question, improvement and change is astonishing and unacceptable news to a lot of people – turning the world they know upside down. It is a mindset that is a massive barrier to the transformative change proposed in economic reform and practically costed policies that make up a Global Green New Deal, which calls for major structural economic and financial reform to rectify the equally enormous ecological changes that the current systems have accelerated. As economist Ann Pettifor states, economics also 'isn't rocket science' and once people know, 'Boy do they act to change things.'[2]

On one day, 27 October 1986, as part of a bigger phase of privatisation led by Thatcher's Conservative government, the London Stock Exchange became a private limited company. The city was in effect deregulated with changes in the structure of financial markets and trading culture, including the removal of fixed commission charges and the switch to electronic trading. These changes made London a major

player on the international finance stage. The Big Bang was an explosion of speculation and there were expressions of concern over the likely longer-term impacts of this particular big bang – it was a period of massive acquisitions and mergers, and concentration of power was focused on the big companies that took over long-standing City firms – the birth of those 'too big to fail' who came to dominate financial cities and make the system increasingly fragile. The Glass-Steagall Act, introduced in the US in 1933 separating commercial and investment banking, was still in force, so US firms crowded into this newly deregulated sphere. It was the beginning of investment banking in the UK, hedge funds and bonus culture.

Thatcher understood the power of language. The buzzwords were 'freedom', 'choice', 'opportunity' and 'prosperity' – words that are hard to argue with, articulating as they do deep-rooted psychological desires of humankind. These words infused our childhoods, helped by a relationship with Charles and Maurice Saatchi, who, as M&C Saatchi, would later say that Thatcher was, 'The best client we ever had.'[3] The power of advertising helped her into Downing Street with the 'Labour Isn't Working' poster depicting a dole queue (actually made up of Hendon Young Conservatives) and the sub-heading, 'Britain's better off with the Conservatives.' The ad business went on to reap multi-millions of pounds from the massive privatisation campaigns unleashed for British Gas, Telecoms, even our water.

In Thatcher's words, this drive towards all-encompassing privatisation of public services was 'nothing less than a crusade to enfranchise the many in the economic life of the nation. We Conservatives are returning power to the people.'[4] Offering shares in these companies the promise was shared democratic public ownership, profit for all, but then dream

and reality ruptured. This mass privatisation has led instead to dysfunction and exploitation, with public services monopolised by overseas firms and investment groups able to make huge profits exploiting a captive market. A board game of the 1980s revealingly captures the way in which this thinking infiltrated public imagination: Poleconomy was marketed as a 'role-playing game about money and power where each player is both Tycoon and Politician', clearly illustrating the blurred boundaries between state and private finance and the corruption of power this could/would lead to.

Perhaps the words that have had the most enduring influence is Thatcher's infamous phrase 'there is no alternative' (TINA). It returned with a vengeance in a speech by former Conservative prime minister David Cameron in 2013, 'If there was another way I would take it. But there is no alternative,' in defence of the massive cuts to spending that would characterise the following years of UK austerity. TINA became a rallying cry for neoliberalism and freedom – of the market, that is.

When, in 2013, after some months of residence in the luxury hotel, Thatcher died in The Ritz, a statement from the White House said, 'The world has lost one of the great champions of freedom and liberty, and America has lost a true friend.' In economic and societal terms, this was an idea of freedom gone awry – freedom divorced from responsibility and accountability. *Liberté* without the *égalité* and *fraternité*.

It has been argued that Thatcher herself never intended this Big Bang to have the far-reaching consequences that it has had. Her origin story is that of a daughter of a grocer who was mistrustful of credit and credit cards, believed in hard work paying off and pronounced a set of moral virtues exemplified in her father's family business. She preached: 'The secret of

happiness is to live within your income and pay your bills on time.' The issue now is that, for many, this is no longer a possibility, with the number of people in the UK being in in-work poverty reaching 4 million by 2017, translating to 1 in 8 in the economy classified as working poor.[5] In 2019 there were 4 million children in poverty.[6] Income just doesn't meet the cost of living in a society overruled by the profit motive.

Thatcher came to power, like Reagan in the US and Pinochet in Chile, helped by the collapse of the old consensus. Britain and the US had experienced two oil shocks and the end of the Bretton Woods monetary system, the Vietnam War, the collapse of Britain's industrial relations and the failures of policies to deal with stagflation. Behind the meritocratic ideals, her economic policies were led by the shadowy, strategic manoeuvring of the architects of neoliberalism.

The British historian Richard Cockett assigns a key role to the little-known Mont Pelerin Society in the battle of ideas leading to the triumph of Thatcherism. In the aftermath and post-war settlements of WWII, when Keynesian support of economic growth with robust welfare regimes was embraced, a group of economists including Friedrich Hayek, Milton Friedman and George Stigler met in Switzerland's Mont Pelerin ski resort with the aim of overturning what they saw as freedom under threat from state socialism, of government intervention turning us into communist slaves. They explicitly recognised that this 'battle' would take a generation and they put in place powerful backers, populated think tanks (that now overlap with those pushing climate denial) and propagated simple messages of growth, freedom and individual liberty into a growing policy vacuum.

Documentary filmmaker Adam Curtis[7] captured the significance of this moment in the transformation of British political life when Thatcher looked to one of these think

tanks for economic guidance: 'She turned to the Institute of Economic Affairs to create the policies for a future government ... Once upon a time their think tank had been marginalised and despised – now it was at the centre of a counter-revolution that was about to triumph.'[8] Britain and the US can be seen as powerful (failed) experiments in neo-liberal economics, which, stripped back from utopian ideals to its real impact, was a 'political project to re-establish the conditions for capital accumulation and to restore the power of economic elites.'[9] The origin and justification of this free-market, laissez-faire economic theory is in the libertarianism of the European Enlightenment, in the pioneer story and values of the US – of self-reliance and rugged individualism. Your life belongs to you and no one else. The paradox of such ideas of liberal democracy, as Astra Taylor[10] points out, is that they were founded on slavery – the antithesis of freedom. Far from the liberty it advertised, neoliberalism has led to new forms of slavery and empire, and a finance system we serve rather than it serving us.

This is what has led us here as we struggled ourselves with creating meaning and money, seeking to find value beyond market transactions and recognising that such freedom is at the heart of what we grappled with. Recent moves to rescue, reform and reconstitute the welfare state are labelled 'radical' and destructively 'revolutionary'. The reality is that we have been subject to an increasing extreme and truly radical, destructive experiment. Whatever the original intentions of economists and politicians, 40 years of understanding money, finance and markets to be neutral forces has broken our social contract to each other and to the world we inhabit. As George Monbiot declares, 'By rolling back the state, neoliberalism was supposed to have allowed autonomy

and creativity to flourish. Instead, it has delivered a semi-privatised authoritarianism more oppressive than the system it replaced'[11] and leading to unsustainable and far-reaching inequalities of wealth.

The current establishment and the media landscape that props it up continue to present and persuade us daily that this is the 'way things are' – that thinking differently is unnecessary and undesired. Neoliberalism has invaded our consciousness, from 'TINA' to the economic narratives adopted by a crisis in the Fourth Estate that can trace a story back to the edges of the Thames in the 1980s and the illusion and collusion of a 'free' press.

A 'free' press

The balance in British industrial relations was also shifting. After the Conservative election victory in 1979, Margaret Thatcher introduced the Employment Acts of 1980 and 1982, and the Trade Union Act of 1984, restricting the powers of unions. These industrial disputes in the early 1980s showed how far the government was willing to intervene on behalf of employers against unionised workforces. In 1981, as riots broke out in Brixton, London, and Toxteth, Liverpool, Thatcher's popularity was waning. In a deal that would have massive repercussions, she enabled press baron Rupert Murdoch to avoid the Monopolies and Mergers Commission, thus allowing him to expand his media empire from the *Sun* and *News of the World* and acquire the *Sunday Times* and the *Times*. Murdoch would not have achieved his move without those deals and legislation made under a Thatcher-led government. The former editor of the *Sunday Times*, Sir Harold Evans, states, 'A newspaper merger

unprecedented in history went through in three days.' And in his book *Good Times, Bad Times* he writes, 'Normally the apostle of competition, on this occasion the lady was ready for turning: the U-turn she executed was in the expectation that Murdoch's affinity with her politics would impel him to ensure favourable coverage.'

The TUC described Murdoch's sway with the British institutional forces – legal, governmental and police – through News International (now News Corp) as 'malign and corrosive'. This has only deepened and news of this 1981 deal came to light in the Leveson Inquiry of 2011, set up to examine relations between the press, politicians and police following the phone-hacking scandal at News International.

1986 was a turning point in the political power and influence of finance and the media. The year-long 'Wapping dispute' was a bitter conflict between Rupert Murdoch and the London print unions, and a significant defeat in the history of the British trade union movement on the tail of the miners' strikes a year earlier. Six thousand newspaper workers went on strike over Murdoch's News International plans to move editorial and print operations from Fleet Street to Wapping in east London, with the demand that unions accept flexible working, agree to a no-strike clause, adopt new technology and abandon their closed shop. The plan was to provoke a strike and then the striking workers were immediately dismissed and met with the full force of the law. Meanwhile News International moved its four titles, the *Times*, *Sunday Times*, *Sun* and *News of the World* to what was now 'Fortress Wapping', protected by razor wire, surveillance and a massive police presence, employing new workers from the electricians union (EETPU), non-unionised TNT drivers and with the police protecting routes in and out.

New technology and adjustments to labour relations may have been needed, but this was a power grab, not a negotiation, with an overriding climate of casual contempt and brutality and putting profits before people. 'For journalists at Wapping, the problem was less the acceptance of the new print technology than the triumphalism of a management that had crushed the unions and saw its journalists as expendable'.[12] On the streets outside this fortress, police methods were criticised because, protected by new legislation banning secondary picketing, the use of excessive force and abuse of civil liberties abounded. Residents marched with banners demanding to 'reclaim our streets from Murdoch's boot boys'.

Rupert Murdoch has continued his ascension through these decades. His organisation now owns Fox News and Sky, and is a global monopoly with an imperial reach spanning the UK, US and Australia, with Papua New Guinea thrown in for good measure. In 2011 the Commons Culture, Media and Sport Select Committee found Murdoch 'not fit' to lead an international media organisation. And yet on he goes. The Media Reform Coalition reported 22 meetings between News Corp (formally News International, but now sounding more dystopian) and UK government ministers, concluding that 'decades of rampant criminality and corruption within the Murdoch newsrooms does not appear to be of concern to the present government [the Conservative government under Theresa May] as senior ministers continue to sit down with News Corp bosses at a rate that dwarfs other companies and organisations. It's as if it's part of their job description.'[13]

Protestors from Extinction Rebellion recently dumped a truckload of manure outside News Corp offices in Brisbane together with placards stating: 'Billionaire liars. Media monopoly. Climate denial. We call bullshit.' In Australia,

Murdoch media represents 70 percent of the nation's total print media, with the former prime minister of Australia, Kevin Rudd, stating, 'Its papers conducted a relentless campaign against any form of economic stimulus during the global financial crisis, arguing that financial markets would magically self-correct. Its far-right agenda on climate change is clear to all.'[14]

The Media Reform Coalition was set up in September 2011 to coordinate the most effective contribution by civil-society groups, academics and media campaigners to debate over media regulation, ownership and democracy. The commitment by it and other organisations, from Spinwatch to Open Democracy, to media pluralism, ethical, investigative journalism is crucial in an era where the monopolies in media and finance threaten democracy. Five billionaires own 80 percent of the UK media. Three companies control 83 percent of UK newspaper circulation.

From the events of the 1980s to *1984*, we increasingly live in a world where 'double speak' and 'alternative facts' surround us and the need to hold power to account and question the vested interests at the heart of our democracy is all the more urgent. Who owns the press? Who censors and compromises news outlets? Who shapes what stories are covered and how? Who frames the debate and excludes critical voices? In whose interests are they operating? Who owns the government?

The construction of a citadel – and why we wanted to storm it

So, if 1986, when we were going about our childhoods in oblivion, was a defining moment when the power of finance

and tax-avoiding billionaire media moguls took its grip on our democracy, where did it take place?

The historic docklands area of Wapping was devastated by the air raids of WWII and the end of Empire. The arrival of containerisation in the 1960s led to the decline and closure of the docks. As Thatcher told a Conservative rally in Newcastle on the eve of her 1979 election, 'Decline isn't good enough for Britain', with the simplistic narrative that decline would be reversed by the move from manufacturing to financial service industries.

In 1981 Secretary of State for the Environment Michael Heseltine formed the London Docklands Development Corporation to redevelop the area. This was a 'quango' with powers to acquire and dispose of land, land that was then designated an 'enterprise zone' in which businesses were given incentives to develop through bypassing lengthy planning approvals, property tax exemption and capital allowances. Downriver the Isle of Dogs was a critical space in this wholesale regeneration project. This site at a loop in the Thames turned into a financial district to rival and overtake the City of London. An early advert for the development of Canary Wharf promised it would 'feel like Venice and work like New York', 'London's Wall Street on the Water'. A 1988 article in *Architectural Review* describes it as a (bad) piece of 'north American cultural colonisation'[15] and US firms were indeed attracted to a UK that was less bound by regulations. Foreign firms could now own UK brokers and Wall Street giants like Goldman Sachs and Salomon Brothers moved on the London Stock Exchange. Canadian property tycoon Paul Reichmann led the creation of a financial services office complex and the first Canary Wharf skyscraper went up in 1990.

London indeed became a global citadel of finance and Canary Wharf would remain at the centre of this as an island of projected prosperity. In another speech marking the opening of Canary Wharf, Thatcher stated, 'We're doing it for those who live and work here now and for those who will live and work here in the future. We're doing it for Docklands.'[16] But this free-market revolution unarguably led to dramatically increasing inequality and the New Labour years did not reverse this tide, embracing as they did free-market reforms and further deregulation. The Millennium Dome facing the Isle of Dogs from across the Thames Reach embodies this continuity – an endorsement and emblem of the ideology they inherited.

A succession of City banks moved in, accompanied by a large chunk of Fleet Street's newspaper operations. The site's own story mirrors the boom and bust of finance as 1990s recession saw it in administration and taken over by Songbird Estates, a consortium including Morgan Stanley. As Lehman Brothers' staff left the bank's building in Canary Wharf with cardboard boxes after the investment bank filed for bankruptcy on 15 September 2008, the whole site was also in crisis, to be rescued by Qatar's and China's sovereign wealth funds.

Trickle-down economics did not reach those living in the run-down social housing in the shadow of these Manhattan-style skyscrapers. '"They trade their billions and I live here on £100 a week sick (benefit),"' said John, who lives in a flat just a few hundred metres from Canary Wharf.'[17] The story of Canary Wharf is a tale of two cities, as a 2018 BBC Radio 4 documentary by Jane Martinson, *The Long Shadow of Canary Wharf*,[18] attests to. Having grown up in council housing here in the 1980s, she returned to talk to those that

live, work and develop there, and discovered very different visions of the past and future, and a history that takes in racial tension, disillusion and protest. In a *Guardian* article about her journey, she describes the Isle of Dogs as 'a microcosm of the social revolution that has changed the face of Britain' where 'extremes of income inequality – from great wealth to desperate deprivation – have revealed social tensions that bedevil the country as a whole.'[19]

The Docklands Community Poster Project (DCPP) led by Peter Dunn and Dr Loraine Leeson in the 1980s articulated these concerns with posters stating: 'Big Money is Moving In: Don't let it push out local people,' and showing the towers as wads of cash and precarious piles of coins. A 'People's Armada' sailed on parliament – a flotilla of barges with a banner proclaiming: 'Docklands Fights Back. Homes. Jobs. Healthcare. Schools. Shops. Parks. For the People,' with a dragon depicting the shape of the river's bends. There was power in solidarity and wide-ranging collaboration between artists and arts organisations (Joint Docklands Action Group and DCPP), local people, local authorities and the GLC (Greater London Council), working in opposition to and soon to be abolished by the Conservative government. Artists and collective making were at the centre of cultural campaigning and an agenda of resistance. A 'People's Charter for the Docklands' was drawn up and distributed to politicians and a 'Peoples Plan'[20] movement addressed economic decline, providing instead detailed alternative plans for the area.[21]

Amid the complexities and controversies that beset large-scale regeneration projects there are always other stories and histories, counter to the one most told and distributed: a lineage and legacy of protests, victories and failures amid a history of erasure. Successes in infrastructure

and global investment cannot be denied, but structurally there is a colossal imbalance of power. The Docklands project was, like the banks, 'too big to fail', the rest was just collateral damage. As Rich Gerard, an ex-docker, said to Jane Martinson in her BBC Radio 4 documentary, 'In a way, the London Docklands Development Corporation was set up basically as a bunch of estate agents, so their major concern about people and communities isn't inbuilt into their structure.'[22] A concern about people and communities isn't inbuilt into the structure of our whole economic system.

Spectres of politics and place

The spectres of these glass and steel towers have haunted our works even before we consciously grasped their full meaning. When we first met, we quickly moved in together in a breeze-block artist's studio in Hackney Wick, an east London industrial zone in which artists occupied the plethora of former manufacturing sites. This was our territory. Then in 2005, as flag-waving crowds cheered the news that London had won the bid to host the Olympic Games, the mood and reality on the ground changed. A vast swatch of east London was designated a blank space on the map. The dominant narratives of development were built on the myth of Hackney Wick and the surrounding area being a 'wasteland'. Boris Johnson, then Mayor of London, described and designated this a nowhere place.

The bird's eye view from the towers afforded a vision of a fresh expanse of east London ripe for development by a new quango on the scene – again, 'too big to fail' and subject to massive debts and bailouts.[23] All the interviews with Sebastian Coe (Chairman of the London Organising Committee of the Olympic and Paralympic Games) high

up in the Canary Wharf HQ of the Olympic Delivery Authority position him as overlord of this eastern land. Like the angels in Wim Wenders' film *Wings of Desire* he has the privilege of an angelic viewpoint with none of the empathy and understanding.

The city is more complex than its aerial view, whether from WWII bomber or rising tower, and the first film we made together was a means of contesting those voices that claimed that the area set to become the London Olympic Park was a desolate no-place. 'The Games', made over two freezing weekends in February 2007, staged a DIY guerrilla Olympics amid the sites set to become the London 2012 Park. Hubcap discus was thrown over piles of rubble and a steeplechase ran through sites set for erasure – housing associations, travellers' sites, circus training spaces, allotments granted land in perpetuity but overruled by the powers of compulsory purchase orders.

Exiled athletes danced around a bonfire with the speculative rising towers of Stratford as backdrop and a podium ceremony took place on land where the past erupted in the form of buried radioactive waste from the Lea Valley's industrial past. At the heart of the film was a lone leotard-clad figure (aka Hilary) running through the night, swinging on football posts, leapfrogging street furniture, jumping from boulder to boulder as the towers of Canary Wharf glittered behind her. This was a swansong, celebration and mourning of a site about to be erased and reformed through Tabula Rasa urbanism. The lone figure could be seen as the 'Olympic spirit', an illusive, illuminating presence roaming a vanishing terrain. The towers of the Docklands became part of the cast, a symbol of the forces controlling the seismic transformations on the ground, in the communities we both passed through and lived in.

In July 2007 this swathe of east London was closed off. Our work continued as the areas surrounding the site were faced with the blank of hoardings and later electric fences as the city was reconfigured. We mixed other kinds of Olympic spirit (in the form of communally foraged sloe gin and elderflower fizz) in a project that took its name from a lost river that ran below the rising stadium, and treasured and charted the diminishing wild spaces. We brought other artists, activists and researchers together in person and on the pages of books,[24] insistent in a mission to make sure the multiple voices would not be erased with the land they had occupied, that challenged the consensual space of the Olympic development. Canary Wharf's towers reappeared as spectre in Hilary's 2014 pop-up book *Legend: An A-Z of the Lea Valley*, produced on a public production line on the edge of the Olympic Park. Within these tactile pages, that which was ignored or demolished erupted into the present amid a poetic miscellany of place names lost and found – a legend to challenge the myth-making, place-making activities of the regeneration agencies.

Ten years later, in 2017, these towers again loomed large – this time cast by Hilary as Valhalla or the seat of the gods in an epic, collaborative audio-visual Ring Cycle, inspired by Wagner's own opus. When Hilary was awarded a major creative development studio award pushing playfulness and risk in artistic practice, she followed the Royal Opera House workshops to Purfleet, displaced from the Olympic site out to this landscape where the City spits out its waste into the Essex/London hinterlands. The award was supported by Acme Studios, Henry Moore Foundation, High House Production Park and the family of Stephen Cripps, and it was set up in the memory of this 'pyrotechnic' artist who worked with the poetic potential of explosion and destruction.

Wagner's epic cycle is bursting with incest, dalliances and battles between gods and mortals, dwarfs and dragons. Stripping it back to its essential story, it is about greed for gold and its all-corrupting power.

Within this subverted interpretation, the M25 orbital road's Dartford Crossing became the rainbow bridge of Valhalla. Filmed from the river and its silt-filled shores, the Rhinemaidens that guarded the gold became Thamesmaidens and their siren song echoed across the Thames from the abandoned WWII concrete barges they reclined on. A 'Boom and Bust Sinfonia' was recruited from the Royal Opera House community choir and other local call-outs to play and sing the flotsam and jetsam from this sublime landscape marked by time, tide, trade and transport. Beyond the landfill sites, refineries, container docks and marshland a distant Canary Wharf is a constant presence and beacon on the horizon. It became a key leitmotif in this work – a modern-day, mortal Valhalla, symbol of capital and control, standing sentry and impacting on all that happens in this landscape of scrapyards, waste management and distribution. In this version of *Götterdämmerung* (Twilight of the Gods) a moonlit army of washed-up zombie bankers stagger towards the viewer, their faces and clothes smudged and covered in mud. Gods of finance, exiled from their dominion and dominance to a landscape of war and waste.

Derek Jarman said that the Docklands development represented, 'a deliberate act of erasure, an act of forgetting, it was as if time, and London's history had for all practical purposes ceased to exist. In pursuit of profit and instant gratification the past had become a foreign country.'[25] *The Last of England*, his 1987 free-verse, celluloid poem, was a disjointed waste

site story filmed amid the rubble of WWII and clearance of the Isle of Dogs, named after an 1855 Pre-Raphaelite painting by Ford Madox Brown depicting two emigrants leaving the shores of England for such a foreign country – Australia. In Jarman's version, emigrants/immigrants huddle under masked guard on what seems like the edge of the world. Sirens sound and time blurs as the ghost-barks of Queen Elizabeth I's hunting dogs roaming the Thames fuse with the harsh utterances of guard dogs. Jarman played with colonial and military history operating in the ruins of Empire, countering the Merchant Ivory, rose-tinted visions of colonial Britain and rupturing the heritage industry's neatly packaged version of history. In doing so, he was attacked, labelled unpatriotic and ideologically estranged from the 'brave new world'.

The Docklands towers that now dominate the London skyline had not yet risen in Jarman's film. Our sights were on the towers that rose after *The Last of England* – an enchanting mirage rising from the dirt. Amid the 'dark, satanic mills'[26] a second city had arisen, making visible the invisible architecture of finance and daring us to make a challenge. Jarman's narrator says, 'Tomorrow has been cancelled due to lack of interest.' His work contained a precarious balance of nihilism and hope where the very act of DIY making, communally, creatively, became the active hope as a character called Spring roams the rubble. Here we stood, three decades later, on a site marked by strikes, social movements, defeats and triumphs of making. The poppy was a key image in Jarman's film, staining apocalyptic skies blood red in an incendiary dream allegory. Now populated by buddleia, could this space flower briefly as a space of 'bread and roses'[27] where aesthetics and event and the poetry and politics of destruction came together?

Entering the stronghold

So why stage Big Bang 2 here, on a swathe of flat, rubble-strewn waste ground jutting out into the royal docks next to Millennium Mills and owned by London Development Authority?

This was a site with a clear view towards the ethereal towers of Docklands. This was our 'money shot' of the money-making mechanism – our chance to turn the power of this iconic skyline against itself with an iconoclastic act.

And aside from that, every good heist needs an explosion. This was to be our 'You're only supposed to blow the bloody doors off!' moment.

To begin with, it all seemed a little too easy. We had a possibility of 'daylight infiltration' and there was no undercover action required. Can we blow up a van for a film? Sure. We were met with an inkling of resistance from the owner of the Newham Film Location Company, who told us he used to work in the City and was an amateur photographer. He asked if filming the explosion was 'absolutely necessary' as he felt it was 'disrespectful'. Apart from this mild rebuke, there was almost no resistance. Layer after layer of bureaucracy fell away with eerie simplicity. We went through all possible procedures and gained all relevant permissions, contacting City airport, Excel, gaining NOTAMS (notice to airmen) for drone and explosion blast radius.

We did a brisk trade, selling bonds from our website, adding a countdown clock to intensify the drama. We travelled to a quarry in Somerset to work with the expert explosives team who had agreed to help us to do a test explosion. And then, a date clash turned everything around. Everyone involved, from location company to police, had neglected to realise our set date was the day of the London

Marathon. It was a blunder that changed everything. An email to change the date led to a further, more detailed probe into our credentials and a complete shutdown of our operations. Email exchanges and mental and logistical turmoil ensued. The kind of diligent interrogation we had been expecting from the off began. A month before the explosion was due to happen, we received an email on 5 April from the Metropolitan Police Service Film Unit informing us that our filming was on hold until we could explain the intent behind the film. The Met Film Unit only works with commercial films, not organisations that are planning demonstrations, and they said that they could see from our website that our film had a 'message' rather than a commercial purpose.

Returning to classic heist structure, this was where we entered the 'stronghold'. In film-script language this is the antagonistic force's static assets and would be the predictable obstacle between the crew and the target. This can come from a flaw in the plan or 'enemy interference' – the antagonistic force realising that something is happening and acting in response.

We hadn't needed to shimmy through lasers, break locks or monitor shift patterns for weeks on end but our own observations and intervention in the world of finance were now being observed by the antagonistic force that revealed itself as Canary Wharf Group PLC – a 'fully integrated private real estate company owned by Brookfield Property Partners and Qatar Investment Authority, among the world's largest commercial real estate companies and funds respectively.'[28]

When the locations company instructed us that we should alert them and ask their permission, we questioned this. We had permission to use this land – three miles away,

in a different borough, under other ownership. It was the first intimation of the not-so-hidden wishes for us to fail, to back down and not even try to do this – as Jez, our stalwart explosives expert, said, 'We're being seen off.'

Only we didn't want to be 'seen off'. Many said why don't you use a green screen? Do it in the quarry and add the backdrop in later. But this was not an option. It was an affront to our need to intervene in the layered space of the city: 'the scenographic compositions of space' and the 'spectacles of might'.[29] The towers were more than feats of civil engineering, they were symbol and part of the not-so-civil engineering of the imagination, their very image a 'self portrait of power'.[30]

Canary Wharf PLC's controlling influence stayed in the shadows, using the police to relay their abstract concerns, instilling fear into the locations company who, with often wilful lack of clarity and communication, added more and more bureaucratic and logistical hurdles through their fear of repercussions. We were told to take all traces of our bonds off the website, to refrain from social media, to take down the countdown clock. To go silent. In effect, we were defused.

The freedom from layers of bureaucracy the 1986 Big Bang had promised only applied to high finance; we were entangled in red tape intended to quash our plans. This was a critical moment in our film, our argument, our artwork and community and there were many defeats that happened, compromises that were enforced and succumbed to in order not to submit to the final compromise – its cancellation.

Who are they and why did they care about some artists doing something down the road? What were they scared of? Not the explosion itself. This couldn't have been 'safer'. The large piece of flat, stone-strewn land stretching out into

docks had been home to multiple film shoots from *Green Zone* to the *Man from U.N.C.L.E.* where gun fights, murder and arson were not questioned. On a site visit we dared not film undercover, the police officer in charge of the MPS film unit explicitly said that if we were *Mission Impossible* this would not be a problem. Our own mission was being made impossible because of our message.

All permissions were made null by the revelation that this could be a moment of meaning. This absurd delineation – a commercial film operation and something with a message immediately categorised as demonstration/protest – was revealing of a society mediated and defined by the market. We were engaged in an unprofitable, philosophical, existential debate about the meaning of life and art with a faceless corporation and its state henchmen. These were deep issues of a kind of deep state. But we couldn't afford to get too deep about it as we set about producing the evidence in an accepted language of commerce and connections. We proved our 'respectability' with the validation of fresh support from Doc Society and the British Film Institute, and a third-time-lucky Arts Council England decision; both had come through in the last couple of weeks, relayed to us by email as we travelled on the miniature railway in Dungeness, the bleak home of a nuclear power station and Derek Jarman's garden. A character in Jarman's *The Last of England* wears the pointed 'heretics hat' of the unbeliever. Did our action undermine the faith in dogma of high finance and brand us in turn heretics? The fact that we were found to be 'respectable' perhaps made our act all the more seditious. This message was not so easily relegated to the margins of stereotyped protester/activist. As is being seen around the world, people from all generations and backgrounds are uniting and rising up for economic justice.

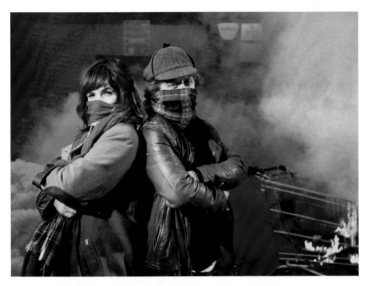

Portrait of Hilary and Dan 'Bank Job' style outside the back of Bank.
Photograph by Linden Nieto and Daniel Edelstyn.

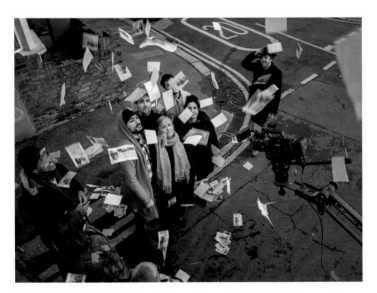

Finding money and community on the streets of Walthamstow in
east London. *Photograph by Peter Searle.*

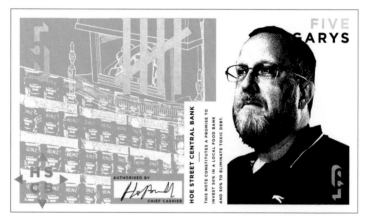

Hoe Street Central Bank (HSCB) banknote with Gary Nash of Eat or Heat food bank.

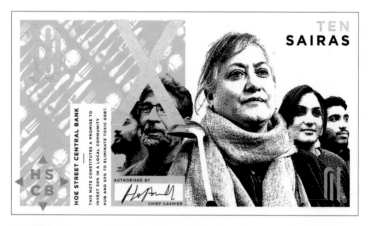

HSCB banknote with Saira Mir and family of community hub PL84U Al-Suffa.

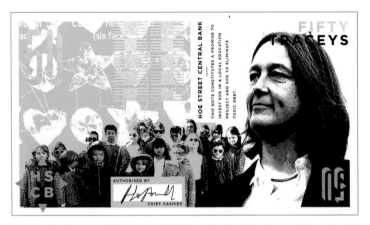

HSCB banknote with Tracey Griffiths, the headteacher of Barn Croft
Primary School.

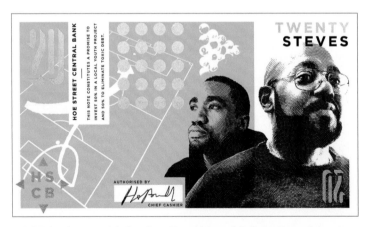

HSCB banknote with Stephen Barnabis and Josh Jardine of the
Soul Project youth service. Banknote design by Phil Seddon, Hilary
Powell and Daniel Edelstyn with photographs by Peter Searle and
Daniel Edelstyn.

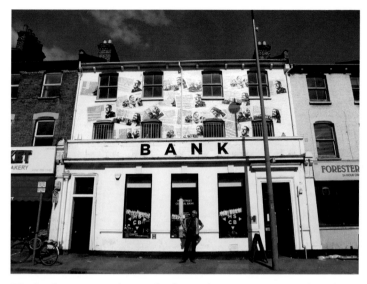

The banknotes pasted onto the front of Hoe Street Central Bank in Walthamstow. *Photograph by Daniel Edelstyn.*

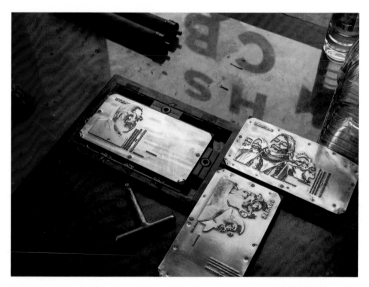

The letterpress plates used for printing our money in Hoe Street Central Bank. *Photograph by Peter Searle.*

Bank Job

Printmaker Spike Gascoigne of Walden Press amid the money drying in Hoe Street Central Bank. *Photograph by Daniel Edelstyn.*

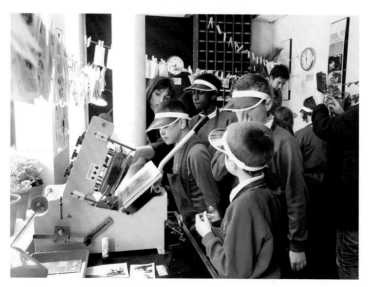

Barn Croft Primary School year 6 visit to do some money printing in Hoe Street Central Bank. *Photograph by Daniel Edelstyn.*

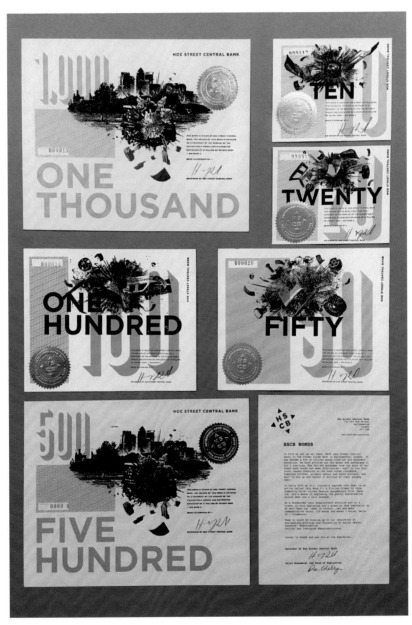

Hoe Street Central Bank issued bonds. *Photograph by Hilary Powell.*

Casting the coins from the remains of the 'debt in transit' van of Big Bang 2. *Photograph by Hilary Powell.*

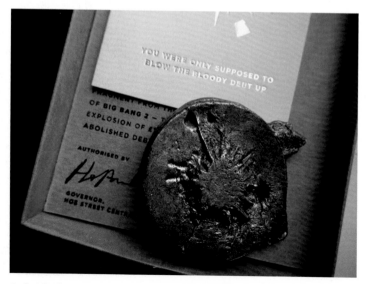

A finished coin made from the remnants of the Big Bang 2 debt explosion. *Photograph by Hilary Powell.*

Bank Job

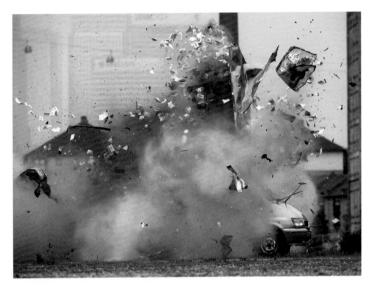

The 'debt in transit' van, filled with paper notes representing
£1.2 million of toxic debt, mid-explosion: Big Bang 2. *Photograph by
Graeme Truby.*

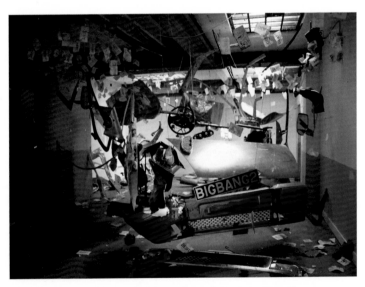

Suspending the aftermath of Big Bang 2 back in Hoe Street
Central Bank. *Photograph by Peter Searle.*

Big Bang 2

The decisive moment

In early May 2019, after weeks of intensive permissions, delicate negotiations and an inordinate amount of tortuous radio silence, we drove onto the site, the meeting's tension slightly deflected by a man taking a piss in the entrance way as everyone arrived. A group made up of locations company, Met police, London Development Authority, explosions team, Excel security and us made its way onto the site. The threat of the presence of the 'representative' from Canary Wharf PLC made them conspicuous in their absence, but perhaps they were all 'representatives'. On this decisive day, there was an awkward camaraderie of backslapping and hand shaking as we ran the diplomatic gauntlet, playing down the importance of siting the van exactly where we'd frame in Canary Wharf, talking in terms of blast, frag and sound radiuses and not the vision we pictured.

In this landscape of war and waste, the military credentials and bearing of the explosives experts gave the operation reassuring credibility and without their presence this would not have gone through. We could not be dismissed as artists mucking around with dynamite. They became the respectable face of the enterprise, helping in a language we were not part of – sharing an irreverent humour and impatience with bureaucracy over action and an awareness of the machinations happening around us and the tactics to use to counter this. Packing up the twisted wreckage of our test explosion they waved us off: 'there she goes with her "art"'. We don't know what made them say yes when Hilary sought them out through a call to the Institute of Explosives Engineers, but we are eternally thankful that we found them. It might have been just a job to them. To us it was a defining moment of our Bank Job.

We knew we were on dodgy terrain. If there was no identifiable problem with the explosion, what right did they have to shut us down? We also weren't so naive to realise that if they wanted to, they could. The UK has a specific defence to copyright infringement known as 'Freedom of panorama', meaning third parties are able to take photographs or make films incorporating buildings or works of artistic craftsmanship that are permanently situated in public places and can broadcast a visual image of these buildings to the public without permission from the copyright owner. So, we were legally free to film this 'incidental' skyline. More often than not when this skyline appears, it enforces the power of business, finance and the state in television series from *The Apprentice* to *Hunted*. Not a problem. Questioning the power of finance. More of a problem. Our friendly police officer intimated that we were foolish to imagine we had gone below the radar.

Attempting to prefigure other lines of bureaucratic attack, we couldn't be sure this murky 'they' wouldn't try defamation or some kind of brand copyright – essentially looking for anything to disempower us. Buildings like the Gherkin even have a copyright on their shape. We were not new to such looming legal intimidation and the threat of the shutdown of physical and intellectual space, and Hilary once again yearned for the time to do a law conversion course so as to be armed with the specific knowledge to fight back.

Our work around the Olympic site had been a guerrilla occupation, seizing moments within the land- and power-grab underway. We operated in a space in time before security and surveillance invaded the site. Later we received phone calls from lawyers over-enforcing brand protections 'on behalf of their sponsors' as we were apparently 'profiting by association' by calling our no-budget artists' film *The*

Games and our spoof/real beverages company 'Olympic Spirit'. In the case of the Olympics and the consensus it sought, the boundaries of the site and event extended to the words that could and could not be used in combination – cordoned off from use. This policing of language itself led to parody, from writer Alistair Sidden's mimicking of the vocabulary of brand protection in *The Art of Dissent* to the Space Hijackers' billboard filled with all the words banned in their combination: '2012, London, Olympics, Two Thousand and Twelve, Summer Games, Twenty Twelve...'[31] When the same group also parodied the 2012 logo in a spoof 'Official Protesters of the London 2012 Olympic Games' website, the official London Organising Committee of the Olympic and Paralympic Games (LOCOG) prompted Twitter to shut them down, with the Index on Censorship (IOC) stating: 'One can only conclude that this is an act of petty, vindictive censorship, hardly in the spirit of plurality and inclusiveness the Olympics is supposed to promote.'[32]

Far from 'disappearing' the action, this act of censorship only made it more visible, with the Space Hijackers reporting:

Visits to our official protest site went through the roof and we saw dozens of Twitter users change their avatar to our anarchist-coloured version of the Olympic logo in support. Eventually after tense negotiations, Twitter allowed us access to our account again, along with the hundreds of new followers that we had gained. We would like to thank LOCOG and the IOC for this official recognition and look forward to working with them to facilitate further protest in the future.[33]

The pursuit of artists often backfires in this manner making the pursuer ridiculous, amplifying the message they intended to suppress and highlighting the shape-shifting

power of cultural action and actors. Though we may have lived through the disillusionment of marches changing nothing, our early days filming with the Space Hijackers for our first series of short films for Channel 4 (*3 Minute Wonders*) instilled in us the potential of creative disobedience. From inflatable pebble stones to dwarf hats and umbrellas, the agile material objects and tactics of social movements can turn power relations temporarily on their head. Riot shields made to look like books or covered in the faces of migrant children set upon by police batons make visible and terrible just what it is they are attacking – freedom of speech, knowledge, lives.[34]

In July 1986 representatives of the world's finance industry gathered to watch the governor of the Bank of England turn the first sod of earth to mark the beginning of the construction of Canary Wharf. The Association of Island Communities released thousands of bees and a flock of sheep. As a protest it did not succeed in halting the rise of the towers but this vision lives on in the imagination of the site and such vivid images invade our collective consciousness. Perhaps it was this disruption of the opaque image of Docklands these antagonistic forces were attempting to shut down – the power of an image to unleash past struggles, further provoke ruptures, even intimations of the decline of the site's power and an implicit acknowledgement of the fragility of its own dream.

This whole space was a ground zero, built on the violence of Empire and political struggle. The faceless bureaucrats attempting to impede our plans were very aware of what this iconic skyline stood for and how it could be 'detourned', visually subverted into something else.[35] The fight to go ahead was a fight to control the uncontrollable – the visual

arena of the city open to intervention and interpretation where its power as a symbol could be used against itself. The explosion they feared was a social media 'bomb', where a seditious message could emanate and be multiplied and amplified. Our Big Bang 2 was a symbolic shattering of the ideology that built it, creating a changing picture in slow motion in front of this vast financial mirage, the process of doing it exposing the precarity of power, control and freedom and censorship in its insidious forms.

Up until the final hour we were on edge. The intense preparations were made more so by the possibility that this could all be futile. In the unnerving and oppressive heat of early May, Linden, the enthusiastic and skilled young skateboarding cinematographer we were training and employing, helped us to flyer the 2,000 nearby flats to let them know that at 9am on Sunday 19 May there would be a loud bang. It was a ghost town. We walked with the children and looked out on the Thames Barrier civil infrastructure protection that carries in its very image the dystopian vision of future flood.

Back in Walthamstow, the bank became an operations hub, housing maps and diagrams of our explosive plans as we coordinated a team of specialist slow-motion camera operators, drone operators, runners, second camera crew, third camera crew... We checked and double-checked again all permissions and protocol, awoke from nightmares that someone would get hurt. We organised paramedics, ticked all the boxes the locations company shoved our way and still we were insecure.

Linden and Hilary drove through the dark to generous friends in Norfolk to collect the decontaminated Ford Transit that would become our 'debt in transit' van. Up early

with the cockerels to begin jet washing, gold spray painting, stencilling – pimping up a Ford Transit until it was ready for its sacrifice. We checked the weather forecast every two minutes for the dreaded shroud of fog that could descend so quickly on the city – the haze of a modern-day 'peasouper' that threatened to obscure both building and meaning.

We drove to the site in the early hours of Sunday morning. One by one, crew members arrived using the language of military precision – o six hundred hours. After the fear of god had been placed in us in the run up to the day, the actual reality of it was surprisingly relaxed. The police officers we had been ordered to employ enjoyed a coffee as crew and paramedics checked out their motorbikes. All of the conditions that had been placed on us were unnecessary. The audience of 'up to 100', pushed up from 'up to 30', with much toing and froing were safely confined to an island site underneath Connaught Bridge – a parcel of land with different ownership and a distant view of the van. There would be no children, no TV broadcasts, no advertising of the time and place of this event to anyone outside the invited bondholders.

On the day, the prison of these rules receded – outside of the danger zone of the explosion itself this Sunday gathering had a jaunty, relaxed air. People strolled onto the site, chatting and sharing in the rapidly dwindling supply of morning coffee and croissants. It was indeed misty – an 'act of god' intervening on behalf of big capital – but as we prepped and positioned cameras it lifted just enough to make a viable shot. Our golden van was rolled into its special spot. The 'bomb' was placed. This was a water bomb developed for use in anti-terror operations where the speed of the water is faster than the electrical discharge of the device. The explosives team placed the 'debts' on the 'debt' – stacks of

hand-stamped paper notes stating 'this note represents £200 of £1.2 million of exploded debt' and we made our way outside of the frag zone.

<div align="center">

3 2 1 and

</div>

<div align="center">

FIRING

</div>

The slow-motion camera operator said he'd never been so anxious at a shoot. There was no leeway for the eight seconds of footage that this advanced high-speed Phantom camera could capture. It was a gathering and a gift. We were shocked that some people travelled miles to share in the moment and bear witness. In the wreckage of Big Bang 2, some were weeping. We just felt relief and exhaustion. No one had been hurt and no one had stopped us. We had gotten away with it. Up to a point. The pressures imposed on us had succeeded in ensuring that this was not the press spectacle piercing the public narrative we had aimed for. But the explosion was 'in the can' with more opportunities for continuing its dissemination. The dramatic tension of the countdown clock was taken away. Our enforced lack of communication also alienated loyal supporters of the project who could not attend. Every person who came onto that site was fought for and in the end, only reluctantly permitted.

The audience drifted back from their exile and surrounded the skeletal remains of the van in an ad-hoc ritual circle, taking multiple pictures and picking up the scattered papers. After testing with only a wad of A4 printer paper, they had worked a treat fluttering towards earth in a slow-motion cloud. We were enveloped in a strange and cathartic peace. As we stayed on site mapping and clearing up the minutiae of

the aftermath of the explosion, the planes began flying again overhead, taking off from the adjacent City Airport with deafening force. It was business as usual after this anarchic interlude. Frazzled from anxiety and sleep deprivation, it felt like a beginning, not a grand finale.

Ironically the doors were the only thing that hadn't blown off.

Creative destruction

Our act of creative destruction countered David Harvey's idea of creative destruction[36] espoused as a central tenet of free-market economic thought and action – the breaking down of prior institutional frameworks and powers, labour and land relations, welfare, ways of life and thought, and prioritising the contractual relations of the marketplace. If this involved the management and manipulation and even the making of crises, we would choreograph our own crisis of material and meaning. We would try to make visible and visceral our understanding of the seismic occurrence of the 1986 Big Bang and its impacts by creating our own reverberating blast waves. As our explosives team laid the 'debts' we, in turn, enacted and wanted to prompt an explosion of thought, an illuminating, constructive moment emerging from this debtonation where all that is solid melts into air… Or… Explodes into fragments.

In hacking the skyline of power and refusing to be awed into subservience by these 'spectacles of might', Big Bang 2 was our moment of erosion and questioning. It became more than a making visual of the spreadsheets of debt cancellation and became a debtonation in our heads, appealing to a sense of freedom and new possibilities of being and

doing – of beginning again. Our Big Bang 2 was a chance to cut through words with action, to allow controlled explosives to do the talking and the image of something blowing up in front of a symbol of financial power to hold in our collective memories. Complete with bugle fanfare it was a howl and a clarion call.

The words of the artist Robert Smithson resonate: 'There is no escape from the physical nor is there any escape from the mind. The two are in a constant collision course. You might say my work is like an artistic disaster. It is a quiet catastrophe of mind and matter'.[37] The run up to the explosion certainly felt like a quiet catastrophe. Now, we worked on hands and knees in our salvage operation, picking up the fragments of this artistic disaster zone and putting them back together in new constellations.

Back in the bank we had been working hard for the arrival of the ritual remnants. Linden, George and Hilary set to work hanging the van in new formation. It was time to fulfil the promise laid out on our bond certificates and distribute the pieces of the explosion to our bondholders. We had possibly/ certainly underestimated the work this would entail and we sped towards opening up the bank (with the K now replaced by a G) once again to the public in time for the local E17 Art Trail and ARTNIGHT. We would create souvenirs of this moment, collectable artefacts of an era, inspired by the proliferation of fragments of the Berlin Wall with questionable concrete lineage and the audacious canned 'last breath of communism' marketed and sold to mark its fall.

We would perform a kind of alchemy where gold-painted van parts picked from the dirt of Silvertown were transformed into something of new value and meaning. Our precious metals were the steel of the transit van body panels and the

aluminium engine parts to be cut and stamped, cast and packaged for distribution. Our research process had taken us into the Royal Mint in Wales, through the Bank of England Museum archives and again, we looked to Walthamstow's history and the presence of the nearby Coppermill, which in the early 1800s produced coinage tokens or the 'Waltham-stow penny' at a time when communities around the country produced low-value coins for everyday goods in response to a severe shortage of currency produced by the government.

We began making HSCB coins, again enlisting the help of experts in each of the new processes needed for this phase of production. Rob Fawcett from nearby Blackhorse Workshop helped us set up our eBay-acquired flypress that needed six big men and an engine hoist to get into the bank. Giles Corby and Drew Cole from London Sculpture Workshop took charge of our hot metal works, melting down aluminium to create an unsophisticated but beautiful form of heavy money. Like the banknotes, the bonds and their associated fragments have made their way into national museums. They are part of the 'Currencies of War and Dissent' collection at the Fitzwilliam Museum in Cambridge. In the words of Assistant Keeper of Coins and Medals Richard Kelleher: 'As a mass-produced medium money was (and is) a powerful vehicle for disseminating the message of the issuer to the consumer, especially in response to stressful events. However, money was also subverted or mutilated as an act of defiance.' They have also found a place in the British Museum's Department of Coins and Medals, 'Home to one of the world's finest numismatic collections.' There is a sense of wonder in picturing these bits of an explosion sheltering alongside Roman coins of gold, Renaissance medals, Ming dynasty currency and Viking hoards discovered by metal detectorists. This was our Walthamstow Hoard. The hidden

histories and treasure we cherished and made from everyday, extraordinary events and collaborations.

The coins, bonds and notes were not collected and assigned value and beauty solely as aesthetic objects. There was recognition that together, as action, event, art making, movement and message they were part of something bigger than its parts where poetics and politics combined with strange force.

Before embarking on the Bank Job, Hilary had been busy making portraits of the last coal miners of South Wales printed with coal dust. Working in a specialist west London studio she was divided from the team of workers required to sprinkle the magic diamond dust onto the works of Damien Hirst that was being manufactured in the same place. They were using the same raw material, carbon, but with wildly different meaning and value.

The absurdity of the divergent value systems begins to make sense when you discover that in the era when financial industries were deregulated, the press monopolised and landgrabs legitimised in the service of finance, the London Docklands Development Corporation was co-sponsor of *Freeze*, the exhibition that defined the art world we emerged into and a freeze-frame of a moment where values of the market would rule. So much so that Damien Hirst's diamond-encrusted skull (*For the Love of God*) become a symbol on the placards of the Occupy movement with the simple heading 'The 1%.'

Art as object to be consumed or art as transformative power? Art as an asset class or 'SWAG' (silver, wine, art and gold) or art as liberation? Only a few weeks ago, we took a virtual tour through the 'art' or act of imagination that is the Museum of Neoliberalism. Created by artist Darren Cullen

with curator Gavin Grindon, this small museum exists in a high-street shopping centre due for demolition in a far-flung corner of Lewisham in south London. From a bottle of Amazon employee's urine to copies of *Teen Boss* magazine and a 'who's who' of this economic doctrine, the space is packed full of the revealing ephemera of an ideology that has pervaded our lives. As the world around us changes fast, the very act of calling it a museum consigns its contents to history as the quaint artefacts of a bygone era, added to the piled wreckage of failed ideologies. And from this wreckage, of a van, of an economic system, comes a chance to imagine better.

CHAPTER 5

Exploded Views

*F*rom printing money to exploding vans, what began in curiosity led to a transformation on multiple scales of our own practice and purpose, of an understanding of the stories and systems that control us and of ways we can change these.

Here we present exploded views – of both the project and the financial system. Seeing both drawn out in their fragments, analysing and putting them back together with their parts recycled, reused, discarded and assembled in new constellations. Pictures are not the only thing in an artist's arsenal. With imagination, storytelling and strategy we can influence and redraw the world, if only we can break through another powerful and intertwined economic story – the one told about an artist's value and power, either confined to market rate or consigned to the margins.

The debt explosion may be freeze-framed in memory and exhibited in suspended animation but we move on. From the workings of our Bank Job, amid the diagrams and schedules,

imagery and voices, mistakes and method, emerges a kind of manifesto. In conclusion: this is the beginning.

An exploded view is a diagram, picture, schematic or technical drawing of an object that shows the relationship or order of assembly of its various parts. In our own Big Bang our views were certainly exploded and our exploded diagram is not perfect. We have drawn it out intuitively as a work in progress and this book represents a vision of these fragments in suspended animation – a snapshot of where we've been and where we are at this erupting moment. We have grappled towards understanding the financial system that surrounds us and permeates our imaginations, and we have done our best to redraw our personal relationship to it, asking questions on behalf of ourselves, our children and our communities. We never claimed to stand above the system and, ultimately, we're all immersed in it.

Mechanics and engineers often reminisce about how they used to take everything apart as children to see how it all worked and then put it all back together again – sometimes in new configurations. Such a desire is basic to inquisitive human nature if allowed to run its course free from the impediments of religious or economic dogmas. The concept of the exploded diagram is useful in highlighting the faults that have brought this engine to the point of seizure, but also in putting forward solutions to solve our over-indebted reality.

We have set in motion a personal process of stripping away at the engine of our economy, and it became clear that what we were told was a simplified and manipulated moral story needing a much clearer diagram to fully understand it. Old notions of debtors as sinners and rogues fell away, and what emerged was a darker, more dystopian picture of democracies under attack, where the powerful feed off the

weak while telling them they owe them. People were already dying as a result of this fabricated story – dying because of austerity, dying because of high personal debt. A system underpinned by media stories that distort the truth in order to up the pace of the attack and without enough people noticing for a fight back to actually occur.

This exploded view is projected throughout the territory we all have to traverse. We have made our way inside its diagrammatic form like some comedy spoof thriller, awkwardly cartwheeling over and around its laser lines, getting singed and shimmying under its beams. Agility is required to navigate and expose the 'spiders web', the 'invisible hands' of the market, the complex fiction of it all internalised in our imaginations.

Now/then

In the classic heist story structure we've played around with, there would be 'the escape'. For Peter Derk it is 'most often neglected because it's the hardest to pull off, but it's what separates the smash and grab from the true heist tale.' He goes on to say that the key to a good heist is to 'give your escape a little more time, just 10 percent more than you think you need. I spent an entire story with these characters, which means I care about what happens to them after the dust settles.'[1] Do we want to give it a little more time? Could we escape, even if we wanted to? Will the dust ever settle? Is the Bank Job even over yet? We can never go back to where we began and now, even as we attempt an ending of sorts, the earth has shifted beneath us and we reorientate ourselves to face the future.

When we imagined an exploded view, exploding our 'debt in transit' van and suspending its parts back in the bank,

we did not imagine the speed at which the debtonation of established economic norms would happen. We had hoped our action and the way we shared it could play a part in a push towards a just system, to work with campaign groups to challenge accepted arguments and create the public pressure for a national debt jubilee. Now it feels like the whole world is blown asunder. We are living in this exploded view, analysing and reconfiguring the broken pieces, seeing the costs played out on those that fall through the gaps in a system improbably suspended on tiny threads.

This view also exposes our profound connections and the fragility of these interconnected lives – an idea so offensive to governments and corporations who believe themselves invincible masters of the universe. The Overton window (the range of policies governments and the public are willing to accept) had already been shifting slowly but significantly. Now, it has been blasted out and the light is shining so brightly in amid the ruined frame and rubble that it is both illuminating everything and casting ominous dark shadows. There are no longer any curtains to close and the task and responsibility is to sift, sort, jettison and rebuild the world in new formation.

Our now will soon be the past. In the period of writing this book between December 2019 and April 2020 the Conservative government came to power. The year 2020 began with the world on fire. Large swathes of the UK were underwater. Satirical cartoons now show people turning on the news and saying, 'God, I miss Brexit,' as the coronavirus pandemic sweeps the world. We have no idea what will happen in the time between finishing this manuscript and our film and when they greet the world in whatever form is possible. All we know is uncertainty. Even writing this is an act of faith as we live in limbo. In truth, as we count down the days of lockdown the writing has been abandoned,

we are just about managing diary entries to keep track of whirling times and minds. We are living in the centre of a dying system, dealing with the grief and hope this entails.

It felt like there was no point in writing as the ground was shifting so fast it was impossible to capture anything. Only now, on day 30, as we put one word after another and sift through the mountain of thoughts, the racing Twitter feeds and piled-up opinion pieces do we slowly move to action. The urgency of the situation led to a breathless paralysis, the prospect and need for a global jubilee so achingly current we could not find a way to ensure we could contribute to this. Hovering outside ourselves, looking on at our lives locked down in a terraced street in London, struggling with children at home, focusing on making sure they are nurtured and held amid the constant calls for some kind of quarantine super-productivity, the financial issues and rage at the government and its fawning press/PR wing, we now take a deep breath as all around us death counts rise.

The virus has made absolutely clear the prevalence of 'bullshit jobs' and highlighted the truth that the people who are valued and paid less in our society are the essential workers. Far from being the great equaliser, it has revealed the vast, existing societal schisms as the vulnerable suffer and sacrifice the most. This inequality plays out in every aspect of the crisis from access to public space, land and property ownership, employment, and in Britain lays bare the erosion of the welfare state for all to see.

One of the key architects of neoliberalism, Milton Friedman, stated: 'Only a crisis – actual or perceived – produces real change. When that crisis occurs, the actions that are taken depend on the ideas that are lying around.'[2] Neoliberalism succeeded in being placed where it was picked up to become the dominant ideology. Now we must make sure that the

ideas lying around, tripped over and unavoidable are those that lead to an equitable future.

Clearing out the shed to make a space to write this, our daughter discovered an old, portable AM/FM radio and wandered the house modulating radio signals, picking up fragments of song and voice, tuning in to the gaps. I tried to explain the wonder of this – that amid the invisible frequencies that surround us are those of the reverberating explosions of dying stars, echoes transmitted through the universe alongside distant lightning storms and a history of pirate radio, rebellious voices and secret codes. In this period that has been called the 'great pause' or the 'reset', the coronavirus has even quietened the Earth itself, allowing seismologists to listen to its other, deeper soundings. This is a moment to tune in to this chance to define our future, to listen to the ignored voices, to hear, sound out and amplify the urgent calls for change. And if the airwaves right now are too full of the excuses and gas-lighting of the powerful exploiting and clinging to power, the challenge is to be inventive and agile in intervening in these dominant debates, opening up new channels of communication both local and global.

In early March 2020, the new chancellor of the exchequer (predictably a former Oxbridge philosophy, politics and economics student, ex-hedge fund manager) delivered a new budget. Then another. Then another. Meanwhile 'crash Monday' kept on crashing and the FTSE and Dow came tumbling down. As Jeremy Corbyn stands down as leader of the UK Labour party, whatever their many foes may claim, four years of a Corbyn/McDonnell-led opposition has destroyed consent for austerity and re-legitimised Keynes and the economic steps now being taken that were previously labelled Marxist and revolutionary. The *Daily Mail* response to the

Labour party's spending plan was 'Corbyn Plan to Bankrupt Britain', its response to similar figures from the Conservative government was 'Dr Feelgood to the Rescue'. All these years, the iconic red budget briefcase delivered a verdict that we had to cut costs, but suddenly, somehow, instead of war, we could afford to house the homeless. Suddenly there is such a thing as society it seems – but only temporarily, in crisis management.

At the time of writing, the UK government's action to protect its citizens has been woefully inadequate, or rather, wilfully negligent, continuing to put profit before people. There is a timeline of failure at every level and the costs are great. The pandemic lays bare the rampant inequality of precarious workers with no recourse to savings versus the fact that bunker sales are rocketing amid the super rich. In economic terms the measures taken do not go nearly far enough as millions of people and small businesses are in immediate, catastrophic financial jeopardy. Across the world, things before dismissed as 'unthinkable' are being proposed and implemented – measures for exceptional times that could, should, be the norm, from paid sick days, universal basic income stimulus, mortgage moratoriums, rent control, homes guarantee, pausing or cancelling collection on student loans.

Positive Money's campaign for the People's Quantitative Easing or 'helicopter money', where government sends money direct to everyone's personal bank account, similar to a universal basic income, so everyone gets this cash (unlike quantitative easing, where only banks do) is now being discussed in articles in the *Times* that say its time has come. In Italy mortgage payments and rents have been suspended, France has suspended utility bills and rent for small businesses. The Pope used his Easter address to advocate a universal basic income. Meanwhile in Spain this has already been implemented, not only as crisis management but as a way ahead.

The critical question now is who gets bailed out? People and planet or the failing old system of finance and billionaires? Richard Branson or citizens one pay-cheque away from destitution? The answer seems so obviously simple and yet, across the world many still reject and disbelieve in the possibility of a just system and direct their vitriol at those who advocate for it rather than those who impose the cruelty of reigning inequality onto them. The 2008 financial crisis should have been a reset, but it went the wrong way – the '1%' consolidated rather than lost their power and ushered in the crippling lie of austerity. In the UK there are already the dangerous murmuring warnings that the measures taken will have to be paid for from somewhere, implying further brutal rounds of such austerity. TINA ('there is no alternative') is dead but our zombie economics still won't accept it.

A rewriting of history is already taking place, denying and deleting the years of underfunding of the NHS and the dismantling of a welfare state that cannot be put back together fast enough. These are the narratives that will attempt a resurgence – a wholesale marketing campaign lulling populations craving 'normality' back into a normal that wasn't working. Debt was already at crisis point, inequality rampant and many are alert to the revelation that the economics we are taught to accept as an immutable force are in fact ideological arguments formed by political decisions.

As governments are forced to take measures of care for their populations, who benefits from and who pays for these interventions? It is imperative to follow the money, to recognise that the social contract is not something to get us through a crisis only to abandon at the other side. There is no other side of this, the world was already in crisis, crying out for the kind of radical, sensible steps required to address the exploitative

model killing the Earth and its inhabitants. The coronavirus reveals something worth fighting for – that the status quo was a lie – and more people are waking up to establish a fairer more meaningful reality. If economic orthodoxy has been ditched now it can be ditched for good. The World Health Organisation states, 'For things to remain the same, everything must change,' talking about the significant, even revolutionary, behavioural shifts required to live in a world where the virus is not just going away. They talk of the resilience required for living with uncertainty. Life is uncertain. There is no going back to normal – we need to adapt to a new world where shared humanity could and should take centre stage. As human beings and societies we can adapt in order to face down serious threats to our existence with speed and agility. It is remarkable and hopeful. Crisis has to empower us further to demand change. To not remain the same.

Knowledge is power

Central to our Bank Job is the idea that 'knowledge is power' and this knowledge is learnt and communicated in many forms. The Bank Job has been an exercise in creative destruction, of outmoded ways of thinking being questioned and shattered in order to reconstruct considered new strategies and tactics of being.

And the challenge is great as the very infrastructure of shared knowledge and collective education is under attack – from compromised media outlets to fake news, from the closure of libraries and community education to the assault on schools and universities through cuts, tuition fees and debt. Britain has closed more than 800 libraries in the last 10 years (up to a fifth of UK libraries). Libraries and in turn

the books they hold are gifts a society gives to its seekers of truth and wisdom. Books have formed us, harbouring stories of the triumph of the underdog, exposing injustice, teaching morality and questioning authority, allowing us to rebel against the assertion of Harry Wormwood in Roald Dahl's *Matilda*: 'I'm big and you're small and there's nothing you can do about it.' It is the reason why books have often been the target of extreme censorship. Hitler oversaw the burning of the authors who set our minds alight, from H.G.Wells to Kafka and Walter Benjamin, in an act of control and violent repression that was mirrored in the dystopian fiction of Ray Bradbury's 1953 *Fahrenheit 451* (the temperature at which book paper catches fire) and Orwell's *1984* where books are consumed by flames in a 'memory hole'. Books may not be being burned but the closure of libraries, the limiting of access to education through debt and narrowing of curriculum have all been part of the suppression of dissenting ideas for change.

Within our bank we set up an ever-expanding 'knowledge bank' sharing a collection of books we were building that informed and sparked the project from David Graeber and Andrew Ross to John Berger and Naomi Klein. Authors coming to the bank for book launches kindly added to this growing library from Andrew Simms and David Boyle's *Economics: A Crash Course* to Max Haiven's *Art After Money, Money After Art: Creative Strategies Against Financialisation* and Oli Mould's *Against Creativity*. Events in the bank supported this core aim of economic education. A recent visit to the MayDay Rooms in central London, an archive, resource and safe haven for social movements, experimental and marginal cultures and their histories, amplified to us the importance of a space in the city to nurture an active knowledge. After losing the bank, it came out of a wish to take students on a journey through similar spaces of knowledge and action.

The hunt was more difficult than we imagined it would be and finding spaces where the critical imagination was welcomed and encouraged is not easy. The Bank Job is currently nomadic, so this now extends to ways of sharing information and community via Hoe Street Central Bank of Ideas, an online space where we can evolve, change and gather members who share our desire for a change in discourse and therefore a shift in reality – something that becomes all the more relevant at a time when we find forms of social solidarity through physical distancing. Now, as we are separated physically, we find ways of joining together, harnessing such collective energy to make sure the power flowing from our current connections can be system changing.

Through the Bank Job we have met many others working towards this goal. The RSA's (Royal Society for the encouragement of Arts, Manufactures and Commerce) Citizens' Economic Council was a programme designed to give citizens a say on national economic policy with a prospectus slogan 'Economics for Everyone'. They recognised that the economy is something the public feel they have little agency in. Ecnmy.org (tagline: 'Live it. Discuss it. Shape it.') is running economy crash courses in the community aimed at empowering participants. The language around these very worthwhile programmes is purposefully non-partisan and 'neutral' but education is not neutral. It is deeply political and acting as if it isn't seems absurd to us. Education is also not propaganda – it is about providing the tools to develop a critical intellect, to question and not accept established narratives at face value, to analyse and come to informed decisions and conclusions. It is about independent thinking and considered research. Above all it is about freedom: 'The freedom to say that two plus two make four. If that is granted, all else follows.'[3]

Economist Ha-Joon Chang explains, economics is a fundamentally political and moral subject.[4] It is time for a PPE (philosophy, politics and economics) for the people as we all embark on a very real crash course where the hypothetical becomes lived experience of collapse. When the founding members of Rethinking Economics (an international network of students, academics and professionals building a better economics in society and the classroom) began studying economics in 2011, the biggest economic crisis of the times was not even mentioned. Nothing to see here. In the book that sparked the movement *The Econocracy*,[5] the authors write, 'The people who are entrusted to run our economy are in almost no way taught to think about it critically.' Recognising that the classical economics being taught across the world was not fit for purpose, they set to work reforming the curriculum to ensure a spectrum of economic ideas rather than one dominant paradigm. As they emerge 're-teaching economics', they become a new generation of teachers empowering further rethinking and reassessing in what is ultimately an exercise of and defence of democracy – who is allowed a voice and who is silenced? What theories and policies are considered set in stone and which get you labelled as economically illiterate for daring to challenge narrow orthodoxy? If those embarking on economics degrees struggle to get an economic education, it is time to rethink education itself – and to think in systems and connections, across siloed subjects and departments, to value expertise and build collaborations across arts, humanities, social sciences and science, opening minds and communications to an interdisciplinary imagination.

Our own adult minds were formed by access to free university education. Maintenance grants and no student fees

enabled social and intellectual mobility. Higher education was a social good guaranteed by the state and an investment in the economy, not only for the highly skilled and knowledgeable workforce it would produce but because academia and learning had their own value. Higher education shouldn't be a privilege to be paid for and spend a lifetime in debt for. The subjects we chose – fine art, history and French – are not a 'useless' luxury and their value is not defined by employability and narrow use function. As the International Covenant on Economic Social and Cultural Rights (ICESCR) has stated, 'Education is both a human right in itself and an indispensable means of realising other human rights.' Education is power. A well-educated mind is powerful and therefore dangerous. The conditions imposed on gaining higher education now are conditions of control and oppression via debt. Conditions where a degree is an asset to be bought and traded are not those in which a free and critical intellect can easily be cultivated. This is a financialisation and commodification of education and the mind.

In this period of writing and as Hilary was running a new course on the MA in Visual Communications at the Royal College of Art, sustained strike action has taken place across UK universities and arts institutions. The posters on the picket lines and in the doors ask, 'Students, where are your fees going?' Casualised chaos. There has been great solidarity on the picket lines between students and secure and casual/precariously employed tutors alongside the tensions of students as customers paying a high price to study at elite, neoliberal institutions/service providers. As Chomsky says, 'When you trap people in a system of debt, they can't afford the time to think. Tuition fee increases are a "disciplinary technique" and by the time students graduate, they are not only loaded with debt, but have also internalized the

"disciplinarian culture". This makes them efficient components of the consumer economy."[6]

And yet all the time there is resistance to this as people recognise their power. Debt Collective's student debt strike has put student debt cancellation and free college on the national agenda in the US. Student Rent Strikes in the UK have previously been successful and are now spreading fast in the wake of the coronavirus. Current pleas for fee refunds due to ongoing disruptions are leading to more urgent calls on the government to write off student loan debt as a 'goodwill' gesture, most potently for student nurses, alongside pressure to scrap student fees altogether. As universities struggle, other forms of education adapt with more agility and speed evident as Antiuniversity Now[7] launches its seventh year as a collaborative experiment in autonomous radical learning. Amid the chaos of strikes and spreading virus, students from Lebanon, Hong Kong, China and India, aware of protest and censorship happening in their countries, set to work building a Google extension to reach outside their 'bubble'. There was an acute awareness of the way in which information reaches us and a desire to be connected to social movements happening elsewhere.

As an independent feature documentary film, book, social media/membership site, collaborative art project and participatory movement, Bank Job is part of a growing ecosystem of alternative voices and media operations aiming to counter and pierce the overriding economic narratives perpetuated in the press and public. But words like 'alternative' and 'marginal' also preempt their marginalisation, making them easily sidelined and dismissed, and the challenge is to smuggle these seemingly dissident though highly common-sense ideas into mainstream debate and collective imagination.[8] As Gramsci noted, culture is a key site of political and social struggle. We see it co-opted and used to uphold the status quo or denigrated

by labels – 'local', 'community', 'activist' – dismissing its reach. And then we see its power. The tagline of the Media Reform Coalition is: 'Know the media, be the media, change the media.' Apply this to culture and to economics and the way it is communicated. Educate, create and make, transform.

Debt and freedom

To talk about debt is to talk about freedom. Debt and democracy, debt and the imagination are inextricably bound. People declare themselves 'debt free' as a mark of honour and often in a way that dismisses those living in the 'debt trap'. In reality, from nation states to individuals, none of us are debt free. Even if not personally in default (and those people are fewer than you think considering mortgages, credit cards, student loans, overdrafts…) the default position is internalised propaganda disguising hypocrisy and injustice. The psychological impacts of being in debt are well known and lifting the humiliation and stigma is critical, but there is also a wider psychology to tackle – to prompt a move beyond sympathy, even empathy for 'poor people' in debt, to a recognition and awakening that we do indeed live in a creditocracy, and that we can change a system that relies on our private shame and collective consent. As Dr Johnna Montgomerie states: 'You may not have debt, but you live in a debt economy that is wholly dependent on other people's debt. And the minute those people cannot take out any more debt or cannot service their loans, you're stuck in the same financial crisis they are. So in the end, we are all in this together, whether we want to admit it or not'.[9]

Above all, this project has been an act of liberation – freeing ourselves and hopefully others from the limited

imagination and language surrounding debt. From playing the rules of a game managed in the name of the 1%, from the idea/fact that the house always wins. At the centre of our Bank Job has been the acquisition and cancellation of £1.2 million of predatory personal debt with the campaign aims of triggering large-scale personal debt write-off across the UK and to put across the case of how this would be beneficial to all of us.

Our Bank Job pulled off the first bit so far. We intervened in the secondary debt markets. The point of this was not charitable; it was not focused on the difference this might make to those individuals whose debt was written off. We did not want to classify these 'debtors' somehow as other, and the focus of blame and pity. It was instead a highly visible, symbolic act, a rallying cry and lightening rod calling for solidarity and, above all, an act of public education.

Before coronavirus (BC), over the last 12 months alone, British household debt has gone up 10 percent. Over 14 million British citizens (nearly 20 percent of the population,) are living in poverty, with growing numbers forced to borrow from high-cost lenders. Personal debt is at its highest ever level with over 9 million people in problem debt. Debtor organising has only become more urgent in the wake of the coronavirus pandemic and the ensuing economic collapse, which will push more people into debt and default. In the UK there has been an illuminating U-turn from 'you will not be forgotten' to 'we cannot protect every household'. Banks are increasing loan interest that millions already can't pay, big banks are yet to pass on the Bank of England's cuts in mortgage rates and, in the US, banks are seizing vital stimulus cheques that have not been made exempt from private debt collection. As we write, many share stories of their gradually, suddenly, spiralling finances and the helpless nausea that

accompanies this. While the government still peddles the narrative of the national debt needing to be paid back, it is clear that personal household debt is central to the problems now. So what can be done?

Rebel debt abolition

We have made one debt write-off. We recognise that this is not a scalable solution to the personal debt crisis, but a valid and indeed compelling form of amplifying a call for a fairer system. In these times, it is not extreme to demand other explosive action and answer a call coming from communities across the country to see this drama of debt cancellation duplicated and intensified. There was a hope that with increased government stimulus, such action would become unnecessary but the opposite is emerging. Some have, optimistically, described the crisis as a real-time shock doctrine in favour of basic social democracy but, if this is to play out, sustained action will be needed as the social safety net and unconditional bailouts seems to be applied to banks and corporations only. High-profile debt write-offs triggered by collective action in communities (and HSCB-inspired local, empowered, cultural participation and education is critical) around the country would be a series of beacons in the night, visualising the demand for change and making sure a new chant replaces, 'Banks got bailed out. We got sold out,' this time.

Collective debt refusal

Strike Debt UK's Twitter handle states: 'Debt is what the few use to shackle the many. Collective refusal is how we fight back. We owe it to each other.'

Right now, the Debt Collective (developed from Strike Debt) is organising, recognising that millions default on their household debts annually and are privately punished for it.

A collective default in the form of a mass debt strike could result from the building of a strong debtors' movement, much like the trade union movement grew. United we are stronger. Debt must be transformed from the private shame of personal failing to a common struggle against systemic exploitation. As Andrew Ross says, 'Asserting the moral right to repudiate debt may be the only way of rebuilding democracy.'[10] Ross puts forward a fundamental challenge to the thesis that an oppressed citizenry should have to pay its debts. They have already paid, multiple times. Now, he says, it's an act of civic responsibility to refuse to pay any more. This call for economic disobedience is growing louder, looking to scale up civil disobedience, to block the flows of finance with legal, political strategies, teach people their rights, expose the system and act together.

Household debt abolition

Should We Abolish Household Debt? is the title of a book published in 2019 by Dr Johnna Montgomerie, head of the department of European and international studies, and reader in international political economy at King's College, London, and the resounding conclusion she comes to is YES. We precariously motorbiked through Storm Doris to meet her in a cosy cafe when we first began this project and were energised by her clarity and commitment. Like Ross, she acknowledges that credit/debt is not just a gatekeeper to a formal economy, it is a reflection of your economic citizenship and, in turn, societal worth. She too rejects the word 'forgive' for 'abolish', recognising that the legal and regulatory system in place around debt is what needs to be changed, not the debtors. They are in debt due to inevitable 'choices' forced on them by conditions those in charge of the economy refuse to address, preferring instead

to follow a model identified by Chomsky where 'costs and risks are socialized to the greatest extent possible, while profit is privatized.'[11]

She tracks back to the 2008 crisis and the fragility of a global financial system that couldn't withstand a slow ratcheting up of non-performing loans in a tiny pool of subprime mortgages. She identifies the scapegoating political culture that blamed this subprime crisis on a minority black and Hispanic people living in deprived urban areas of the US for the sin of wanting a home. This is a blame game that has continued to be directed at poor people and not the profiteering of banks and corporations, failure of political leadership and governance of markets.

The solutions she outlines are less economic disobedience than a step-by-step strategy to structurally reform away from a toxic, debt-dependent economy – a growth model in which people are addicted to debt, the government is addicted to our debt and the banks, too, are also addicted to our debt. She identifies the problem/bad debt and a critical part of this is the personal debt mountain.

In essence she proposes making cheap credit a public good and not a privilege for the banks and the wealthy alongside a comprehensive package of debt abolition. This involves legal changes in which debt collectors will no longer be able to buy debt packages at a discount but claim full redemption value – a simple stop to an unfair business practice. She advocates cancelling student debt and getting rid of non-performing loans on the balance sheets of British households in much the same way that the Bank of England has cleared the non-performing loans of the banks since 2008. Central to her concept is extending the low-interest loans and refinancing packages already offered to banks and other financial institutions since 2008 to the British and American

public. Each proposal seeks to address the imbalance of power between the finance system and citizens, and to stop finance industries determining the rules that guarantee their profitability and hold society to ransom. She highlights the hypocrisy in the attitude that sees a bailout supporting bank's profits as a sound, technocratic form of financial intervention but a form of heresy when it's helping out households. Critically she emphasises that debt abolition could be of benefit to the whole economy and society. As she told us, 'This is not about poor relief. Debt relief benefits everyone in all kinds of ways. And therefore it should be considered more closely as a really viable common sense solution to ending our dependence on debt overall in the UK.'

A debt jubilee

Since we started this project, the urgency has increased. Payment 'holidays' and calls for recipients of payday loans to have one month interest free are drops in an ocean of debt. We are one of the signatories on a letter to the chancellor of the exchequer organised by Jubilee Debt Campaign: 'We call on you to take urgent and immediate action to prevent the COVID-19 pandemic deepening the debt trap faced by millions of low-income households and pushing millions more into problem debt'.[12] This action includes:

- Freezing repayments on all unsecured debt (including loans, credit cards, and rent-to-own finance), with no accrual of interest during the repayment holiday.
- Freezing utility, rent and council tax payments with no build up of arrears.
- Writing off council tax and social security debts.
- Suspending all debt collection and enforcement activity with immediate effect.[13]

While these are yet to be implemented in the UK, the economic turmoil is pushing indebted countries into crisis. Jubilee Debt Campaign is now campaigning hard to tackle unjust debt across the world, calling on the IMF to cancel Global South debt and on the G20 to cancel, not suspend, the debt payments of 77 of the poorest countries in the world. Debt write-off as a reset button has never been more plausible or necessary to address wider economic injustices. Could we emerge from this with what is, in effect, a global jubilee that, combined with other measures, from banking regulation to taxing the rich, addresses the vast imbalance of wealth and power? As we currently exist in the 'during', we will finish this book before we see the full impacts of this crisis. The moment is there for transformative decision making — to use the current emergency to build an inclusive, sustainable economy that emerges ready to face the climate crisis. The economic and social necessity for such action is growing but the political leadership is out of step and short sighted.

A critical thing to realise is that all of these actions are working together, informing and advancing each other, from our cultural action and its dissemination to movements for economic disobedience to the work of academics and civil-society organisations.

Thriving

As we write, the birdsong blares around this London terrace street, and in the garden tadpoles swim in a makeshift pond and a blackbird sits on her nest next to the shed. Walking the dogs every night we take simple pleasure in occupying the centre of each street, defying any cars to start their engines. For those of us with the privilege of time and space to think, there is a job to

imagine and share a vision of a different world. Headlines now read, 'Himalayas are visible to parts of India for the first time in decades,' and, 'Cleanest air in London for 70 years.' Air pollution intensified the pandemic, but the pandemic has, temporarily at least, allowed the planet to take a breath. It has shown it can be done, not through a permanent lockdown, but by illustrating that it is very possible to transition quickly to clean energy and transportation. Across the world, city states have responded and adapted – making bike-share systems free and increasing bike lanes – the car-free streets and free transit fares that have been championed for years by urban sustainability advocates become an instant reality. The coronavirus can empower us to demand and make change quickly. As Fanny Malinen[14] writes from her quarantine in Finland, 'Whatever the future is, this pandemic is a dress rehearsal,' and we need to act fast.

We read diary notes from a near and distant past when the streets were filled with love and rage not silence:

Wed 9 October 2019. Leaving the 'Rebel Bank' to join the Extinction Rebellion on the streets of Westminster. Through reverberating drumming and the consistent drone of helicopters overhead, there is sense of precarious peace and solidarity. The chants of, 'This is what democracy looks like,' 'The people have the power'… 'Power!' – 'People!' Call and response sound out amid the bastions of power that ignores these voices. West of Parliament Square beside 'the sanctuary', 'Section 14' is shouted out as tents are removed but people quietly move in and stay put. Outside the Cabinet Office a banner read, 'The Future is Here.' I search the windows for signs of political life or courage while armed guards protect 10 Downing Street and it feels as if the future has been usurped and squatted.

Opposite the pristine architecture of power and privilege, making my way through the solar-powered campsite bases

and banners of Norwich Quakers bordering St James Park, I
bump into Ann Pettifor, author of The Case for the Green
New Deal. *Having been instrumental in the massive debt*
write-offs of the Jubilee 2000 movement, she has become a
supporter and ally. I tell her that I'm reading her book and it's
inspiring but it's more than that. Her book has kept us going
with its emphasis on the fact that big changes can happen
fast, that the systems we live under are not set in stone and
that a total change to the economic system is the only way.
The Green New Deal is 'a comprehensive plan for stemming
the breakdown of earth's life support systems.'[15] *It demands*
major system change (economic and ecological) tackling the
self-regulating, globalised, financial system that accelerates the
extraction and consumption of earth's finite assets.

So, could this crisis be the time when we 'accidentally save
the world'? Not without massive linked-up efforts to fight
the coronavirus capitalism emerging under the 'inexorable
control of the masters of the financial universe.'[16] Writing
Small Is Beautiful: A Study of Economics as if People Matter in
1973, E.F. Schumacher argued that the 'natural capital' of the
Earth's resources is irreplaceable and to squander it threatened
life itself and that traditional economics was itself bankrupt
by failing to recognise the value of the social and natural
commons. Fifty years later and his words are unfortunately
still relevant and voices around the world are joining together
in a bold reimagining of an ecologically, economically just
system, to redesign prosperity and restructure our economies
to deliver a better quality of life for people and the planet.
In a bid to not fall back on easy mechanisms, Amsterdam
has now taken on Kate Raworth's 'doughnut model'[17] as a
transformative tool in which the graph of endless growth is
replaced by the shape of a doughnut – the shape in which the

core needs of society are met within ecological boundaries and the sweet spot for humanity to thrive on a thriving planet.

Dancing atoms and wild gardens

During the Bank Job, Dan's mum died. He drove through the night, making it to her side only just in time to say goodbye. She talked of seeing the scans of the cancer as it took over her body with wonder and terror; a constellation of cells – a whole universe expanding inside her. In accordance with her wishes we scattered her ashes across far-flung corners of the United Kingdom, amid the swaying grasses of a Buddhist burial ground overlooking a winding Devon river valley, with grandchildren rubbing illicit dust into the mossy green graves of a Catholic churchyard, a silent Kaddish in a Jewish cemetery, clumps of carbon in the waters of the lough of Dan's childhood. In her death, she sought to bring a family closer together on this odyssey of the ashes, taking her own place in the places she had loved and that held her loved ones, and in doing so attempting to bring her rag-tag bunch of off-spring together. The seeds and cuttings she always generously offered to us from her garden combine in ours with cuttings from my green-fingered parents and grandparents. The pull of the earth led us from an industrial studio to a Victorian terrace and in our garden that leads to railway line, we are enveloped in a congregation of daisies as living memories.

Now, many who can, plant, gather and save seeds for future propagation. Across the world, from the icy wastes of Svalbard to the Australian outback seed banks preserve diversity. We hope that this project can contribute to an 'ideas bank' working in the same way, building a store of ideas spread on the winds, held in trust, ready to be sown and nurtured now.

Exploded Views

These ideas may currently be labelled weeds, unruly botany disrupting the accepted order of things, sprayed into submission by toxic forces, but there is no such thing as a weed.

Sprouting in the cracks of an untenable system that suppresses and destroys life, these are the ideas to cherish – ideas of resilience, beauty, sustenance and healing. In her case for a regenerative economy, Kate Raworth uses the metaphor of the economist as gardener who far from being laissez-faire is a steward, embracing evolution and creating conditions where plants can thrive. The Green New Deal, debt jubilees, universal basic income – their virtues are all too clear and those who suppress and ridicule them do not have humanity and the planet's best interests in mind. Commentators deride the discovery of a forest of magic money trees when just economic plans are proposed, yet seem not to want to notice or understand that behind the smoke, mirrors and razor wire these forests bloom on private grounds. The green of money comes before a green and blue planet.

In the community library of our new office, I reach again for Derek Jarman's book on his garden,[18] sharing in his hatred of lawns and his understanding of 'modern nature'[19]. 'Paradise haunts gardens, and some gardens are paradises. Mine is one of them.' In this time of lockdown, the garden is a paradise and sanctuary that many yearn for, and there is an urgent need for rewilding – of our spaces and minds. Jarman's unlikely garden at Prospect Cottage, bound only by the horizon and thriving on a bleak shingle bank in the shadow of Dungeness's nuclear power plant, prospected for home and hope in what many would see as a wasteland. 'What are the roots that clutch, what branches grow out of this stony rubbish?'[20] We began with our own roots and now find that the very origin of the word 'radical' is in these roots – radiating out, going to the origin, essential.

Disobedience

Risk and play. Amid the earnest call for economic justice these were the things that drove us. The greatest enclosure of the commons in recent times is that of our minds and our capacity to imagine better, and we were ready to rail against that. Our journey into debt literally and metaphorically made us rethink the stories and histories we were and weren't told, and took us through the visible and invisible architecture of finance from the towers of Canary Wharf to discarded high-street banks. It exploded our ways of seeing much as the compulsory anatomy classes at art school, drawing cadavers in the medical schools, lectured in Ruskin and Beuys, reading John Berger[21] and learning to move from observation to understanding. It triggered our need to uncover and understand the structures of enchantment hidden from view and keeping us all under their spell. In *Doughnut Economics* Kate Raworth writes, 'The most powerful tool in economics is not money, nor even algebra. It is a pencil. Because with a pencil you can redraw the world.' We had a lot more than a pencil and have set about using ink, buildings, film, social media, and explosives in our expanded redrawing of our lives, work and understanding of the world.

The etymology of the word 'apocalypse' is in an 'unveiling'—dropping illusion and finding revelation. Isn't that what this has all been about? That 'quiet catastrophe of mind and matter' extending to a turning point in a drama, a sudden overturning of expected narrative. Growing up, Revelations was the strange and scary book at the back of the Bible, full of fire and locusts; now it is revelations or illuminations we seek and share for, for as Lucy Lippard says: 'The power of art is subversive rather than authoritarian, lying in its connection of the ability to make with the ability to see – and then in its

power to make others see that they too can make something of what they see... and so on.'[22] We have exercised the power of the insurrectionary imagination and found it contagious. In *Disobedient Objects*[23] Katherine Flood and Gavin Grindon emphasise the substantial, underestimated role material culture and making play in social movements, responding to powerful enemies with more powerful images and stories. Calls now for economic disobedience need to be matched by the disobedient spirit, disobedient objects and spaces that challenge power and create beautiful, joyful trouble and change.

In 1975 workers facing redundancy in the British arms manufacturer Lucas Aerospace made a radical 'swords to ploughshares'[24] proposal[25] countering the 'warfare state' and prioritising social good over profit by repurposing their machinery and skills to turn from making arms to making solar heating appliances, kidney dialysis machines and wind turbines. The plan was rejected but the power of this conversion of making and meaning is there in proposals for the green industrial revolution, a vision of a democratised, grassroots transformation of the economy and the need to rebel against and reinvent expected use and value. The pandemic has forced a temporary reimagining and requisitioning – Luis Vuitton and Barbour make personal protective equipment and masks, perfume brands make hand sanitiser, the Chinook helicopters that fly above us as we lie restless and awake are taking supplies to the temporary Nightingale hospital.

We are living in a state of emergency where, as the virus has laid bare the total deficiencies of neoliberal capitalism, it has also opened up a space for increasing authoritarianism and the consolidation of wealth and power even further away from the people. The political, public language around the pandemic is full of images of war – of the frontline and battle stations. This dangerous vocabulary has pervaded descriptions of our own

work as 'testing the minefield', expendables sent out to probe and pave the way for the reception for ideas and actions.

But if we are on a 'war footing' then it is as well to remember that the welfare state emerged from a war-time response, and that alongside the oppressive language and violence of debt and a finance system working against people and planet, there are opportunities and obligations of resistance, rebellion and renewal. Turn the secondary debt markets against themselves, challenge and transform the meaning of the iconic skyline of finance, reimagine a defunct bank, make magic money and trade bonds – expose debt as a tool in the oppressive apparatus of crony capitalism. Through processes of transformation and making, play a part in the move to repurpose the machinery of extraction for sustainability – a Lucas plan on the finance system and our imaginations that dismantles the master's house and nurtures our planetary home and the communities we make here.

There is a sense that as artists we are not qualified or allowed to speak in this arena. On the one hand, there is an increasing dismissal of experts and, on the other, a denigration and marginalisation of the voices speaking truth to power. Yet, here we are, engaging and acting, aware of both our limitations and our potent strength. We are obliged to educate ourselves, we have a responsibility to share knowledge and a commitment to using the tools we have – and for us, imagination and making, physically and digitally, are those that can move beyond white papers, are harder to categorise and therefore harder to repress and control. Artists are committed doers and artists are organisers – resourceful visionaries well placed to imagine and implement a better world.

END

ACKNOWLEDGEMENTS

Attempting to acknowledge and thank everyone who has helped form this project and our ongoing practice is to take a meandering journey back in time. Our real debts are always to our families, friends and communities. As we began this book with our childhoods we owe and thank our parents for their care and commitment and the curiosity they nurtured and provoked. There is probably, unfortunately, no doubt that we will omit some names here. We appreciate you all. It has been a long process and we have loved meeting and working with so many people through it. Because we have done this together we don't get a chance to thank each other but we do, deeply and with love.

In late 2013 our neighbour, filmmaker Tim Brocklehurst, told us about an article he had read about Strike Debt buying up and abolishing millions of dollars of student and medical debt in the US. He thought it could be a good subject for a documentary – little did we know it would take six years and many wrong turns. In the beginning of this process Dan delved into comedy with Gwilym Lloyd, acting the bank manager in the kitchen. Thanks to Noé Mendelle whose early enthusiasm for the project led Dan to Scotland and the Edinburgh Pitch, where the reception of an early trailer for what was then *Debtonator* helped dispel doubts and spur him on. Film producer Christo Hird has been a long-term supporter and confidante providing advice and connections from early meetings with Dan on London Bridge to discuss an adaptation of Charlie Chaplin's *Modern Times* to current

feedback on the film as we complete the edit and get set to send it out into the world. We have probably also chosen to forget a lot of the rejections and rebuffs but can also offer some thanks, even to these, for helping make us stronger and more resilient.

Old friend Christophe Tweedie joined Dan as he headed off to the US to meet Strike Debt, continuing a collaboration that began in student newspaper and early photographic careers. The trip was helped by the early support of Charlie Phillips of *Guardian* documentaries and was the real beginning of the project. In New York and Los Angeles Dan met Andrew Ross, Laura Hannah, Dawn Nicole Lueck and all at the Debt Collective who helped, talking clearly about their mission and making the introductions to groups fighting for student debt relief, and Craig Antico and Jerry Ashton of RIP Medical Debt and their valuable advice on how we might do this in the UK.

There are books that have travelled with us through this and play a key role – thinkers and writers who continue to provoke and inspire from Andrew Ross (*Creditocracy*) to Neala Schleuning, Ann Pettifor to David Graeber's *Debt: The First 5,000 Years*. From this epic history of debt came the idea to dramatise it that led us to a 'scrapyard of historical thought' in Outen's yard in Purfleet, and a packed night of filming Orwell (Gary Merry) speeches, God (Kate Evans) at the hairdresser (real-life hairdresser Claire Cross), Compte and Durkheim arguing (Anthony Styles and Paolo Longheu), Thatcher (Natalia Rolleston) and Jesus (Frederick Roll) on the cross. Thank you all who came and took part in this seemingly unending night of filming with good cheer – Hamish Harrington, Minnie Harrington, Cheryl Radley, Frances Barry, Jules Dakin, Glen Turner, Alexander Gueder, Mandy Jumeau, Chris Walker, Danny Worthington and Jon Bentick.

Acknowledgements

To our nephew Guy Edelstyn in charge of pyrotechnics. To Tom Maine, Alessandro Ugo (thanks to Gillian McIver) and Emily Keene (already initiated into rooftop filming with the Debtonator) on camera. Thanks to Nick Edison, actor and assistant director, and fantastic photographer Tony O'Brien who we'd already frequented Rainham Marshes with on our previous estuarine adventure in 'Ring Cycle'.

Back on the streets of Walthamstow we began asking are we living in a creditocracy? We were helped by many in answering this. Steven Saxby local vicar made introductions, Doug Saltmarsh consistently supported us and Sonali Bhattacharyya and Sophie Bolt were allies as we connected with people through a project photographing local labour supporters of Jeremy Corbyn, from firemen to NHS workers. We are thankful to Jacqui Connor for the trust given to us at this early stage with an introduction for an interview with John McDonnell, then Shadow Chancellor of the Exchequer. Corbyn, McDonnell and their team brought hope and the possibility of a better system to us and many. We talked to Tom Davies and Norman Coe at Christian Kitchen and then, as governor of our children's nursery school, Dan met Gary Nash of Eat or Heat food bank. He was the first to come onboard with our banknote plan and we began making our prototype notes in the shed.

We marked the opening of our garden 'mint' with a small explosion helpfully rigged again by our nephew and with cucumber sandwiches by Charlotte and Kevin Matthews who kindly came along to mark the occasion with Sophie Bolt. With the first batch complete we launched this prototype in the tin church Stafford Hall, and we thank everyone who came to the supper club we held there, who bought these prototype artworks and posed for photographs as Debtonators in their gardens and on their rooftops from

Bank Job

Liz and Matt Pepler to Liz and Joe Swift. Thanks to the Hornbeam Cafe for providing the food for this and other events, to Anna Skodbo and Monooka and Piotr Jordon for music here and elsewhere; Gina Boreham for turning up and singing throughout our lives and Stav B artist and bartender extraordinaire who has backed the project and, together with Anka Dabrowska brought critical debate together with cocktails and fun at many events in our lives.

The belief and support of people at this stage kept us going and we began to reach out to others. We thank all those involved in these early days – those we interviewed that do not appear in the final film – from Jeremy Gilbert to Carl Packman, good old friend Andy Cave and the team we built around filming early trailers, including Duncan McCann of the New Economics Foundation and his children getting good at walking in slow motion. Thanks to the ambitious, helpful young team of Naomi Sonaye-Thomas, Tee Craven and Ruby Maclean, to Peter Searle for bringing his professional portrait photography skills to our 'motley crew' and Maria Saxby for stepping in to look after the children at times amid the chaos.

We thank all the people who featured on our banknotes, who stuck by the project and gave their time being photographed and interviewed and welcomed us into their lives. Saira, Farooq, Zuber, Sanah and Aadam opened up a new world to us – of appearances on Islamic TV, and participation in local events with the mayor. We are proud to have worked with you all and happy to know you. To Steve Barnabis and Josh Jardine - thank you for sticking with us, visiting the bank, showing interest in the processes at work and bringing new communities into the building. We are sorry we didn't manage to secure the bank for all of

Acknowledgements

you to play a role in and use. Thank you for sharing in our excitement and empathising when our hopes were dashed. To Tracey Griffiths for agreeing to become a banknote and all the teachers, staff and afterschool club team at Barn Croft Primary School for their support – to Christine Moses for running around with the children Bank Job-style and Louise Duke who came to the bank and stayed a day printing money with her grandson. To all the children and all the parents at the school who bought the 'Traceys' and came to the bank and got involved. Thanks to Carla Cruz for getting stuck in printing, Kat and Nat for lending costume rails and bringing biscuits, Magda and Alex for buying the first notes. When we moved, slightly reluctantly, to Walthamstow we carried on commuting along the canal back to the artist's studios of Hackney Wick. The dogs and children changed that, introducing us to our new home place. The school really is a community and we could not have managed the long days and evening events at the bank without the love and support of the friends we have made there. Thank you for all you do, looking after the children, coming to events, offering help – Sarah Giddens and Simon Boniface, Alanna and Marc Molloy, Melissa King, Gail and Simon Doggett, Rikke Albert, Sarah Ream and Henry Hockings.

Thanks to Olivia Farnesy for alerting us to the bank and Nicky Petto for loyally working with us in these days of preparations and later giving your time at events. Your influence in this and other projects from pop-up books to scrap symphonies is greatly appreciated. Thank you to the Waltham Forest arts development team for your early enthusiasm for the project that enabled us to take the plunge on our first opening. To Abi Lemon and the team for then using the bank as venue and spreading the word. Indycube were our key ally throughout our time in 151–155 Hoe Street.

Bank Job

We are forever grateful for the support of Mark Hooper, Dai Lloyd, Mike Scott, Mari Ellis Dunning and the team – 'crazy dancers' with shared values and a belief in allowing spaces to grow and thrive in their own way. We retain respect and admiration for the legal aid solicitors who enabled both Indycube and ourselves to occupy this space on the High Street for that time and wish them all the best. To the secret barrister for opening our minds further to the injustice eroding their lifelong commitment to justice.

Time in the bank is a blur of production, visits and events. Thank you to those that were interested enough to turn up at the beginning – to Tony Greenham for speaking at the launch and Stella Creasy for getting Matthew Taylor of the Royal Society for the encouragement of Arts, Manufactures and Commerce to come along. Thank you to all who popped in to find out what was going on, who made special trips from afar and shared news of it in your communities. We thank all those who came and gave their time to speak at the many events. Discussing the importance of an economic education for all with a bit of debunking the national debt with RSA Citizens' Economics Council's Kayshani Gibbon, Claire Birkett (Ecnmy.org), Beth Munroe (Shout Out, UK) and John Weeks from Prime Economics. Looking at forms of money and its creation with Rachel Oliver (Positive Money), Brett Scott bringing his heretical imagination, Duncan McCann of NEF weaving stories of currencies, Sue Wheat introducing the local Local Exchange Trading System scheme. Examining housing debt and alternative housing models with Michael Edwards (University College London Planning, JustSpace), Joe Beswick (New Economics Foundation), Jessie Brennan (artist and community land trust resident) and Waltham Forest Community Land Trust. Talking 'manufacturing dissent' with Jeremy Gilbert, Ruth

Acknowledgements

Catlow of Furtherfield, artist Max Dovey, Nick Mahony of the Raymond Williams Foundation and Joe Todd (co-founder of the world transformed). Exploring *Useful Work Versus Useless Toil* with William Morris himself (aka actor Sean Wilkinson), Mark Hooper, Sophie Hope, Ruth Beale and Amy Feneck (Alternative School of Economics), and debating debt and democracy with Sarah Jayne Clifton of Jubilee Debt Campaign, Jonathan Bartley (Green Party), Duncan McCann, David Graeber and Joel Benjamin.

The whole time in the bank was an education and as we explored ownership models we organised 'Co-Operatives in the Co-Op' inviting Torange Khonsair of Public Works running an MA course on The Commons, Calverts, a cooperative printer we have a valued working relationship with, Paula Goes of Faircoin, Carlota Sanz of Economy for the Common Good and our local food co-operative Organic Lea who have become friends and allies as we later enjoyed their produce in the food from Hornbeam, and the monthly Soup, Water, Bread events organised by Sally Labern of Drawing Shed.

We were particularly excited by the book launches we were able to host at the bank, contributing to its growing role as a 'knowledge bank'. Thanks to Verso books and Oli Mould with *Against Creativity*, Andrew Simms and David Boyle with a *Crash Course in Economics* (The Ivy Press), and a particular thanks to Pluto Press for really coming onboard with the event around Max Haiven's *Art After Money, Money After Art* and providing more books for the growing library. We are now members of the press's Left Book Club. Further book debate happened thanks to Mark Hart in the form of the Walthamstow rock 'n' roll book club, and whatever the event there was always a great atmosphere in the bank thanks to both Stav B and Murray Alexander, and Paul Bradley for

also bringing the cocktails with music by Kieron Maguire, Zac Gvirtmann and Garance Louis.

Thank you so much to those who stuck with us and supported these events – Raymond Williams Foundation, an UnLtd Award, Community Ward funding and the Lipman Miliband Trust. Thank you to Ben Campkin of UCL Urban Laboratory for continuing to believe in and support us, and to Stuart Field who worked with us on gaining a Network for Social Change grant. Each of these made such a big difference to our ability to commit and continue. We were happy to be part of E17 Art Trail and Art Night 2019, each helping us reach out to more people and add to the little pots of money enabling us to keep going. Thank you to Art Licks Weekend and Artquest for awarding HSCB the Workweek Art Prize, and to East London Printmakers for featuring the bonds in their exhibition that led to them winning the Printmaking Today prize and Jackson's Art Prize. East London Printmakers have been such an influence in the work's development from Hilary first taking printmaking courses there to her time as artist in residence. The Jackson's team were amazing and the prize allowed us to stock up on enough gold spray paint to complete our plans!

We are thankful to the many others who organised and held their own events in the bank, helping to keep it on the map as a space of debate and action – Unfair Debt Group hosting a 'Debt Story Cafe', local MP and council 'debt' drop-in sessions, Extinction Rebellion and NHS campaign group meetings, podcasts, young people's visual art projects, listening parties, laughter yoga with Barry Sykes. We thank Billy who worked on plans for a cafe and the loyal 'tenants' who put up with us through the ever-changing project and space. To Christine Hawkins successfully finishing her PhD, Ginette White for putting up with us tearing the walls down

Acknowledgements

around her, the Geeksweat podcast team, and Riley Ramone regularly popping in to work and organising 'Analogue Tech in the Digital Era'. In the final months we were very happy to be joined by the team from Stories and Supper – a social enterprise sharing the stories behind migration headlines.

We thank the bank. For all it was to us, had been and could be in the future. Thanks to the local studies archive at Vestry House Museum, HSBC archives and Gillian Lonergan at Co-Op Archives for helping us delve into its past. To Paul for stopping the flooding, Andrew Islam for his can-do attitude and work, Anna Skodbo, Steve and Elio for fire system assistance, the Waltham Forest Borough of Culture 'Make It Work' grant team for enabling the transformation and to Forest recycling project and the many people on Walthamstow sell or swap, specifically Kirsten Sibley for helping us kit out the bank. A salute to Mark Clack at Wood Street Walls, sign writer Jake Tyler and Subvertiser for transforming the rebel bank's façade to invite all in.

Although we are no longer in the bank we learnt a lot and met many new people through our plans to stay. Thank you to Jack Fortesque and David Panton of Acme, to Rebecca Davey and Kate Cowan and all at Waltham Forest Council for their support, including councillors Tom Connor, Ahsan Khan and Vicky te Velde. To Nudge Plymouth for prompting us to investigate community shares and David Boyle of the Community Share Company and Brian Titley of Cooperatives Assistance for tough advice. Thanks to Nesta's Sarah Mcloughlin, Rosalyn Old and Peter Baeck for sharing their research, Neil Leslie of Building Legacies and also Enterprise Enfield for their business support. Thanks to locum MP Kizzy Gardiner and MP Stella Creasy, and Raja Moussaoui and Amy Lamé of the Mayor's Culture at Risk team for offering their

support. Thank you to our friends and neighbours Kristin Trommler and Tilo Guenther for all their time and support mentoring the fantastic group of student architects from Kingston University – Ralitsa Genkova, Priya Kana, Brett McCurdy, Aayat Jariwala and Aldrin Mallari. We valued the work of Kevin McGloin and team at Appleyard and Trew and we learnt so much through this process that won't be wasted. In the chaos of leaving the bank at Christmas, generous George Sabapathy worked alongside us as we underestimated the amount of stuff to shift. Thank you to good old friend Bob Brown for storing the van parts, and Natasha McFadzean and team at The Mill for being flexible and allowing us to move into our new office over this festive period.

We've already mentioned the team of people who came to print the money and later bonds. They made the Bank Job. Alistair Gentry, Farah Ishaq, Sue Brown, Alison Kay, Anthony Lane, Isabell Blackwell, Miranda Moore, Lucy Gregory, Catherine Armstrong, Sanah Mir, Kathy Patterson, Meltem Tigli, Melissa Tigli, Suzanne Lemon, George Sabapathy, Faaiza Ali, Sulaimaan Sajad. They had countless conversations, helping with university tours and supervising National Citizen Services participants. Thank you to the William Morris Gallery for making us look a bit more professional at interview stage, to Peter Cotrill and team at Waltham Forest College for inviting us in to share the project and Zed (zero emission deliveries) Walthamstow for welcoming Hilary as cycle courier and helping distribute leaflets and deliver food. Thanks, too, to everyone who offered to volunteer, wanting to help but where we didn't find a way of including you. To designer Phil Seddon who remains on the project, who was there on the events desk, on guillotine and stamps and to his wife Rebecca who offered regular support mucking in at supper clubs and events. Another thanks to those who shared

Acknowledgements

their specialist knowledge of processes and equipment, Spike Gascoigne, Matt McKenzie, Helen Porter, Rob Fawcett, Andrew Baldwin, Stephanie Turnbull, Giles Corby and Drew Cole. We thank Peter O'Donnell for his patience and generosity in teaching us the early photographic techniques that are opening up to new projects as we write.

Thank you to the curators and institutions who collected the banknotes and by doing this helped the project reach out further – Rowan Bain at Vestry House Museum, Vyki Sparkes at Museum of London, Jennifer Adam at the Bank of England Museum, Gill Saunders at the V&A, Tom Hockenhull at the British Museum and Richard Kelleher at Fitzwilliam Museum, Cambridge. To everyone across the world who bought and continues to buy banknotes and bonds. It has been amazing writing envelopes addressed to locations as far afield as Texas and Singapore, the Outer Hebrides or caravan parks on the Scottish Borders, and thinking of everyone united in a common desire to make a fairer economic system. To Oliver Duke-Williams who mapped these out for us and to friends near and far who consistently supported us – Hugh Hartford and Ruth Grove-White, Ross Birkbeck and Burgundy Applegate, Lucy de Laszlo and Alec Birkbeck, Christo Hird and Anna Haworth, Layla Rosa and Anna Hart. To new friends, collaborators and members of the Bank Job – from Nicole Skelty working on a rock opera of the finance system to Mark Hislop of Exhale Brewery and plans in process. To our families who, perhaps at first not being too keen showed their support anyway – from Hilary's Dad Rev John Powell who donned his robes and talked to us about debt in the tiny chapel of Mwnt where we were married, to Paul and Tegwen Edelstyn who drove all the way from Wales to attend the explosion. It might not have been as easy to get behind as a Vodka Empire but has been more

all-encompassing and life transforming for us. We wish Lindy could see it all come together.

Thank you to Heenan Gray for his early support and introduction to Roland Roberts who made the purchase of debt possible. We have been moved by the messages from communities around the country getting in touch wanting to do the same and now thank Adrian Davies from Nestegg for helping with our FCA application to hopefully enable this to happen, the Finance Innovation Lab for putting us in touch and Fanny Malinen of Research for Action for working with us on many applications and plans for how we contribute to a bigger debt write-off and economic justice.

Thank you to Jeremy Earnshaw (Jez), Paul Rigg and the whole team at Alford Tech who made it possible to literally blow that debt up. We thank the good timing and support of the British Film Institute, Doc Society and Arts Council for stepping in with letters of support enabling the explosion to happen and the big team effort that led to this from film location company to police, paramedics, fire team, security and a large crew on camera (Micah Walker), slow motion camera (Jack Rowley) and drone (Jan Bednarz). Hats off to Sarah Campbell for donning helmet to play bugle and to Graeme Truby for keeping his nerve to capture the amazing still images. Thanks to John Burton of Urban Space Management for helping us find the site and Paul Clarke of LDA for helping secure it.

We extend our thanks to all those individuals and organisations who invited us out and about to talk about the project and spread the word from Robert Manners and Plymouth School of Art to Lara Luna Bartley at the University of the West of England, Swansea's Urban Foundry to Manchester Festival of Social Science, the Ruskin Prize to Theater Rotterdam. We loved welcoming different groups into the

Acknowledgements

bank and introducing them to the project from sixth form college students to University teachouts and talks. We always looked forward to the arrival of Robin Wilson with new assemblies and were happy to receive our certificate from Sarah Dixon and Sharon Bennett visiting from 'The Bureau for the Validation of Art'.

Thank you to the writers, podcast makers, and press that helped the project reach out further. From early support from *Waltham Forest Echo* and *The E List* to the fortuitous visit from Anna Leach that led to a *Guardian* article that went viral. Thanks to Martin Sandbu from the *Financial Times*, the *Big Issue*, artist Wuon-Jean Ho for writing in *Printmaking Today* and Josie Thaddeus-Jones and photographer Andrew Testa for coming to the explosion and getting it into the *New York Times*. Everything made a difference (thanks to Louise Atkinson of curatorspace for another viral one) and we valued the conversations and contributions from Chiara Ambrosio's Raft for the wonderful Resonance FM to Sarah Cuddon's Tate Podcast. The conversations continue with those we have met as champions and collaborators along the way from Chris Harker of UCL Institute for Global Prosperity to Johnna Montgomerie and Jubilee Debt Campaign. We thank you all for your time and belief. We appreciated the solidarity from A.J. Tear of Hackney's Positive Money group and Hannah Dewhirst of Rethinking Economics/ Positive Money and hope we can build on these relationships as the film now travels. Thank you to Mark Godber and Artsadmin for bringing artists to the bank as part of Imagine 2020, a move that led to new collaborations and an event – with Andrew Simms, Lucy Neal and Chaitanya Kumar – that is the launchpad for future work on the economics of climate breakdown and a global green new deal. The discoveries and relationships made through the project

have been illuminating and transforming and we keep these provocations and inspirations with us from Kate Raworth's *Doughnut Economics* and Ann Pettifor's *Case for the Green New Deal*, to Rob Hopkin's *From What Is to What If?*

As we write this we emerge from a new and fantastic working relationship with Alice Powell, the film editor who has worked with such skill, humour and patience on this long, intensive process. Working through years of footage we have rediscovered animations by Martin Pickles and Amena Dede Sackey, early edits by Ross Birkbeck, and now face a finished feature documentary film. It has been a pleasure and a relief. Thanks to Lisa Marie Russo and Sandra Whipham for watching it so far and to Doc Society for getting behind the project. As we complete this process we look back at the many people who have helped make this happen. Christo Hird, long-term producer, old time collaborator Stephane Malenfant, new and old music collaborators, Nick Graham-Smith and Jesse Braun, Jolie Holland and Stevie Weinstein-Foner for bringing their voices to the soundtrack and the Orchestra of Cardboard, George Sabapathy on edit and much more, and a team of fantastic young filmmakers. Thanks to runners Thomas Wilson, Frazer Randalls, Claire Armstrong, Louis Andros and Mina Afkhami. Clement Ducruet who endured steady cam training and rooftops in the early days, Pablo Castano who has helped with the full gamut of filming, bond packing, child and dog care, Olivia Hird joining us in the cold bank producing podcasts and assisting with camera, filmmaking neighbour and friend Natalie Sloan, bright young assistant editor Lauren Smith and Linden Nieto who joined the team bringing cinematographic flare and a get-stuck-in attitude, driving country lanes to test explosions with Hilary and doing a fair share of DIY.

In this later period, becoming invisible, heads down in the production of the film and book and plans for the future,

Acknowledgements

there is a sense of it being over to everyone around us. Thank you to friends Zerrin Ozlem Biner and Manuel Arroyo-Kalin for the recognition of this sustained commitment, to finding some peace together in lockdown and recognising the need to balance kite flying and marsh roaming with critical thinking and political dissent. In this period of turmoil, Hilary began teaching at the RCA. A big thank you to Jessie Brennan and Debbie Cook for trusting in her and to the students who in turn provoked new questioning and purpose. Thank you to all those who contributed to ways of understanding the 'structures of enchantment' that surround us – Alberto Duman, all at the MayDay Rooms, Catherine Flood, Susie Steed and Darren Cullen. Together you have helped renew our energy.

And finally, thank you to everyone at Chelsea Green Publishing. To Jon Rae for all your patience and persistence, to Muna Reyal for making it easy to trust and let go, to Patricia Stone for such excellent organisation, and to Katie Read, Rose Baldwin, Matt Haslum and Margo Baldwin. Your enthusiasm has been a joy to be greeted with in this period.

Thank you to whoever has been intrigued enough to open this book and read about this Bank Job.

NOTES

Introduction

1. Rolling Jubilee is a Strike Debt project conceived as 'a bailout of the people by the people'. https://rollingjubilee.org.
2. Ross, *Creditocracy*.
3. Emma Rowley, 'Bank Bail-Out Adds £1.5 Trillion to Debt', Telegraph, 16 January 2011, https://www.telegraph.co.uk/finance /newsbysector/banksandfinance/8262037/Bank-bail-out-adds -1.5-trillion-to-debt.html.
4. Jill Treanor, 'RBS Sale: Fred Goodwin, the £45bn bailout and years of losses', *Guardian*, 3 August 2015, https://www.theguardian.com /business/2015/aug/03/rbs-sale-fred-goodwin-bailout-years-of -losses; Ben Moshinsky, 'The UK Government Has Recouped the £20 Billion Cost of the Lloyds Bailout', *Business Insider*, 21 April 2017, https://www.businessinsider.com/uk-government-lloyds-sale -2017-4?r=UK.
5. Philip Alston, *Statement on Visit to the United Kingdom* (London: United Nations Human Rights Office of the High Commissioner, 2018), https://www.ohchr.org/en/NewsEvents/Pages/DisplayNews.aspx ?NewsID=23881&LangID=E.
6. Phillip Inman and Caelainn Barr, 'The UK's Debt Crisis – in figures', *Guardian*, 18 September 2017, https://www.theguardian.com /business/2017/sep/18/uk-debt-crisis-credit-cards-car-loans.
7. Inman and Barr, 'The UK's Debt Crisis'.
8. David Clarke, 'Poll Shows 85% of MPs Don't Know Where Money Comes From', *Positive Money*, 27 October 2017, https:// positivemoney.org/2017/10/mp-poll/.

Chapter 1: The First Big Bang

1. Matthew 5:5, the Bible.
2. Bumper sticker slogan by Strike Debt.
3. Scenes and dialogue from the cult classic film *Withnail and I* directed by Bruce Robinson (1987) continue to accompany us through life.

4. Experimental documentary film by Dziga Vertov made in 1929 showing the dynamism of a city and the power of montage.

5. 1936 silent comedy by Charlie Chaplin.

6. Words of the narrator/director Derek Jarman in his film *The Last of England* (1987).

Chapter 2: Revelations: Debt and Money

1. *How to Re-Establish a Vodka Empire* was our first feature documentary released in 2011.

2. Ross, *Creditocracy*.

3. From Charlie Phillips, then documentary commissioning editor at the *Guardian*.

4. Heinz Duthel, *The Trilateral Commission and the New World Order* (n.p., IAC Society, 2010), 52–53.

5. Frankl, *Man's Search for Meaning*.

6. Tam Harbert, 'Here's How Much the 2008 Bailouts Really Cost', MIT Management Sloan School, 21 February 2019, https://mitsloan.mit .edu/ideas-made-to-matter/heres-how-much-2008-bailouts-really -cost; Joël Reland, '£1 Trillion Was Not Spent on Bailing Out Banks During the Financial Crisis', Full Fact (website), 4 July 2019, https:// fullfact.org/economy/1-trillion-not-spent-bailing-out-banks/.

7. Ben King, 'What Is Quantitative Easing and How Will It Affect You?' *BBC News*, 18 June 2020, https://www.bbc.com/news/business -15198789#:~:text=Between%202008%20and%202015%2C %20the,programme%20between%202009%20and%202012.

8. Ross, *Creditocracy*.

9. Written and directed by John Carpenter (1988).

10. T.S. Eliot, 'Little Gidding', *Four Quartets* (London: Faber, 2001).

11. Ann Pettifor, 'Philip Hammond Ought to Dispel the Economic Myths that Hold Women Back', *Guardian*, 7 March 2017, https:// www.theguardian.com/commentisfree/2017/mar/07/philip -hammond-economic-myths-budget-international-womens-day.

12. John Weeks talking at an Economic Education event at HSCB in March 2018. John Weeks is an economist and member of Prime Economics. He is author of *The Debt Delusion: Living within Our Means and Other Fallacies* (London: Polity Press, 2019).

13. Keynes, *The Means to Prosperity*.

14. Tim Price, 'How FDR Learned to Stop Worrying and Love Keynesian Economics', Roosevelt Institute, 26 April 2012, https://

Notes

rooseveltinstitute.org/how-fdr-learned-stop-worrying-and-love
-keynesian-economics/.

15. Philip Alston, *Statement on Visit to the United Kingdom* (London:
United Nations Human Rights Office of the High Commissioner,
2018), https://www.ohchr.org/en/NewsEvents/Pages/DisplayNews
.aspx?NewsID=23881&LangID=E.

16. Michael Robinson, 'Shaking the Magic Money Trees', BBC Radio,
31 January 2018, radio broadcast, https://www.bbc.co.uk
/programmes/b09pl66b.

17. The Money Advice Service, *Indebted Lives:The Complexities of Life in Debt*,
report, November 2013, https://mascdn.azureedge.net/cms/indebted
-lives-the-complexities-of-life-in-debt-november-2013-v3.pdf.

18. UCL Institute of Global Prosperity, *Payback? Coordinating Solutions to
the Debt Crisis*, e-conference, September 2018, https://www.ucl.ac
.uk/bartlett/igp/events/2018/sep/payback-coordinating-solutions
-debt-crisis-e-conference.

19. Kate Raworth, 'A New Economics,' in *This Is Not a Drill:An
Extinction Rebellion Handbook* (London: Penguin, 2019).

20. The Overton window is a model for understanding how ideas in
society change over time and influence politics. It was developed
in the mid-1990s by the late Joseph P. Overton. All social reform
movements have to shift the Overton window to make progress.

Chapter 3: The Heist Begins

1. Anna Leach, 'The Rebel Bank, Printing Its Own Notes and Buying
Back People's Debts', 23 March 2018, https://www.theguardian
.com/world/2018/mar/23/hoe-street-central-bank-walthamstow
-london-debt.

2. Johnston Birchall, *The International Co-operative Movement* (Manchester:
Manchester University Press, 1997).

3. Carlota Sanz of Economy for the Common Good UK was also
present and this is a key question they pose. https://www.ecogood
.org/en/

4. Quotes of support from the petition and social media we circulated in
December 2019.

5. Adam Spiegel James, quote from the petition and social media we
circulated in December 2019.

6. Nicole Skeltys, quote from the petition and social media we circulated
in December 2019.

7. In reference to Rob Hopkins, *From What Is to What If: Unleashing the Power of Imagination to Create the Future We Want* (White River Junction, VT: Chelsea Green, 2019).

Chapter 4: Big Bang 2

1. Twitter arguments witnessed with Brian Cox.
2. A conversation with Ann Pettifor in the Bank, June 2018.
3. In a full-page advert in the *Sunday Times*, April 2013.
4. Margaret Thatcher, speech to Conservative Party Conference, Bournemouth, Hampshire, UK, 10 October 1986, https://www.margaretthatcher.org/document/106498.
5. Richard Partington, 'Four Million British Workers Live in Poverty, Charity Says', *Guardian*, 3 December 2018, https://www.theguardian.com/business/2018/dec/04/four-million-british-workers-live-in-poverty-charity-says.
6. 'Child Poverty Facts and Figures', Child Poverty Action Group (website), updated March 2019, https://cpag.org.uk/child-poverty/child-poverty-facts-and-figures?gclid=CjwKCAjw_qb3BRAVEiwAvwq6VtTNii9UNypclrp1QiyWZgjxq-NsFDyIMFYraJn31u6CWCoopkymcBoCwJAQAvD_BwE.
7. Adam Curtis is a filmmaker whose work includes *Hypernormalisation* (BBC, 2016). He wrote on the subject on the BBC blog 'Adam Curtis_ The Medium and the Message', https://www.bbc.co.uk/blogs/adamcurtis/entries/fdb484c8-99a1-32a3-83be-20108374b985.
8. Cockett, *Thinking the Unthinkable*.
9. Harvey, *A Brief History of Neoliberalism*.
10. Astra Taylor is an activist, filmmaker, member of the Debt Collective and author of *Democracy May Not Exist But We'll Miss It When It's Gone* (London: Verso, 2019).
11. George Monbiot, 'Neoliberalism Promised Freedom – Instead It Delivers Stifling Control', *Guardian*, 10 April 2019, https://www.theguardian.com/commentisfree/2019/apr/10/neoliberalism-freedom-control-privatisation-state.
12. Isabel Hinton, 'Wapping: Twenty years, twenty voices', interview by Joy Lo Dico, *Independent*, 22 January 2006, https://www.independent.co.uk/news/media/wapping-twenty-years-twenty-voices-523987.html.
13. 'Murdoch's Lobbying Efforts Are Increasing, New Analysis Finds', Media Reform Coalition, 5 February 2017, https://www.mediareform.org.uk/featured/murdochs-lobbying-efforts-increasing-new-analysis-finds.

Notes

14. Kevin Rudd, 'Democracy Overboard: Rupert Murdoch's long war on Australian politics', 6 September 2019, https://www.theguardian .com/commentisfree/2019/sep/06/democracy-overboard-rupert -murdochs-long-war-on-australian-politics.

15. Tom Wilkinson, 'The Architecture of the Big Bang', *The Architectural Review*, 27 October 2016, https://www.architectural-review.com /essays/the-architecture-of-the-big-bang/10014225.article.

16. Margaret Thatcher, speech visiting London Docklands, London Docklands Development Corporation Offices, Ledger Building, 13 April 1984, https://www.margaretthatcher.org/document/105660.

17. Guy Faulconbridge and Andrew Osborn, 'Thatcher's Legacy: A citadel of finance atop once-derelict docks', 16 April 2013, https://www.reuters .com/article/uk-britain-thatcher-wharf/thatchers-legacy-a-citadel -of-finance-atop-once-derelict-docks-idUKBRE93F0S920130416.

18. Jane Martinson, 'The Long Shadow of Canary Wharf', documentary on *BBC Radio*, 30 August 2019, https://www.bbc.co.uk /programmes/b09zn0ln.

19. Jane Martinson, 'Canary Wharf: Life in the shadow of the towers', *Guardian*, 8 April 2018, https://www.theguardian.com/commentisfree /2018/apr/08/canary-wharf-life-in-the-shadow-of-the-towers.

20. Similarities have been drawn with the Chartists. Taking their name from the Magna Carta, this group operating in the mid-1800s also harnessed the political symbolism of the river.

21. Information about the People's Plan for the Royal Docks: http:// www.wemadethat.co.uk/journal/view/the-unlimited-edition-the -peoples-plan-participatory-and-intellectual-democ.

22. Martinson, 'The Long Shadow.'

23. Around the same time the banks were bailed out the government also bailed out the Olympic Park and developments to the tune of nearly £6 billion of taxpayer's money.

24. Powell and Marrero-Guillamón, *The Art of Dissent.*

25. Ackroyd, *London: The Biography*, 760.

26. William Blake. *And Did Those Feet in Ancient Time.*

27. 'Bread and Roses' is a political slogan coined by Rose Schneider-mann and recognises the need to meet the basic human provisions alongside the equal need to flourish – sustenance and beauty.

28. Qatar Investment Authority is the sovereign wealth fund of the State of Qatar with their website stating that since 2005, 'We have built a major global portfolio that now spans a broad range of asset classes and regions.'

29. In his opus *Das Passagen-werk* (*The Arcades Project*), Walter Benjamin states, 'We need to re-appropriate these city images and spaces to create layered personal records of travels and explorations that can puncture these scenographic compositions of place and transform these spectacles of might.'

30. Guy Debord, *The Society of the Spectacle* (Detroit: Black and Red, 1984).

31. The billboard read: '2012, London, Olympics, Two Thousand and Twelve, Olympia, Summer Games, Twenty Twelve, Spirit in Motion, 2012 Gold, Olympiad, Silver Games, Paralympian, Faster Higher Stronger, Citius Altius Fortius, London Medals, Olympian Sponsors. Whoops! All of these words and phrases are now illegal to print. …and so is this billboard which has no planning permission! It shouldn't be here. So. We can be naughty.'

32. Padraig, 'Olympic Organisers Shut Down 'Space Hijackers' Protest Twitter Account', Open Democracy, 24 May 2012, https://www .opendemocracy.net/en/opendemocracyuk/olympic-organisers -shut-down-space-hijackers-protest-twitter-account/.

33. 'Official Protesters of the Olympics!' Space Hijackers (website), https://www.spacehijackers.org.

34. Explored in the 2014 V&A London exhibition *Disobedient Objects* and associated catalogue/book. Catherine Flood and Gavin Grindon, *Disobedient Objects* (London: V&A, 2014).

35. The concept of *détournement* was developed by the Situationists and is a method of appropriating and altering an existing media artefact or message in order to give it a new, subversive meaning.

36. David Harvey, 'Neoliberalism as Creative Destruction', *Annals of the American Academy of Political and Social Science* 610, NAFTA and Beyond: Alternative perspectives in the study of global trade and development (March 2007), 22–44.

37. Robert Smithson, interview with Patricia Norvell, Alexander Alberro and Patricia Norvell, eds., *Recording Conceptual Art* (Berkeley: University of California Press, 2001), 131.

Chapter 5: Exploded Views

1. Peter Derk, 'The 8 Keys to a Good Heist Story', Litreactor, 8 June 2018, https://litreactor.com/columns/the-8-keys-to-a-good -heist-story.

2. Friedman, *Capitalism and Freedom*.

3. Orwell, *Nineteen Eighty-Four*.

Notes

4. Reema Patel, 'Why Economics Has a Democratic Deficit', Open Democracy UK, 19 October 2017, https://neweconomics .opendemocracy.net/economics-democratic-deficit/

5. Earle, Moran, and Ward-Perkins, *The Econocracy*.

6. Noam Chomsky, 'The Corporatization of the University', filmed July 2013 in Rackham Auditorium, University of Michigan, https:// www.youtube.com/watch?v=66w9Lf9yuZA.

7. Antiuniversity Now is a collaborative experiment to challenge institutionalised education, access to learning and the mechanism of knowledge creation and distribution. http://www.antiuniversity.org/.

8. The Bank Job has garnered a lot of press, from the BBC *One Show* to the *Financial Times* and *New York Times*.

9. Talking to us in March 2020 and available to watch at the Bank Job membership site. https://membership.bankjob.pictures/jointhejo.

10. Andrew Ross, 'Nine Arguments for Debt Refusal', Strike Debt! (website), 7 February 2014, https://strikedebt.org /nine-arguments/.

11. Chomsky, *Hopes and Prospects*.

12. Letter organised by the Jubilee Debt Campaign to the Chancellor of the Exchequer, 1 April 2020, https://jubileedebt.org.uk/wp -content/uploads/2018/07/Letter_-Covid-19-and-the-Household -Debt-Trap_FINAL.pdf.

13. https://jubileedebt.org.uk/wp-content/uploads/2018/07/Letter _-Covid-19-and-the-Household-Debt-Trap_FINAL.pdf.

14. Fanny Malinen is a researcher, writer and activist. She is working with us on the Bank Job, with the New Economics Foundation, the Unfair Debt Group and as part of Research for Action – a worker's co-operative producing work to support social, economic and environmental justice.

15. Pettifor, *The Case for the Green New Deal*, 9.

16. Pettifor, *The Case for the Green New Deal*, xiv.

17. Raworth, *Doughnut Economics*.

18. Jarman and Sooley, *Derek Jarman's Garden*.

19. Jarman and Laing, *Modern Nature*.

20. T.S. Eliot, 'The Waste Land'.

21. Berger, *Ways of Seeing*.

22. Lucy R. Lippard, 'Trojan Horses: Activist art and power', in *Art after Modernism: Rethinking Representation*, ed. Brian Wallis (Boston: David R. Godine, 1984).

23. Flood and Grindon, *Disobedient Objects*.
24. Isaiah 2:4, the Bible.
25. Lucas Aerospace Workers Alternative Corporate Plan, the January 1976 document produced by the workers of Lucas Aerospace Corporation.

SELECTED BIBLIOGRAPHY

Ackroyd, Peter. 2000. *London: The Biography*. First edition. London: Chatto & Windus.

Berger, John. 2008. *Ways of Seeing*. First edition. London: Penguin Classics.

Boyle, David, and Andrew Simms. 2019. *Economics: A Crash Course: Become an Instant Expert*. Ivy Press.

Chomsky, Noam. 2011. *Hopes and Prospects*. London: Penguin.

Cockett, Richard. 1994. *Thinking the Unthinkable: Think-tanks and the Economic Counter-revolution, 1931–83*. London: HarperCollins.

Earle, Joe, Cahal Moran, and Zach Ward-Perkins. 2017. *The Econocracy: On the Perils of Leaving Economics to the Experts*. First edition. London: Penguin.

Evans, Harold. 1983. *Good Times, Bad Times*. London. Weidenfeld and Nicolson.

Flood, Catherine, and Gavin Grindon. 2014. *Disobedient Objects*. First edition. London: V&A Publishing.

Frankl, Viktor E. 2004. *Man's Search for Meaning: The Classic Tribute to Hope from the Holocaust*. New edition. London: Rider.

Friedman, Milton. 2002. *Capitalism and Freedom: Fortieth Anniversary Edition*. Anniversary edition. Chicago: University of Chicago Press.

Graeber, David. 2014. *Debt: The First 5,000 Years*. 2nd revised edition. Brooklyn: Melville House Publishing.

Haiven, Max. 2018. *Art After Money, Money After Art: Creative Strategies Against Financialization*. London: Pluto Press.

Harvey, David. 2007. *A Brief History of Neoliberalism*. New edition. Oxford: Oxford University Press, U.S.A.

Havel, Václav, and Timothy Snyder. 2018. *The Power of the Powerless*. Vintage Classics.

Hopkins, Rob. 2019. *From What Is to What If: Unleashing The Power of Imagination to Create the Future We Want*. White River Junction: Chelsea Green Publishing.

Jarman, Derek, and Olivia Laing. 2018. *Modern Nature: Journals, 1989 – 1990*. First edition. Vintage Classics.

Jarman, Derek, and Howard Sooley. 1995. *Derek Jarman's Garden*. First edition. London: Thames and Hudson Ltd.

Keynes, John Maynard. 2012. *The Means to Prosperity, the Great Slump of 1930, the Economic Consequences of the Peace*. n.p.: Oxford City Press.

McKee, Robert. 1999. *Story: Substance, Structure, Style and the Principles of Screenwriting*. Reprint. London: Methuen Publishing Ltd.

Montgomerie, Johnna. 2019. *Should We Abolish Household Debts?* Medford, MA: Polity Press.

Morris, William. 1993. *News from Nowhere and Other Writings*. Edited by Clive Wilmer. New edition. London: Penguin Classics.

Morris, William. 2008. *Useful Work Versus Useless Toil*. UK edition. London: Penguin.

Mould, Oli. 2018. *Against Creativity*. London ; Brooklyn, NY: Verso.

'Neoliberalism as Creative Destruction – David Harvey, 2007'. 2020. Accessed May 20. https://journals.sagepub.com/doi/abs/10.1177/0002716206296780.

Orwell, George. 2004. *Penguin Great Ideas: Why I Write*. Rev edition. London: Penguin.

Orwell, George, and Thomas Pynchon. 2004. *Nineteen Eighty-Four*. New edition. London: Penguin Classics.

Pettifor, Ann. 2019. *The Case for the Green New Deal*. London: Verso Books.

Powell, Hilary, and Isaac Marrero-Guillamón. 2012. *The Art of Dissent: Adventures in London's Olympic State*. London: Marshgate Press.

Raworth, Kate. 2018. *Doughnut Economics: Seven Ways to Think Like a 21st-century Economist*. First edition. London: Random House Business.

Rebellion, Extinction. 2019. *This Is Not A Drill: An Extinction Rebellion Handbook*. First edition. Penguin.

Ross, Andrew. 2014. *Creditocracy: And the Case for Debt Refusal*. First edition. OR Books.

Ross, Andrew, David Graeber, George Caffentzis, Nicholas Mirzoeff, Occupy Wall Street, and Strike Debt. 2014. *The Debt Resisters' Operations Manual*. Oakland, CA: PM PRESS.

Schumacher, E.F., and Jonathan Porritt. 1993. *Small Is Beautiful: A Study of Economics as if People Mattered*. London: Vintage.

'The 8 Keys to a Good Heist Story'. 2020. *LitReactor*. Accessed May 20. https://litreactor.com/columns/the-8-keys-to-a-good-heist-story.

INDEX

Index

Index

Index

Index

Index

ABOUT THE AUTHOR

Peter Searle

Hilary Powell's work ranges from audio-visual epics, supported by Acme and Henry Moore Foundation, to print works collected by V&A and MoMA. She has a track record of involving diverse communities in making – from public participation in the production of a pop-up book of the Lower Lea Valley to large-scale print collaborations with demolition workers and material scientists as 'alchemist in residence' at UCL Chemistry.

Daniel Edelstyn is an experienced film director and producer with multiple commissions for Channel 4. His first film *How to Re-Establish a Vodka Empire* was critically acclaimed and opened at BFI London Film Festival before being released across the UK and US.

They come together in Optimistic Foundation CIC, investigating and tackling urgent economic, philosophical and social issues of our time through anarchic, joyful cultural production.

Their *Bank Job* feature documentary film is made with the support of the BFI Doc Society Fund. To find out more and watch the film visit www.bankjob.pictures.